encyclopaedia of
themes and subjects in painting

encyclopaedia of
themes and subjects
in painting

HOWARD DANIEL

Introduction by JOHN BERGER

with 390 illustrations, 35 in colour

THAMES AND HUDSON · LONDON

For the Velebits
of Circe's island

© 1971 THAMES AND HUDSON LTD, LONDON

Printed in Great Britain by Jarrold and Sons Ltd, Norwich

ISBN 0 500 18114 4 *Clothbound*
ISBN 0 500 20108 0 *Paperbound*

Introduction

The largest part of this book comprises a dictionary of the most common recurring subjects to be found in European painting from the early Renaissance to the mid-19th century. Approximately 300 entries are illustrated by paintings – nearly all of which are easel pictures – by about 150 artists. But, as is the case with all dictionaries, the entries have a general reference: they do not merely refer to the works illustrated. The purpose of the dictionary is to inform the visitor to any art gallery or collection about the traditional yet now obscure subject matter of the paintings he is likely to find there.

The fact that such a dictionary is necessary indicates that the pictorial tradition to which the paintings belong is no longer vital: the meaning of the paintings, on one level at least, is no longer obvious to their public. The culture which once produced the paintings is no longer the same culture which has formed those who look at them. The tradition as a whole is now a historical fact rather than a continuing and living reality. And this remains generally true even if a few exceptional works appear to transcend their tradition and to speak to us directly about some unchanged aspects of human experience.

What follows consists of a short essay which attempts to outline the meaning of the pictorial tradition of the easel painting as a historical whole. It is possible today to do this (or to try to do it) precisely because the tradition has reached its end, because we can now see it from the outside, free from its own self-justifying and self-perpetuating criteria. We also have the advantage today – if we wish to see it as an advantage – of realizing that European culture was never the unquestionable summit of world culture.

I believe that the major difficulty of communication between art experts and a general public is largely due to the pretence that the European tradition of fine art continues unbroken. The experts live in the past without appreciating the extent of the gap which separates this past from the present. The general public lives in the present with, at the most, a false nostalgic curiosity about the past. The pre-condition now for understanding the art of the period we are considering is a sense of historical distance. Both experts and public tend to shrink from such a sense.

This essay is an attempt to define very roughly the use to which European painting was put since the Renaissance: the overall social and ideological purpose which it served. The dictionary offers definitions of some of the references which paintings used in pursuit of this purpose. The essay approaches the question: *Why?* The dictionary begins to answer the question: *With What?* There remains the question of *How?* But this is the question upon which the vast majority of art historians have already concentrated in their books.

Has anyone ever tried to estimate how many framed oil paintings, dating from the 15th century to the 19th, there are in existence? During the last fifty years a large number must have been destroyed. How many were there in 1900? The figure itself is not important. But even to guess at it, is to realize that what is normally counted as art and on the evidence of which art historians and experts generalize about the European tradition, is a quantitatively insignificant fraction of what was actually produced.

From the walls of the long gallery those who never had any reason to doubt their own significance look down in perpetual self-esteem, surrounded by gilded frames. I look down at the courtyard around which the galleries were built. In the centre a fountain plays sluggishly: the water slowly but continuously overbrimming its bowl. There are weeping willows, benches, and a few gesticulating statues. The courtyard is open to the public. In summer it is cooler than the city streets outside: in winter it is protected from the wind. I have sat on a bench listening to the talk of those who come into the courtyard for a few minutes' break – mostly old people or women with children. I have watched the children playing. I have paced around the courtyard when nobody was there, thinking about my own life. I have sat there, blind to everything around me, reading a newspaper. As I look down on the courtyard, before turning back to the portraits of the 19th-century local dignitaries, I notice that the gallery attendant is standing at the next tall window and that he, too, is gazing down on the animated figures below. And then suddenly I have a vision of him and me, each alone and stiff in his window, being seen from below. I am seen quite clearly but not in detail for it is forty feet up to the window and the sun is in such a position that it half dazzles the eyes of the seer. I see myself as seen. I experience a moment of familiar panic. Then I turn back to the framed images.

The banality of 19th-century official portraits is of course more complete than that of 18th-century landscapes or that of 17th-century religious pieces. But perhaps not to a degree that matters. European art is idealized by exaggerating the historical differences within its development and by never seeing it as a whole.

The art of any culture will show a wide differential of talent. But I doubt whether anywhere else the difference between the masterpieces and the average is as large as it is in the European tradition of the last five centuries. The difference is not only a question of skill and imagination, but also of morale. The average work – and increasingly after the 16th century – was produced cynically: that is to say its content, its message, the values it was nominally upholding, were less meaningful for the producer than the finishing of the commission. Hack-work is not the result of clumsiness or provincialism: it is the result of the market making more insistent demands than the job.

Just as art history has concentrated upon a number of remarkable works and barely considered the largest part of the tradition, aesthetic theory has emphasized the disinterestedly spiritual experience to be gained from works of art and largely ignored their massive ideological function. We spiritualize art by calling it art.

The modern historians of Renaissance and post-Renaissance art – Burckhardt, Wölfflin, Riegl, Dvorak – began writing at the moment when the tradition was beginning to disintegrate. Undoubtedly the two facts were somehow linked within a fantastically complicated matrix of other historical developments. Perhaps historians always require an end in order to begin. These historians, however, defined the various phases of the tradition (Renaissance, Mannerist, Baroque, Neo-classic etc.) so sharply and explained their evolution from one to the other with such skill that they encouraged the notion that the European tradition was one of change without end: the more it broke with or remade its own inheritance, the more it was itself. Tracing a certain continuity in the past they seemed to guarantee one for the future.

Concentration upon the exceptional works of a couple of hundred masters, an emphasis on the spirituality of art, a sense of belonging to a history without end – all these have discouraged us from ever seeing our pictorial tradition as a whole and have led us to imagine that our own experience of looking today at a few works from the past still offers an immediate clue to the function of the vast production of European art. We conclude that it was the destiny of Europe to make art. The formulation may be more sophisticated, but that is the essential assumption. Try now to see the tradition from the far distance.

'We can have no idea,' wrote Nietzsche, 'what sort of things are going to become history one day. Perhaps the past is still largely undiscovered; it still needs so many retroactive forces for its discovery.'

During the period we are considering, which can be roughly marked out as the period between Van Eyck and Ingres, the framed easel picture, the oil painting, was the primary art product. Wall painting, sculpture,

the graphic arts, tapestry, scenic design and even many aspects of architecture were visualized and judged according to a value system which found its purest expression in the easel picture. For the ruling and middle classes the easel picture became a microcosm of the whole world that was visually assimilable: its pictorial tradition became the vehicle for all visual ideals.

To what uses did the easel picture pre-eminently lend itself?

It permitted a style of painting which was able to 'imitate' nature or reality more closely than any other. What are usually termed stylistic changes – from Classical to Mannerist to Baroque and so on – never affected the basic 'imitative' faculty; each subsequent phase simply used it in a different manner.

I put inverted commas round *imitative* because the word may confuse as much as it explains. To say that the European style imitated nature makes sense only when one accepts a particular view of nature: a view which eventually found its most substantial expression in the philosophy of Descartes.

Descartes drew an absolute distinction between mind and matter. The property of mind was self-consciousness. The property of matter was extension in space. The mind was infinitely subtle. The workings of nature, however complicated, were mechanically explicable and, relative to the mind, unmysterious. Nature was predestined for man's use and was *the ideal object of his observation.* And it was precisely this which Renaissance perspective, according to which everything converged on the eye of the beholder, demonstrated. Nature was that conical segment of the visible whose apex was the human eye. Thus, imitating nature meant tracing on a two-dimensional surface what that eye saw or might see at a given moment.

European art (I use the term to refer only to the period we are discussing) is no less artificial, no less arbitrary, no closer to total reality than the figurative art of any other culture or period. All traditions of figurative art invoke different experiences to confirm their own principles of figuration. No figurative works of art produced within a tradition appear unrealistic to those brought up within the tradition. And so we must ask a subtler question. What aspect of experience does the European style invoke? Or, more exactly, what kind of experience do its means of representation represent? (Ask, too, the same question about Japanese art, or West African.)

In his book on the Florentine Painters Berenson wrote: 'It is only when we can take for granted the existence of the object painted that it can begin to give us pleasure that is genuinely artistic, as separated from the interest we feel in symbols.' He then goes on to explain that the tangibility,

the 'tactile value' of the painted object, is what allows us to take its existence for granted. Nothing could be more explicit about the implications of the artistic pleasure to be derived from European art. That which we believe we can put our hands upon, truly exists for us; if we cannot, it does not.

The European means of representation refer to the experience of taking possession. Just as its perspective gathers all that is extended to render it to the individual eye, so its means of representation render all that is depicted into the hands of the individual owner-spectator. Painting becomes the metaphorical act of appropriation.

The social and economic modes of appropriation changed a great deal during the five centuries. In 15th-century painting the reference was often directly to what was depicted in the painting – marble floors, golden pillars, rich textiles, jewels, silverware. By the 16th century it was no longer assembled or hoarded riches which the painting rendered up to the spectator-owner but, thanks to the unity that chiaroscuro could give to the most dramatic actions, whole *scenes* complete with their events and protagonists. These scenes were 'ownable' to the degree that the spectator understood that wealth could produce and control action at a distance. In the 18th century the tradition divided into two streams. In one, simple middle-class properties were celebrated, in the other, the aristocratic right to buy performances and to direct an unending theatre.

I am in front of a typical European nude. She is painted with extreme sensuous emphasis. Yet her sexuality is only superficially manifest in her actions or her own expressions; in a comparable figure within other art traditions this would not be so. Why? Because for Europe ownership is primary. The painting's sexuality is manifest not in what it shows but in the owner-spectator's (mine in this case) right to see her naked. Her nakedness is not a function of her sexuality but of the sexuality of those who have access to the picture. In the majority of European nudes there is a close parallel with the passivity which is endemic to prostitution.

It has been said that the European painting is like a window open on to the world. Purely optically this may be the case. But is it not as much like a safe, let into the wall, in which the visible has been deposited?

So far I have considered the methods of painting, the means of representation. Now to consider what the paintings showed, their subject matter. There were special categories of subjects: portraits, landscapes, still lifes, genre pictures of 'low life'. Each category might well be studied separately within the same general perspective which I have suggested. (Think of the tens of thousands of still-life canvases depicting game shot or bagged; the numerous genre pictures about procuring or accosting; the innumerable uniformed portraits of office.) I want, however, to

concentrate on the category which was always considered the noblest and the most central to the tradition – paintings of religious or mythological subjects.

Certain basic Christian subjects occurred in art long before the rise of the easel painting. Yet described in frescoes or sculpture or stained glass their function and their social, as distinct from purely iconographic meaning was very different. A fresco presents its subject within a given context – say that of a chapel devoted to a particular saint. The subject *applies* to what is structurally around it and to what is likely to happen around it; the spectator, who is also a worshipper, becomes a part of that context. The easel picture is without a precise physical or emotional context because it is transportable. Instead of presenting its subject within a larger whole it offers its subject to whoever owns it. Thus its subject *applies* to the life of its owner. A primitive transitional example of this principle working are the crucifixions or nativities in which those who commissioned the painting, the donors, are actually painted in standing at the foot of the cross or kneeling around the crib. Later, they did not need to be painted in because physical ownership of the painting guaranteed their immanent presence within it.

Yet how did hundreds of somewhat esoteric subjects apply to the lives of those who owned paintings of them? The sources of the subjects were not real events or rituals but texts. To a unique degree European art was a visual art deriving from literature, as evidenced by so many of the entries in this Guide. Familiarity with these texts or at least with their *personae* was the prerogative of the privileged minority. To the majority such paintings would have been readable as representational images but unreadable as language because they were ignorant of what they signified. In this respect if in no other most of us today are a little like that majority. What exactly happened to St Ursula? we ask. Exactly why did Andromeda find herself chained to the rocks?

This specialized knowledge of the privileged minority supplied them with a system of references by which to express subtly and evocatively the values and ideals of the life lived by their class. (For the last vestiges of this tradition note the *moral* value still sometimes ascribed to the study of the Classics.) Religious and mythological paintings were something more than mere illustrations of their separate subjects; together they constituted a system which classified and idealized reality according to the cultural interest of the ruling classes. They supplied a visual etiquette – a series of examples showing how significant moments in the life should be *envisaged*. One needs to remember that before the photograph or the cinema, painting alone offered recorded evidence of what people or events looked like or should look like.

Paintings applied to the lives of their spectator-owners because they showed how these lives should ideally appear at their heightened moments of religious faith, heroic action, sensuous abandon, contrition, tenderness, anger, courageous death, the dignified exercise of power, etc. They were like garments held out for the spectator-owners to put their arms into and wear. Hence the great attention paid to the verisimilitude of the *texture* of the things portrayed.

The spectator-owners did not identify themselves *with* the subjects of the paintings. Empathy occurs at a simpler and more spontaneous level of appreciation. The subjects did not even confront the spectator-owners as an exterior force; they were already theirs. Instead, the spectator-owners identified themselves *in* the subject. They saw themselves or their imagined selves covered over by the subject's idealized appearances. They found in them the *guise* of what they believed to be their own humanity.

The typical religious or mythological painting from the 16th century to the 19th was extraordinarily vacuous. We only fail to see this because we are deceived by the cultural overlay that art history has given these pictures. In the typical painting the figures are only superficially related to their painted surroundings; they appear detachable from them: their faces are expressionless; their vast bodies are stereotyped and limp – limp even in action. This cannot be explained by the artist's clumsiness or lack of talent; primitive works, even of a low order or imagination, are infinitely more expressive. These paintings are vacuous because it was their function, as established by usage and tradition, to be empty. They needed to be empty. They were not meant to express or inspire; they were meant to clothe the systematic fantasies of their owners.

The easel picture lent itself by its means of representation to a metaphorical appropriation of the material world: by its iconography to the appropriation by a small privileged minority of the 'human values' of Christianity and the Classic world.

I see a rather undistinguished Dutch 17th-century self-portrait. The look of the painter has a quality which is not uncommon in self-portraits. A look of probing amazement. A look which shows sight questioning what it sees.

There have been paintings which have transcended the tradition to which they belong – some of which are illustrated in this book. These paintings pertain to a true humanity. They bear witness to their artists' intuitive awareness that life was larger than the available traditional means of representing it and that its dramas were more urgent than conventional iconography could ever allow. The mistake is to confuse these exceptions with the norms of the tradition.

The tradition and its norms are worth studying, for in them we can find

evidence such as exists nowhere else of the way that the European ruling classes saw the world and themselves. (Paintings in this category are also illustrated in this book.) We can discover the typology of the fantasies of the ruling class in different periods. We can see life rearranged to frame their own image. And occasionally we can glimpse even in works that are not exceptional – usually in landscapes because they relate to experiences of solitude in which the imagination is less confined by social usage – a tentative vision of another kind of freedom, a freedom other than the right to appropriate.

In one sense every culture appropriates or tries to make the actual and possible world its own. In a somewhat different sense all men *acquire* experience for themselves. What distinguishes post-Renaissance European practice from that of any other culture is its transformation of everything which is acquired into a commodity; consequently, everything becomes exchangeable. Nothing is appropriated for its own sake. Every object and every value is transmutable into another – even into its opposite. In *Capital* Marx quotes Christopher Columbus writing in 1503: 'By means of gold one can even get souls into Paradise.' Nothing exists in itself. This is the essential spiritual violence of European capitalism.

Ideally the easel picture is framed. The frame emphasizes that within its four edges the picture has established an enclosed, coherent and absolutely rigorous system of its own. The frame marks the frontier of the realm of an autonomous order. The demands of composition and of the picture's illusory but all-pervasive three-dimensional space constitute the rigid laws of this order. Into this order are fitted representations of real figures and objects. All the imitative skill of the tradition is concentrated upon making these representations look as tangibly real as possible. Yet each part submits to an abstract and artificial order of the whole. (Formalist analyses of paintings and all the classic demonstrations of compositional rules prove the degree of this submission.) The parts look real but in fact they are ciphers. They are ciphers within a comprehensive yet invisible and closed system which nevertheless pretends to be open and natural. Such is the tyranny exercised by the easel painting and from it arises the fundamental criterion for judging between the typical and the exceptional within the European tradition. Does what is depicted insist upon the unique value of its original being or has it succumbed to the tyranny of the system? The reader can apply this criterion for himself to the works illustrated.

Today visual images no longer serve as a source of private pleasure and confirmation for the European ruling classes; rather, they have become a vehicle for its power over others through the mass media and publicity. Yet it is false to draw a contrast between these recent commercial developments and the hallowed tradition of European art. Their references may

be different: they may serve a different immediate purpose: but their determining principle is the same – a man is what he possesses.

Delacroix was, I think, the first painter to suspect some of what the tradition of the easel picture entailed. Later other artists questioned the tradition and opposed it more violently. Cézanne quietly destroyed it from within. Significantly, the two most sustained and radical attempts to create an alternative tradition occurred in Russia and Mexico, countries where the European model had been arbitrarily imposed on their own indigenous art traditions. To most young artists today it is axiomatic that the period of the easel picture is finished. In their works they try to establish new categories in terms of media, form, and response. Yet the tradition dies hard and still exerts an enormous influence on our view of the past, our ideas about the role of the visual artist and our definition of civilization. Why has it taken so long to die?

Because the so-called Fine Arts, although they have found new materials and new means, have found no new social function to take the place of the easel picture's outdated one. It is beyond the power of artists alone to create a new social function for their art. Such a new function will only be born of revolutionary social change. Then it may become possible for artists to work truly concretely and constructively with reality itself, to work with what men are really like rather than with a visual etiquette serving the interests of a privileged minority; then it may be that art will re-establish contact with what European art has always dismissed – with that which cannot be appropriated.

JOHN BERGER

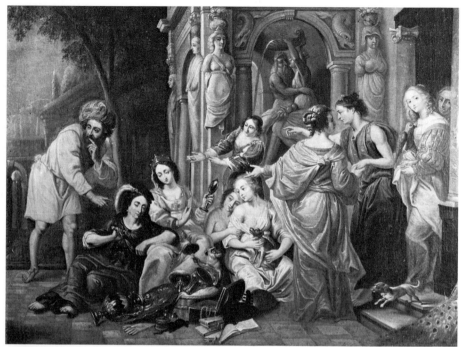

Achilles and the daughters of Lycomedes (detail). David Teniers the Younger, 1610–1690

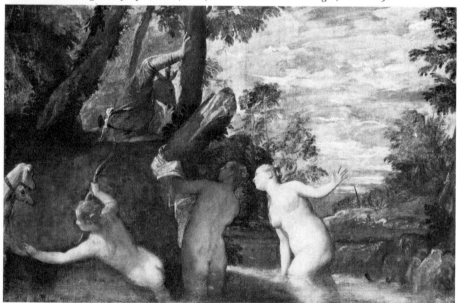

Diana and Actaeon. Paolo Veronese, c. 1528–1588

A

Abraham, see *Isaac.*

Achilles Son of the mortal Peleus and the
Greek sea goddess Thetis (*q.v.*). According to
one version, Thetis sought to bestow immor-
tality on her child by immersing him in the
waters of the Styx. His body was then invul-
nerable, except for the 'Achilles heel' by which
he had been held. Thetis was told Achilles
would die at Troy. To avoid this fate she tried
to keep him out of the Greek army by dressing
him as a girl and hiding him among the
daughters of King Lycomedes on the island of
Skyros. The Greeks sent the cunning Ulysses
to find Achilles. He trapped Achilles by in-
cluding among gifts for the girls a sword and
armour which the transvestite hero seized
when the alarm was sounded. Achilles is the
hero of the *Iliad*, which is largely about his
prowess, his tantrums, and his anger at the
killing of his friend Patroclus by Hector (*q.v.*),
the Trojan champion. He in turn kills Hector,
and – after the end of the *Iliad* – was himself
killed by Paris (*q.v.*), who wounded him in his
vulnerable heel.

Actaeon A Greek huntsman who accident-
ally came upon Diana (*q.v.*) and her maidens
bathing in a forest pool. He was too fascinated
to pass on. For the crime of looking, the angry
goddess of the hunt turned Actaeon into a
stag. His own dogs immediately set upon him
and tore him to pieces. This is thought to be
one of the many myths relating to the incest
mechanism – punishment for an even acci-
dental look at something forbidden. It is one of
those subjects offering a theme central to the
idea of painting itself: there is a kind of collu-
sion between the spectator of the painting, the
voyeur within it, and the painter himself, all
three concentrating on the figure caught
naked.

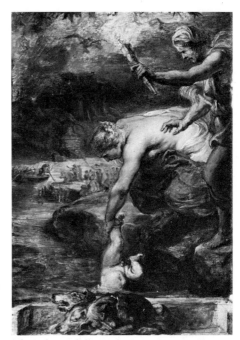

*Thetis dips Achilles in the Styx. Peter Paul
Rubens, 1577–1640*

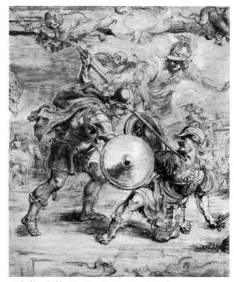

*Achilles kills Hector. Peter Paul Rubens,
1577–1640*

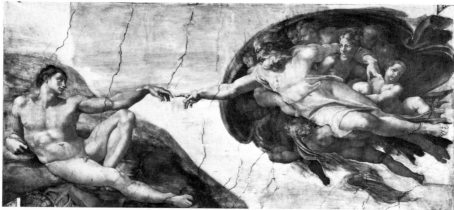

The Creation of Adam. Michelangelo Buonarroti,
1475–1564

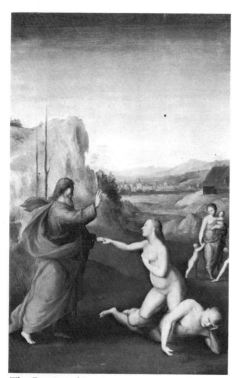

The Creation of Eve. Fra Bartolommeo,
c. 1474–1517

Adam and Eve

Creation of Adam The source in Western art for the creation of man is Genesis i and ii. According to Genesis ii, 7 the Lord God formed Adam from dust and breathed life into his nostrils. This is not the act generally depicted in most creation paintings. The best known of these paintings is Michelangelo's on the Sistine ceiling which shows life being transmitted like an electric spark through the finger tips. Adam lived 930 years (Genesis v, 5).

Creation of Eve After Adam's vast exercise in taxonomy – the giving of names to all living creatures – Genesis records (ii, 20–24) Adam's need for a 'help meet'. The Lord God put Adam into a deep sleep, removed one of his ribs and converted it into the first woman. It was not until after the temptation and the eating of the forbidden fruit that Adam called the woman Eve.

Temptation and Fall Genesis iii relates how the Garden of Eden's talking serpent – frequently represented in art as having the top half of a woman – tempted Eve to eat the forbidden fruit which offered the divine power of knowing good and evil. Eve persuaded Adam to eat some of this forbidden fruit. The primal pair immediately became aware of each other's nakedness. Theologians considered the events in Eden for a long time. St Augustine (*q.v.*) finally developed the concept of Original Sin – later reconfirmed by Calvin – whereby Adam's sin was transmitted to all his descendants through the act of propagation. He

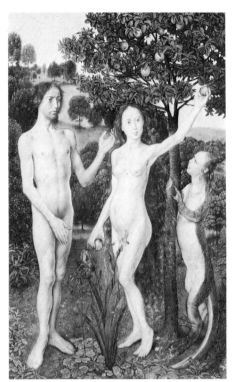

The Temptation and Fall. Hugo van der Goes, active 1467–1482

thereby set in motion an anxiety mechanism which still dominates European morality.

Expulsion from the Garden Genesis iii goes on to record the Lord God's discovery of Adam and Eve's disobedience. The man blames the woman, the woman blames the talking snake, and the Lord God brings to an end his experiment in immortality. Henceforth mankind will reproduce sexually, with all the complications inherent in that relationship. Man will make his living by the sweat of his brow, but outside Eden from which he is expelled for ever. Cherubim guardians and a whirling fiery sword at the entrance of Eden prevent man from ever returning to immortality and the easy life. The theme was frequently used – as by Masaccio – to represent the tragic aspect of the human condition. The whole story of the expulsion has been interpreted as a symbol of birth itself.

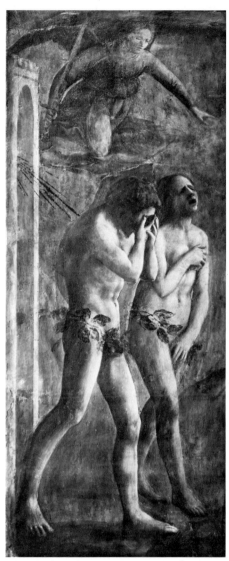

The Expulsion from Paradise. Masaccio, 1401–1428(?)

The Expulsion, with the Labours of Adam, Eve, Cain and Abel. Detail from the 'Hours of the Duchess of Burgundy', c. 1450

Toiling Genesis iii, 23 completes the story of Adam, whose fate as a result of his fall and expulsion from Eden was 'to till the ground from whence he was taken'. The scene of Adam and Eve toiling is very common in Gothic illuminated manuscripts of the late feudal period and is visual evidence of man's inferiority and submission before divine authority whose representative on earth was the Church.

Adonis, see *Venus*.

Adoration of the Kings, see *Adoration of the Magi*.

Adoration of the Magi Matthew ii relates how the wise men or *magi* – the sacred priestly caste of the Persians – followed a star to Bethlehem and found Mary and the child Christ whom they worshipped and presented with gifts of gold, frankincense, and myrrh. The simply told Epiphany story which makes no mention of the number of wise men, underwent a glamorous transformation. By the 7th-century there are three wise men (from the number of gifts?) and they now have the names of Caspar, Melchior and Balthazar. By the 12th century they have been promoted to kings and their royal remains buried in Cologne. The story had an obvious attraction for the Church, major patron of artists. Homage of earthly kings to Christ the Heavenly King established the divine source of its own authority.

Adoration of the Shepherds The scene is described in Luke ii, 15 and 16. '. . . the shepherds said one to another, let us go even unto Bethlehem . . . and they came with haste and found Mary, and Joseph and the babe in a manger.' The Holy Family lodged there because there was no room for them in the local inn. Painters frequently included in the scene an ox and an ass. The Gospels give no date, and it was not until the 4th century that the feast was celebrated on 25 December (a date which corresponds roughly with Hanukah, with ancient festivals of the birthday of the sun, and with Saturnalia, and Dionysia).

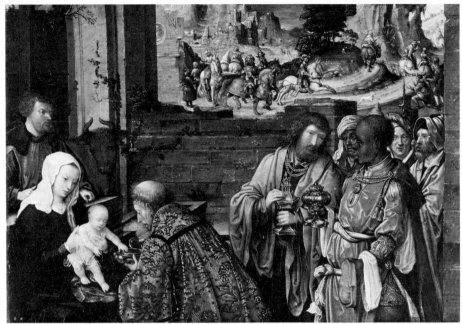

Adoration of the Magi (detail). Lucas van Leyden, c. 1494–1533

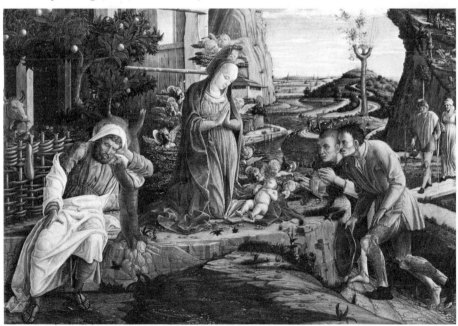

Adoration of the Shepherds. Andrea Mantegna, c. 1431–1506

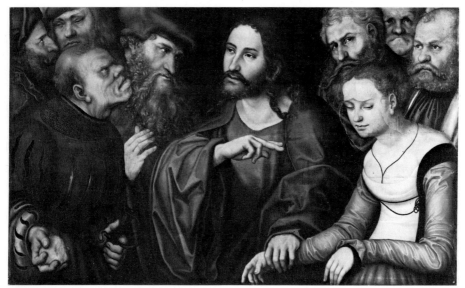

Christ and the woman taken in adultery.
Lucas Cranach the Elder, 1472–1553

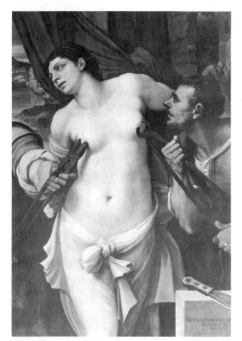

The Martyrdom of St Agatha (detail).
Sebastiano del Piombo, c. 1485–1547

Adultery, Woman taken in John viii, 3–7
describes the trap set for Christ by the scribes
and Pharisees who brought before him a
woman caught in the very act of adultery,
asking him if according to Mosaic Law she
should not be stoned. His reply, 'he that is
without sin among you let him first cast a stone
at her' sent them off in shamed disarray. He
then dismisses the woman with the admonition
to 'sin no more'.

Aeneas Aeneas, hero of Virgil's epic *The
Aeneid*, was an ally of the Trojans whom he
supported with great valour during their
ten-year war with the Greeks. On the fall of
Troy he fled, carrying his aged father on his
back and leading his little son. He was fol-
lowed by some surviving Trojans and they
took with them the city's *Penates*. He wan-
dered for many years in the eastern and central
Mediterranean. Among his adventures was an
encounter with Dido, Queen of Carthage,
which ended in her death from unrequited
love, and a visit to Hell to see his now dead
father. Aeneas finally arrived in Latium,
carved out a kingdom for himself and became
the ancestor of the Romans. The epic is Virgil's
conscious glorification of Rome and his master
Augustus.

Agatha, St This saint came from a pros-
perous family in mid-3rd-century Catania,
south-east Sicily. An early Christian, she
attracted the lecherous governor, Quintianus.
When she resisted his advances, he gave her
into the charge of a brothel madame appro-
priately named Aphrodisia. Thirty days with
Aphrodisia who ran a family business with her
nine prostitute daughters only confirmed
Agatha in the advantages of a sinless life. Then
according to Caxton's translation of the
Golden Legend 'Quintianus did her to be tor-
mented in her breasts and paps, and com-
manded that her breasts and mammels should
be drawn and cut off.' They were miracu-
lously healed but she died. Her attributes are
pincers and her breasts on a dish. She is
invoked against natural disasters.

Agnes, St This saint was a young victim of
a Christian-hating Roman in the hard times of
Diocletian. Refusing to marry the son of the
Roman prefect, she was led through the streets
naked to a brothel. Her hair grew miracu-
lously long and covered her. An angel pro-
tected her virginity in the brothel. Indeed, her
intended husband tried to ravish her in the
brothel but was stricken dead. Her prayers
brought him back to life. After resisting
incineration she finally died from a sword
thrust. Her attribute is a lamb, a pun on her
name. *Agnus* in Latin is lamb. The saint is
invoked for chastity.

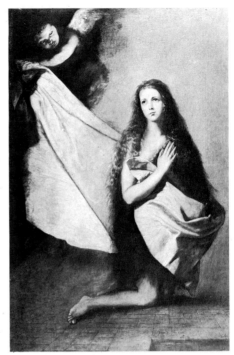

St Agnes. José de Ribera, 1588–1652

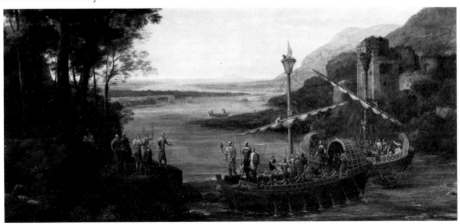

The Landing of Aeneas in Italy (detail). Claude Lorraine, 1600–1682

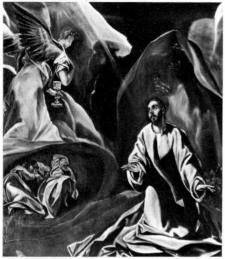

The Agony in the Garden (detail).
El Greco, 1541–1614

The Agony in the Garden. Andrea Mantegna,
c. 1431–1506

Agony in the Garden The fourth act in Christ's passion is known generally as *The Agony in the Garden* and is described in several of the Gospels. It occurs between *the Last Supper* (*q.v.*) and *the Betrayal by Judas* (*q.v.*) and takes place on the Mount of Olives in a garden called Gethsemane where Christ was wont to rest and meditate. Luke xxii, 42–44 describes the scene in which his disciples sleep while he prays 'saying, Father, if thou be willing remove this cup from me: nevertheless not my will but thine, be done. And there appeared an angel unto him from heaven, strengthening him. And being in an agony he prayed most earnestly; and his sweat was as it were great drops of blood falling down to the ground.' In painting, the cup is frequently used as a symbol of the Agony. Following the version in Matthew xxvi, 37, Peter and the brothers John and James are often shown asleep in the foreground. The face of the suffering Christ inspired paintings with the title *Man of Sorrows*, the phrase from Isaiah liii, 3, '. . . a man of sorrow and acquainted with grief'.

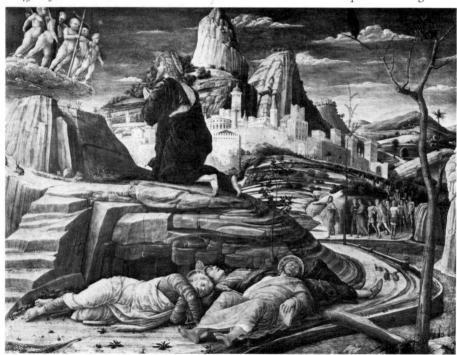

The wedding of Alexander and Roxana (detail).
Sodoma, 1477–1549

Alexander Alexander the Great (356–323 BC) as he is usually known, was King of Macedonia. With a small well-disciplined army of Macedonians and Greeks he set out on a series of conquests. In the few years after his defeat of Darius (*q.v.*) at the battle of Issus (*q.v.*) he was master of the Middle East between the Nile and the Indus. His bold solution of complicated problems is illustrated by his way with the unravellable Gordian Knot. With one sword-blow he severed the Knot which according to legend gave mastery of Asia. The most important result of his activities was the spread of Hellenic culture, e.g. the first Buddha images owe much to statues of Apollo. He died of malaria in Babylon at the age of thirty-three. As a personality he comes down to the Middle Ages and Renaissance as a godlike conqueror of distant lands and in art often appears in contemporary knightly garb. In the Middle Ages numerous legends gathered round him, of which the most frequently illustrated is his flight to Heaven carried by griffins.

Amazons A legendary race of women – all warrior-hunters – who lived in Asia Minor near the Black Sea. They are said to have removed their right breasts to make better use of the bow, but are not shown thus in art. Making occasional use of men in neighbouring cities to perpetuate their race, they otherwise lived in exclusively feminine settlements. In Greek mythology their queens fared badly.

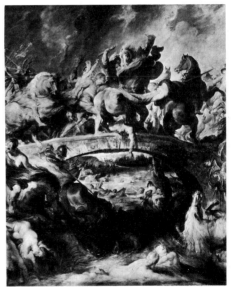

Battle of the Amazons (detail). Peter Paul
Rubens, 1577–1640

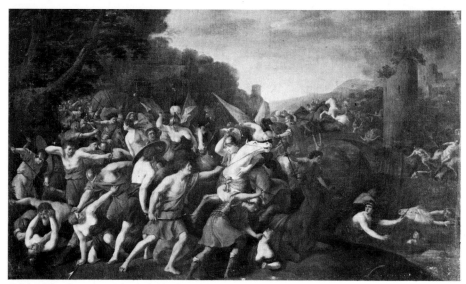

Battle of the Amazons. School of Charles Lebrun, 1619–1690

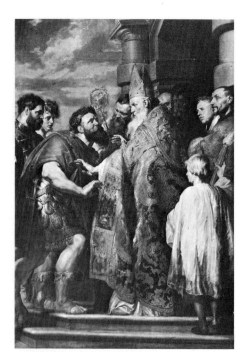

St Ambrose dissuading Maximus.
Anthony van Dyck, 1599–1641

Hercules slew Hippolyta in his labour of seizing her girdle, Theseus abducted Antiope – no relation of the Antiope (*q.v.*) seduced by Jupiter disguised as a satyr – and Achilles killed Penthesilea, the ally of Troy. To the Renaissance imagination the Amazons were an ideal image of aggressive feminine sexuality.

Ambrose, St One of the greatest of the early Church Fathers, he was born about AD 340 at Trier, one of the main cities of the Roman province of Gallia of which his Christian father was prefect. After being educated in Rome, he in turn became a high official of the Empire, governing two provinces from Milan. At that time Milan was rent by religious feuds connected with Arianism. Ambrose's administration of Milan was so popular that he was acclaimed bishop of that city. He brought peace to Milan and although not trained in Church matters he became one of the great ecclesiastical scholars and teachers. He was responsible for the conversion of St Augustine (*q.v.*). Such was Ambrose's authority that he successfully defied and corrected the Emperor Theodosius I who had permitted Catholics to be massacred at Salonica.

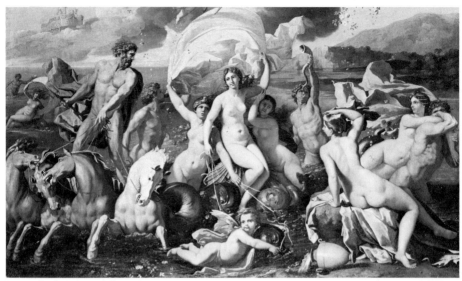

Triumph of Neptune and Amphitrite. Nicolas Poussin, 1594–1665

Ambrose was instrumental in stamping out the Arian heresy.

Amor, see *Cupid.*

Amphitrite Amphitrite was a Nereid, or sea goddess. Neptune (*q.v.*) the god of the sea originally wanted to marry Thetis (*q.v.*) but rejected her after learning of the prophecy that her son would be greater than his father. Neptune then sought out the unenthusiastic Amphitrite. To avoid his attentions, she fled to north-west Africa but was retrieved by one of Neptune's dolphins who was rewarded by becoming a constellation. She married Neptune and had to accustom herself to a philandering husband with a penchant for strange love affairs with creatures such as harpies, horses, and nymphs.

Andrew, St One of the fishermen Apostles, brother of Peter. The success of his mission in Greece aroused the ire of the Roman governor, who had him crucified by being tied to an X-shaped cross. His attributes are a book and the so-called St Andrew's cross. He is the patron saint of Scotland, and is invoked against gout and stiff-neck.

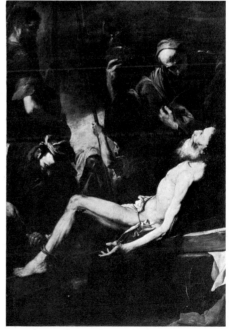

Crucifixion of St Andrew. José de Ribera, 1588–1652

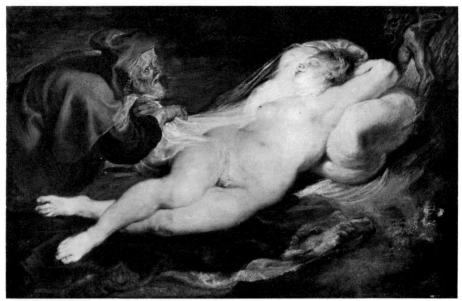

Sleeping Angelica and the Hermit. Peter Paul Rubens, 1577–1640

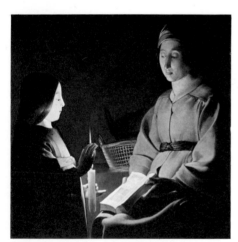

St Anne teaching the Virgin (detail).
Georges de la Tour, 1593–1652

Andromache, see *Hector.*

Andromeda, see *Perseus.*

Angelica One of the heroines of Ariosto's great Renaissance poem *Orlando Furioso.* The main theme in this epic collection of myths is the struggle between the Saracens and Christians. The Christian champion Orlando (Roland) brings Angelica, Queen of Cathay, to Charlemagne's Court where she stirs up dissension among his knights. When she marries the Saracen champion Medoro, Orlando becomes mad (*furioso*). Her adventures – not always glamorous – included capture by pirates and an attempted desert seduction by an old hermit.

Anne, St Mother of the Virgin Mary (*q.v.*) and wife of Joachim. She appears frequently in paintings, teaching the Virgin Mother to read and embroider. She also appears with the Virgin Mary sitting on her lap, holding the Christ Child.

Annunciation Most paintings of the *Annunciation* are based on the story in Luke i, 26 ff. in which the Archangel Gabriel, the messenger of God – in early paintings he is the main figure and bears a sceptre like Mercury – tells the Virgin Mary that she will bear Jesus. Later, Mary becomes the dominant figure and Gabriel generally bears a white lily, symbol of purity and the flower of the Virgin. In Sienese paintings of the *Annunciation* Gabriel sometimes bears an olive branch, the lily being the flower of Florence, Siena's rival. The dove descending towards Mary, or hovering over her, is a symbol of the Holy Ghost entering her. To make it more explicit a small baby is sometimes shown sliding down behind the dove.

Antaeus, see *Hercules.*

Antiope Daughter of a Theban named Nycteus (or of the river god Asopus), she was seduced by Jupiter disguised as a satyr. She

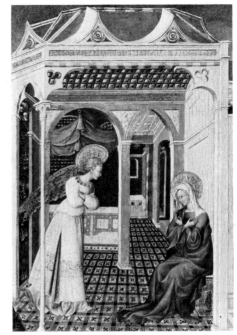

The Annunciation (detail). Giovanni di Paolo, 1403–1482

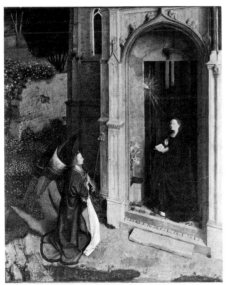

The Annunciation. Studio of Jan van Eyck, active 1422–1441

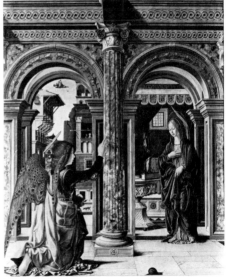

The Annunciation. Francesco del Cossa, c. 1435–1477

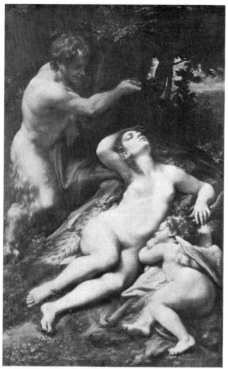

Antiope's Dream. Antonio Correggio,
c. 1494–1534

bore him two sons. The Renaissance respect
for classical mythology enabled painters to
portray a particularly erotic theme, the seduc-
tion of a sleeping woman by a half-beast.

Antony, St (Abbot) Antony, a rich young
4th-century Egyptian, lived the fashionable
life. He suddenly gave all he had to the poor
and retired to the desert as a hermit. His
successful resistance to temptations carefully
worked out by devils was exemplary. A raven
fed Antony and his associate hermit friend,
Paul, by bringing them a daily loaf of bread.
St Antony's attributes are a bell, a crutch, and
a pig, all of which seem to have become
attached to him because he was the patron of
an order of Hospitallers in France who looked
after the sick and had the privilege of allowing
their pigs to forage in the streets. St Antony is
also at the same time patron of swineherds.
The saint was invoked against erysipelas, or
St Antony's fire, and venereal diseases. The
theme of the temptation of St Antony inspired
a surprising number of the most powerful and
sustained works by northern painters between
the 15th and 16th centuries, among them
Bosch and Grünewald. It seems that their
interest in the subject went far beyond its
original or illustrative meaning. St Antony
becomes for them the embodiment of the

The Temptation of St Antony (detail showing a Black Mass). Hieronymus Bosch,
c. 1450–1516

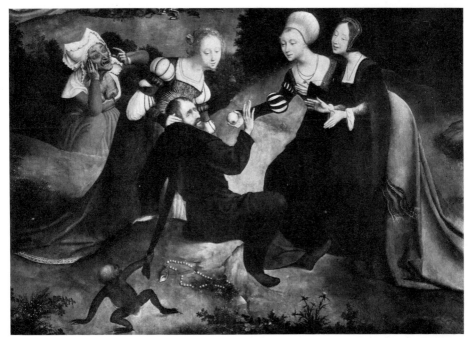

The Temptation of St Antony. Joachim Patinir, early 16th century

desperately isolated individual conscience, against whom all the evil and suffering of a transitional world breaks in order to make him doubt the meaning of his own existence. Such an interpretation of the subject must have been partly formed by the historical development leading to the Reformation. For Bosch, St Antony is threatened by the malevolent force of evil rituals – his principal actors are monsters carrying out with grave decorum and punctilio the offices of a Black Mass. For Grünewald the threat takes the form of disease, the plague, death, and genetic malformation. It is significant in this respect that his St Antony was specially painted for a hospital in Alsace which cared for the venereally infected.

Antony of Padua, St A 13th-century Portuguese, attracted to Assisi by the work of St Francis (*q.v.*), whose friend he became. He died in Padua at the age of thirty-six. Painters sometimes represent him carrying the Christ Child, accompanied by a kneeling ass. This

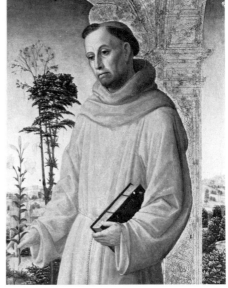

St Antony of Padua (detail). Vincenzo Foppa, 1427/30–1515/16

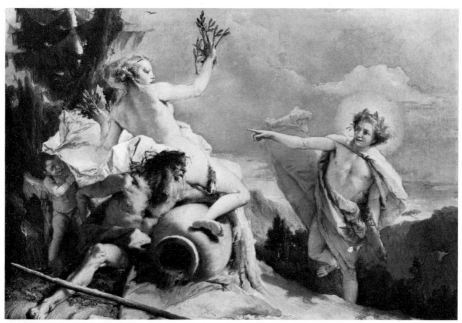

Apollo and Daphne. Giovanni Battista Tiepolo, 1696–1770

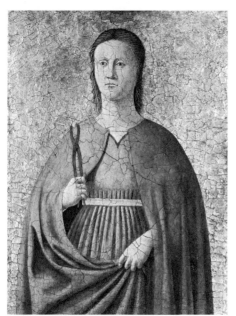

St Apollonia. Piero della Francesca,
c. 1416–1492

commemorates the story of the Albigensian heretic who was dramatically convinced of the miracle of the Eucharist. His ass knelt down when St Antony passed by, carrying the Host. The saint is invoked to secure the return of lost property.

Aphrodite, see *Venus.*

Apollo and Daphne Of the many versions of the story, the one favoured by painters concerns Daphne as an object of Apollo's lust. The beautiful daughter of the river god Peneius caught the roving eye of Apollo. Resisting his attentions she was pursued. Almost at the point of rape her prayer to the earth goddess was answered. She turned into a laurel tree in Apollo's arms. The laurel was Apollo's sacred plant.

Apollonia, St Martyred during the 3rd-century persecutions of the Alexandrian Christians. In early accounts her jaws were broken by violent blows. It was not before the Middle Ages that she is thought of as having had her

teeth pulled out. Her attributes are pincers and a tooth. She is understandably patroness of dentists and is invoked against toothache.

Apostles The Apostles (the Greek word *Apostolos* means messenger) were twelve of Christ's many disciples chosen for their special closeness to him. Except for Judas Iscariot who came from southern Judea, the others were Galileans. Their number had symbolic significance in Jewish history and culture. According to Mark iii, 14 and 15, Jesus '... ordained twelve, that they should be with him, and that he might send them forth to preach, and to have power to heal sicknesses, and to cast out devils'. Their names – identical in Mark and Matthew but varying somewhat in Luke and the Acts – are: Simon called Peter, his brother Andrew, James and John the sons of Zebedee, Philip, Bartholomew, Thomas, Matthew, James the son of Alphaeus, Thaddeus, Simon and Judas (replaced by Matthias after betraying Christ). Paul is also counted as an Apostle, on the strength of his vision of Christ on the road to Damascus. In painting, the Apostles are most frequently represented as a group, each holding his emblem, and with a scroll giving a sentence from the 'Apostles' Creed'.

Four Apostles: John, Peter, Paul and Mark (detail). Albrecht Dürer, 1471–1528

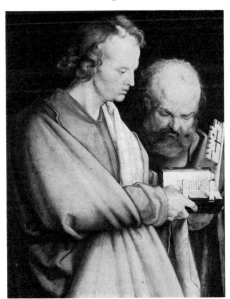

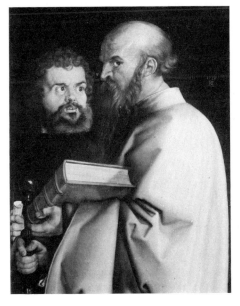

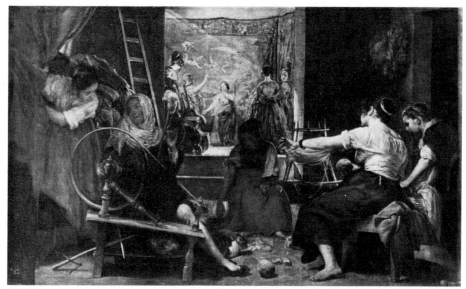

The Competition between Arachne and Pallas Athene (The Spinners). Velazquez, 1599–1660

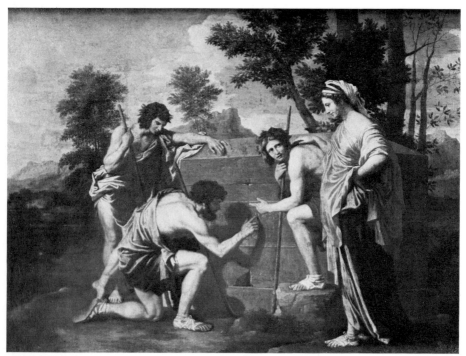

'Et in Arcadia Ego' (detail). Nicolas Poussin, 1594–1665

Arachne The story of Arachne is a perfect example of hubris – the folly of competition with the gods. The young Lydian, Arachne, famous for weaving and needlework, challenged Minerva the goddess of industry and household arts. Disguised as an old woman the goddess tried unsuccessfully to dissuade Arachne from her folly. Thereupon Arachne wove a great tapestry illustrating the disorderly love life of the gods. Minerva found no fault in the work but using her power – the ultimate resort of the gods – she turned Arachne into a spider to weave for ever the thread produced by her own body. The scientific name for the spider family *Arachnida* comes from Arachne.

Arcadia A backward rural part of the Peloponnesus which in Virgil became an archetype of ideal country life and in Renaissance and post-Renaissance thought a setting for an entirely happy and free life, summed up in the notion of the Golden Age. In a philosophical painter such as Poussin a more serious idea emerges. In his famous painting *Et in Arcadia Ego*, the graceful figures examining the phrase inscribed on the tomb are quietly contemplating the inevitability of their own mortality.

Argonauts, see *Jason*.

Ariadne, see *Bacchus*.

Armida, see *Rinaldo*.

Arnolfini Giovanni Arnolfini was a 15th-century silk merchant and banker from Lucca who had settled in Bruges. The famous wedding portrait by Jan van Eyck is full of the symbols which works of that kind displayed, e.g. shoes for domesticity, the little dog for fidelity, the hand being offered and held for good faith, the single lighted candle in daytime for the presence of God, etc. See p. 37.

Artemis, see *Diana*.

Ascension There are two sources in the New Testament for the Ascension, the end of Christ's physical presence on earth. Luke xxiv, 51 tells how '. . . while he blessed them, he

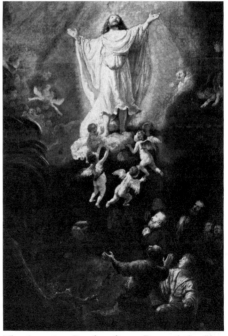

The Ascension. Rembrandt van Ryn, 1606–1669

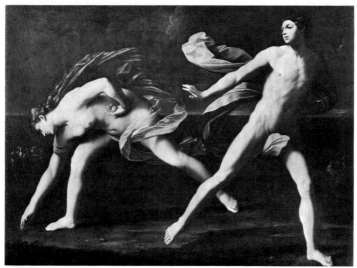

Atalanta and Melanion. Guido Reni,
1575–1642

was parted from them, and carried up into
heaven'. Acts i, 9 relates more specifically that
'... while they beheld, he was taken up; and
a cloud received him out of their sight'.

Assumption, see *Virgin Mary.*

Atalanta Exposed as a baby by a disgruntled
Arcadian father who wanted a son, Atalanta
was suckled by a bear, survived and grew up
as a huntress. She could out-wrestle and
out-race any man. She dispatched suitors who
failed to outrun her. Melanion beat her by a
trick. He borrowed three golden apples from
Venus and dropped them in front of Atalanta
as they raced. She stopped to pick them up
and was beaten. Their subsequent marriage
ended poorly. They profaned a grove sacred
to Jupiter and were turned into lions.

Athena, see *Minerva.*

Atlas When the Titans were defeated by the
gods under the leadership of Jupiter, various
punishments were meted out to them. Atlas,
one of the Titan leaders, was sent to what is
now north-west Africa where his punishment
was to support the heavens on his shoulders
for ever. While doing this he somehow
managed to keep an excellent orchard whose
finest tree produced golden apples. Notwith-

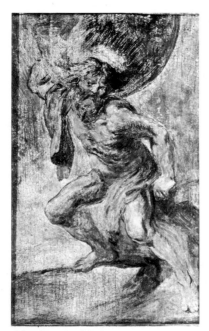

Atlas. Peter Paul Rubens, 1577–1640

standing the inconvenience of his burden he also managed to father a number of daughters, the best-known being the Hesperides who tended his orchard. One of the labours of Hercules (*q.v.*) was to bring back some of the Golden Apples of the Hesperides. To enable Atlas to pluck some apples, Hercules relieved him of his burden, and then had to trick him into taking it back. According to Ovid's *Metamorphoses* Atlas later refused hospitality to Perseus (*q.v.*), who showed him the Gorgon's head and turned him into the stone which we know as the Atlas Mountains of North Africa.

Augustine, St One of the four great Church Fathers was born in North Africa in AD 354. He was a good scholar but led a riotous life and had an illegitimate son called Deodatus. He finally but slowly accepted Christianity under the influence of his mother and St Ambrose of Milan. During this period he wrote his immortal phrase, 'Make me continent and chaste, O Lord, but not yet.' He was one of the first great systematizers of Christian theology. He tells the story of his spiritual development in his still readable *Confessions*, the beginning of confessional autobiography. His attributes are a heart – whole, broken, or transfixed – and a book. He is sometimes shown with a small boy at his feet whom he had once seen trying to empty the sea into a hole in the sand; when told by Augustine that his efforts were in vain, he replied that his task was no harder than Augustine's attempts to expound the Trinity. See p. 41.

Aurora One of the daughters of the Titans was Aurora (or Eos) the goddess of the dawn. Venus was jealous of her youth and beauty, and spurred her into unhappy love affairs with a series of mortals. For her favourite, Tithonus, Aurora obtained immortality but not youth. As he aged she had him first shut up, and later turned into a grasshopper. Their son, Memnon, was killed by Achilles (*q.v.*) at Troy. The tears she shed for Memnon each morning were the origin of dew. Another unhappy lover was Cephalus, who was temporarily abducted from his wife Procris (*q.v.*). See p. 40.

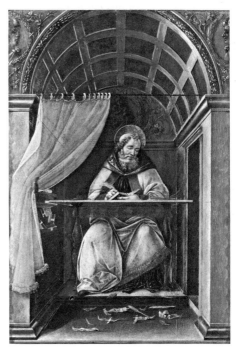

St Augustine. Sandro Botticelli, c. 1445–1510

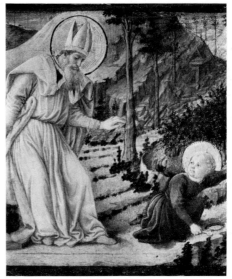

St Augustine and the child (detail). Fra Filippo Lippi, c. 1406–1469

B

Babel, Tower of The origin of the Tower of Babel was the *ziggurat* or seven-stepped pyramid temple of Marduk built near ancient Babylon. It was three hundred feet high and occupied an area of about two thousand square yards. The story of the Tower of Babel is yet another hubristic myth in which an ancient people – the Hebrews – were warned of the folly of competition with God. Genesis xi related that ' . . . the whole world was of one language, and of one speech . . . and they said, go to, let us build us a city and a tower, whose top may reach unto heaven. . . . ' The Lord then confounded their language 'that they may not understand one another's speech. So the Lord scattered them abroad.' From this confusion of tongues comes the word 'babel'.

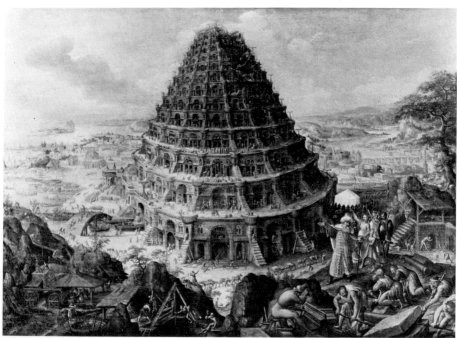

The Tower of Babel. Marten van Valckerborch, 1542–1604

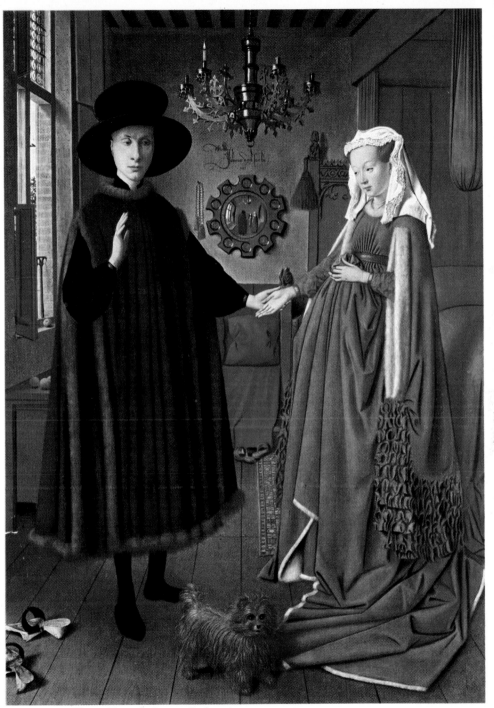

Giovanni Arnolfini and his wife. Jan van Eyck, active 1422–1441

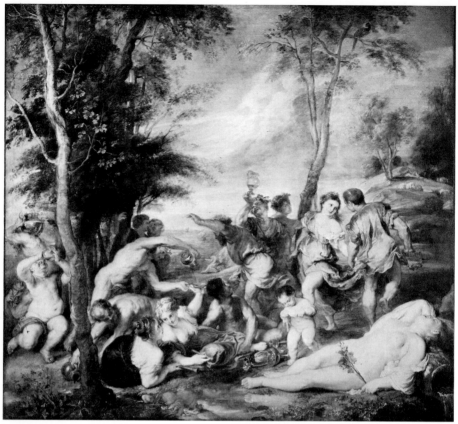

Bacchanal. Peter Paul Rubens, 1577–1640

Bacchanalia Festivals held in honour of
Bacchus (Dionysius) imported into Roman
civilization from the Greek cities in southern
Italy. The cult of Bacchus (*q.v.*) appears to
have started in Thrace. Originally wine
festivals of a mystical, sacred nature, they
degenerated into drunken revelries and mass
debaucheries. They were banned by the
Roman Senate in 186 BC. The respectability
bestowed on classic antiquity by Renaissance
scholars permitted painters such as Titian,
Rubens and Poussin to depict Bacchanalia,
crowded with naked Bacchantes (*q.v.*), as
scenes of erotic and liberating abandonment.

Bacchantes The raving women (Maenads)
who with Satyrs (*q.v.*) formed part of the train
of persons accompanying Bacchus on his
drunken processions. Their uncontrollable

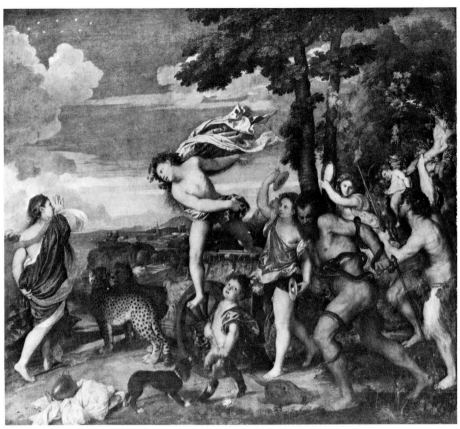

ecstatic frenzies were frequently appeased by
tearing men, and even their own children, to
pieces.

Bacchus and Ariadne. Titian, c. 1487/90–1576

Bacchus Bacchus (Dionysius) was born from
the thigh of his father Jupiter where he had
been transplanted as a foetus removed from
his mother Semele when the jealous Juno
caused her destruction. He was the classic god
of the grape vine. Travelling on a chariot
drawn by panthers and accompanied by his
Bacchantes (*q.v.*) and his Satyrs (*q.v.*) the
handsome young man visited many countries
and introduced viticulture. He married
Ariadne, daughter of King Minos of Crete,
after she had been abandoned in Naxos by
Theseus (*q.v.*). On her death Bacchus threw
into the heavens the crown he had given her.
It became a constellation. See p. 40.

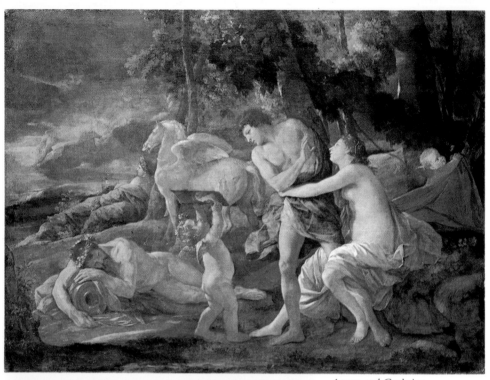

Aurora and Cephalus.
Nicolas Poussin, 1594–1665

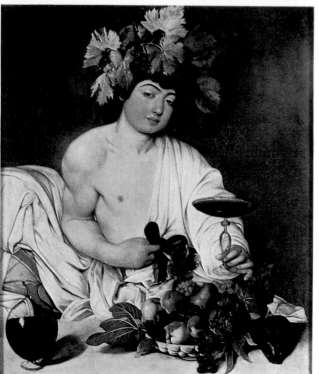

Young Bacchus. Caravaggio,
1573–1610

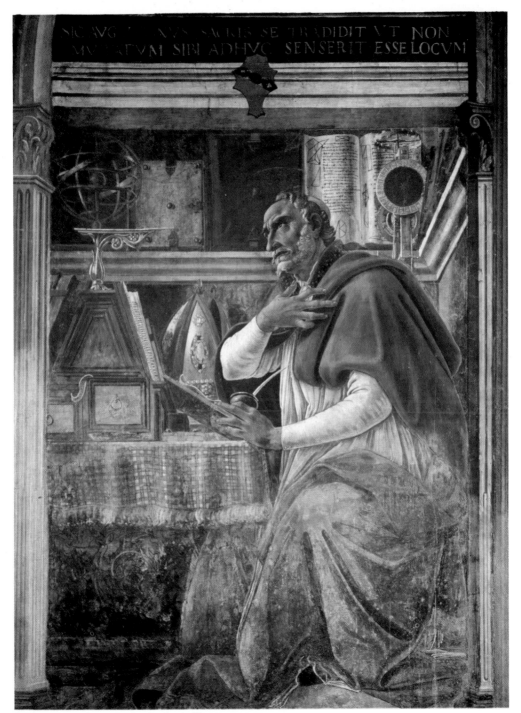

St Augustine in his study. Sandro Botticelli, c. 1445–1510

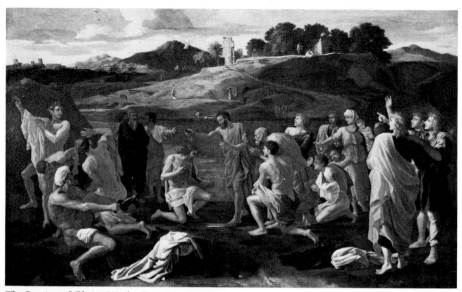

The Baptism of Christ. Nicolas Poussin, 1594–1665

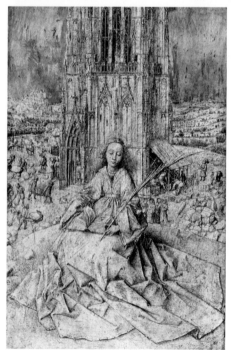

St Barbara (detail). Jan van Eyck,
active 1422–1441

Baptism The first of the Seven Sacraments
(*q.v.*) – from the Greek *baptizo*, I immerse.
Jewish in origin – although a form of purify-
ing by immersion was practised in the
Eleusian mysteries and in many Near Eastern
cults – it was a cleansing rite of initiation in
which pagans converted to Judaism had their
uncleanness washed away. During a great
religious revival in the Jordan valley John the
Baptist baptized Christ in the waters of Jordan
and the spirit of God descended on him like a
dove (Mark i, 10). What distinguished this
baptism from normal Jewish baptism was the
introduction of the idea of repentance for sins
and preparation for the Last Judgment (*q.v.*).
See p. 44.

Barbara, St A saint who because of her great
beauty was kept in a tower by her father. He
was obsessed with torturing her and in Cax-
ton's words commanded 'the hangman that
he should cut off with his sword her paps'.
The increasingly enraged father reserved for
himself the *coup de grâce* and killed her with a
sword thrust. He was immediately afterwards
consumed by fire. The saint's attributes are a
three-windowed tower (for the Father, Son,
and Holy Ghost), a sword, and a chalice.

Bartholomew, St One of the Apostles about whom little is known. He evangelized in the Near East and was martyred in Armenia by being flayed alive. His attributes are a flaying knife and a book. He sometimes carries a human skin. He is the patron of many occupations, including butchers and the leather trades, and is invoked against nervous diseases.

Bathsheba The story of David's adultery with the beautiful Bathsheba, wife of one of his officers, Uriah the Hittite, is told in 2 Samuel xi: ' . . . David arose from his bed and walked upon the roof . . . saw a woman washing herself, and the woman was very beautiful to look upon . . . and David sent messengers and took her.' David disembarrassed himself of Uriah by arranging his death in battle. He married the pregnant Bathsheba but they were punished. The prophet Nathan rebuked David and correctly foretold the death of the child which was the product of his sinful union with Bathsheba. After David's repentance they had a second son, Solomon, who succeeded him. See p. 45.

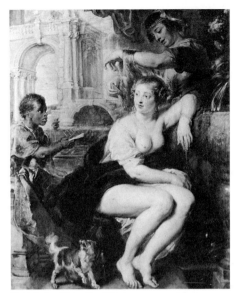

Bathsheba. Peter Paul Rubens, 1577–1640

(Below) St Bartholomew with donor, St Agnes and St Cecilia. Master of S. Bartholomew, c. 1500

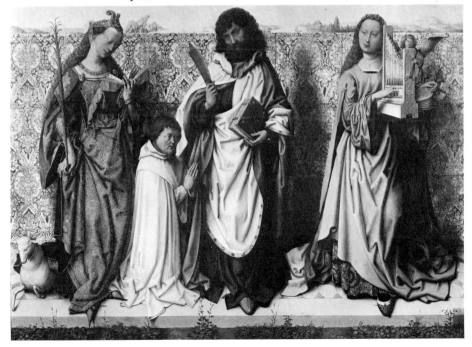

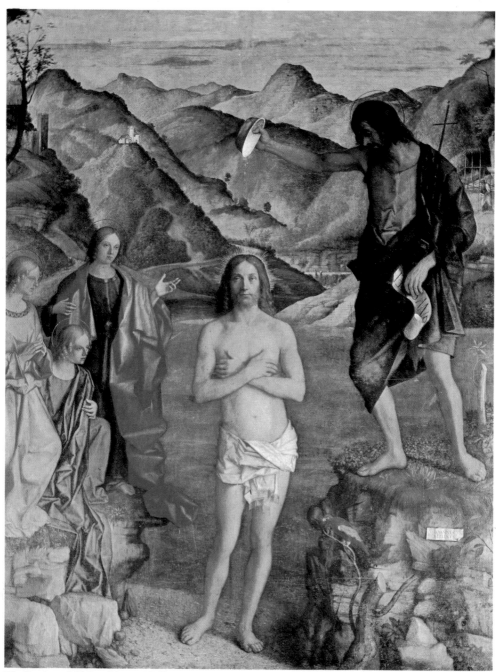

The Baptism of Christ. Giovanni Bellini, c. 1430–1516

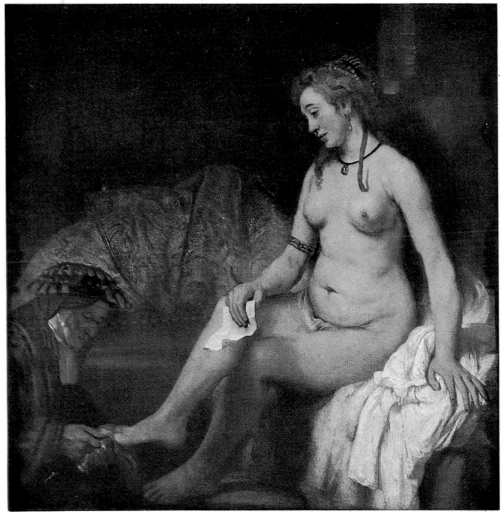

Bathsheba. Rembrandt van Ryn, 1606–1669

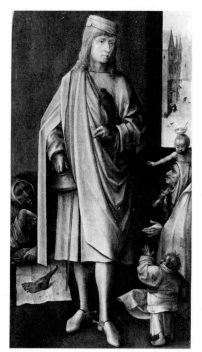

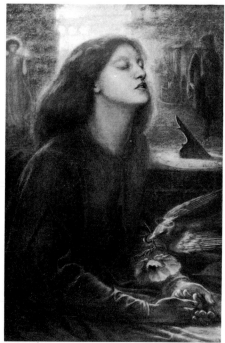

St Bavon. Hieronymus Bosch,
c. 1450–1516

'Beata Beatrix' (Beatrice).
Dante Gabriel Rossetti, 1828–1882

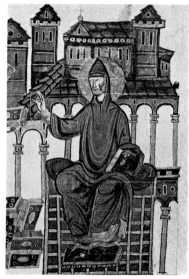

St Benedict, detail from an 11th-century
manuscript

Bavon, St Except for being the patron of
that now rare sport of falconry, little is known
of this 7th-century local saint, particularly
venerated in Ghent, Haarlem, and Liège. In
those cities there are churches called after him.

Bearing of the Cross, see *Calvary.*

Beatrice Dante fell in love with Beatrice
Portinari when she was but a nine-year-old
child. He tells the story of his passion for the
young Florentine girl in the *Vita Nuova.*
Although he only saw her a few times before
she died in her twenty-fourth year, he immor-
talized her as his guide through Paradise in the
Divina Commedia.

Belshazzar's Feast, see *Daniel.*

Benedict, St St Benedict of Norcia in
Umbria (AD 480–543) left his wealthy family
to become a hermit. He founded at Monte
Cassino the headquarters of the order which

bears his name and whose rules set the standard for monastic life in Europe for centuries. The combination of ascetic exercises and prayer with physical labour which made the monasteries also self-sufficient had a particularly stabilizing value in a period of great chaos brought about by the invasions of the so-called barbarians. His attributes are a broken sieve, a raven and a book. He is the patron of coppersmiths and is invoked against witchcraft.

Bernard, St This son of an aristocratic house entered the Cistercian order in AD 1113, and at the age of twenty-five founded the austere monastery of Clairvaux. He became one of the most powerful spiritual leaders of Europe. At Vézelay his preaching was the formal start of the disastrous Second Crusade which killed more Jews in Europe than Moslems in the Holy Land. He appears in painting wearing a white Cistercian habit, adoring the Virgin.

The Vision of St Bernard (detail).
Fra Filippo Lippi, c. 1406–1469

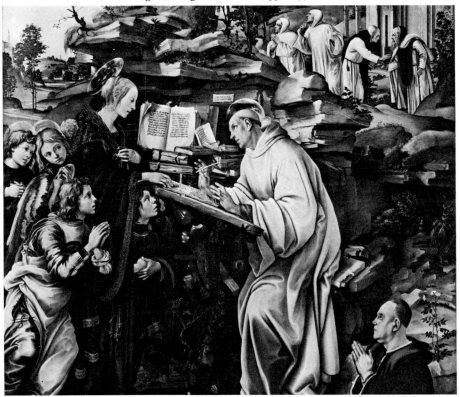

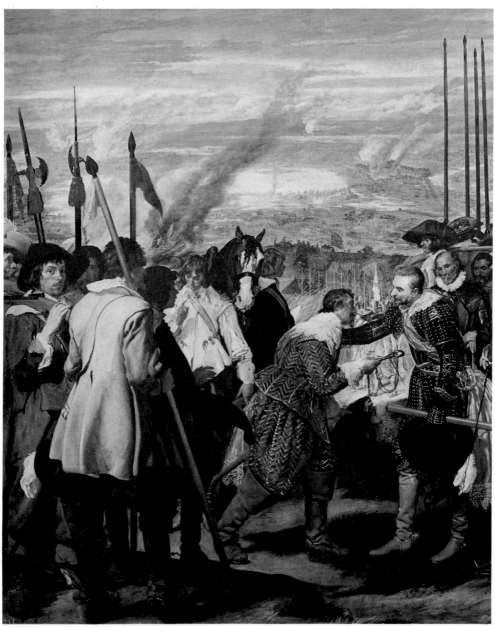

Surrender of Breda (detail). Velazquez, 1599–1660

Bernardino, St A noble of Siena (AD 1380–1444). As a young man he became a Franciscan and bravely ran the local hospital during a plague outbreak. A great and popular preacher, he is said to have preached to audiences of up to 30,000 people. One of the great moral forces of his times, he feared no temporal authority. The monogram IHS (*q.v.*) for the Sacred Name of Jesus was given special prominence in his preaching campaigns. His commonest attributes are three mitres, representing the three bishoprics he is said to have refused.

Black Mass, see *Antony, St (Abbot).*

Bonaventura, St This great Franciscan schoolman was born in 1221 near Viterbo, Italy. Educated like so many 13th-century scholars at the University of Paris, he wrote the official life of St Francis (*q.v.*), whose order of Friars he subsequently headed. The saintly man consistently rejected honours – he refused the Archbishopric of York – but finally accepted a Cardinal's hat. The Papal envoys who brought it were asked to hang it on a tree while Bonaventura finished washing dishes in a convent near Florence. He died in Lyon in 1274 at the Fourteenth Oecumenical Council, the victim, it is claimed, of poison.

Breda, Surrender of Breda, an important fortress town on the Meuse in southern Brabant, changed hands frequently during the sixty years' war between the Spaniards and their rebellious subjects, the largely Protestant Dutch. On 5 June 1625 after a ten-month siege the town was surrendered by the Dutch to the Spaniards led by their hired Genoese general Spinola. The chivalrous tone of the scene in Velazquez's great military painting – in which there is an imaginary portrait of Spinola – contrasts with what we know was the ferocity of the Spanish attempt to hold their possessions in the Low Countries.

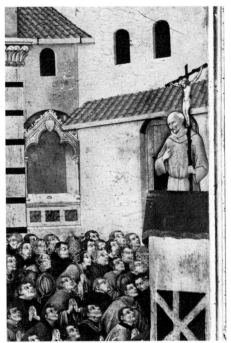

St Bernardino preaching (detail). Sano di Pietro, 1406–1481

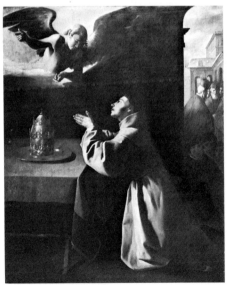

St Bonaventura (detail).
Francisco de Zurbarán, 1598–1664

C

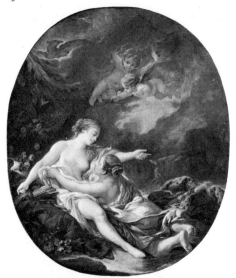

Jupiter and Callisto. François Boucher,
1703–1770

Callisto Another sacrifice to the lust of
Jupiter was Callisto, one of the virgin com-
panions of Diana (*q.v.*). For this seduction
Jupiter disguised himself as Diana. Before the
unfortunate Callisto realized she had been
duped, she was already pregnant. When the
real Diana discovered her plight (a scene
illustrated by Titian), she turned Callisto into
a bear and let loose her dogs. Jupiter saved her
by lifting her up into the heavens where she
and their son became the constellation known
as the Great and Little Bear.

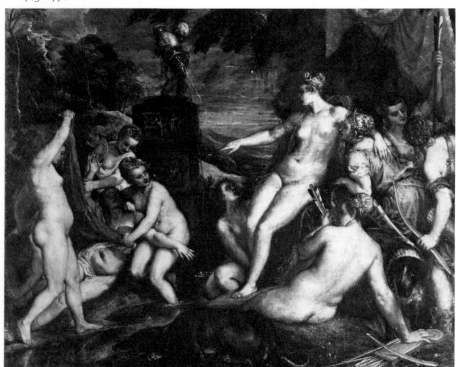

Diana and Callisto. Titian, c. 1487/90–1576

Calvary, Road to John xix, 17 describes
Christ carrying the cross on the road to Cal-
vary, or Golgotha – the place of a skull – where
he was crucified. The other three Evangelists
report that Christ was helped by a Jew named
Simon who came from Cyrene in North
Africa. The road to Calvary became a subject
of great interest to painters in the Renaissance.
During the late Middle Ages a convention grew
up that some fourteen clearly defined events
took place on the Road to Calvary. These are
known as the Stations of the Cross, and are as
follows: 1 Jesus condemned to be crucified.
2 He receives the cross. 3 Falls under weight
of cross. 4 Meets his sorrowing mother.
5 Simon of Cyrene helps Jesus to carry the
cross. 6 Veronica (*q.v.*) offers her handkerchief
for Jesus to wipe his face. 7 Jesus falls again.
8 Jesus speaks to the Jerusalem women.
9 Jesus falls once more. 10 Jesus is stripped.
11 The nailing to the cross. 12 Death on the
cross. 13 The deposition from the cross.
14 The laying in the sepulchre. See p. 65.

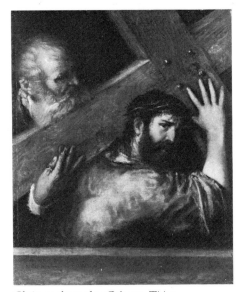

*Christ on the road to Calvary. Titian,
c. 1487/90–1576*

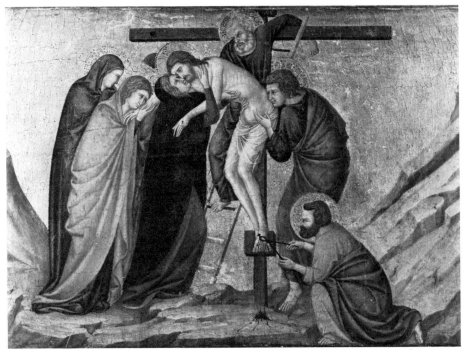

Calvary: the Deposition. Ugolino di Nerio, fl. 1317–1327

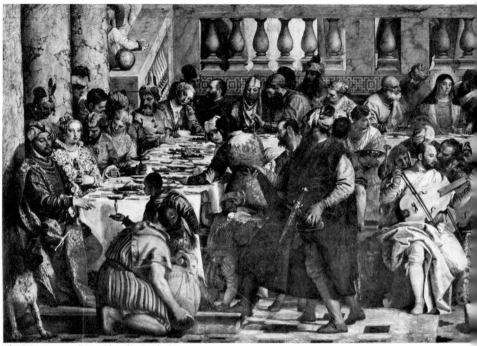

The Marriage at Cana (detail). Paolo Veronese, c. 1528–1588

St Casilda (detail). Francisco de Zurbarán,
1598–1664

Cana, Marriage at Christ's first miracle took place at a wedding in the Galilean town of Cana. John ii describes the events when the mother of Christ reported that there was no wine. Christ thereupon converted the water in six stone waterpots (about one hundred gallons) into fine wine. Some scholars consider the story an allegory for the changing of the water of Judaism into the wine of Christianity. The original story probably touches upon one of the realities of poverty; later, many painters saw the subject as an opportunity for depicting a sumptuous banquet.

Casilda, St Daughter of a Moorish king in 11th-century Spain, she sympathized secretly with her father's Christian captives. She took bread to the starving prisoners and it always turned to roses at the approach of authority. In Spain, particularly at Burgos and Toledo, her name is invoked against bad luck, haemorrhage, and sterility.

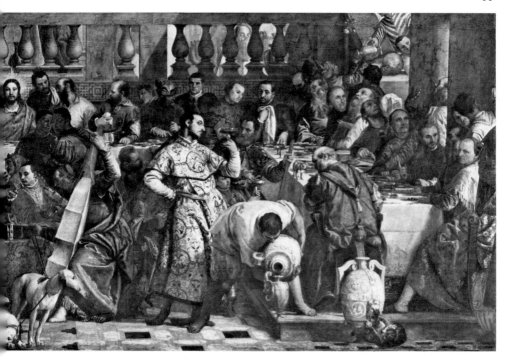

Castor and Pollux When Jupiter (*q.v.*) covered Leda (*q.v.*) in the guise of a swan, she gave birth to two eggs. Out of one hatched Clytemnestra and Castor, and out of the other Helen (*q.v.*) and Pollux. The two inseparables, Castor and Pollux – called the *Dioscuri* by the Greeks – engaged in the usual adventures of Greek heroes. They took part in the expedition of the Argonauts (*cf.* Jason), in cattle robbing, and in miscellaneous ravishings, the most famous being that of the Daughters of Leucippus (*q.v.*). The *Dioscuri* were protectors of sailors and of the Olympic Games.

Catherine of Alexandria, St This high-born Alexandrian girl was a 4th-century convert to Christianity. In a dream she made a mystic marriage with Christ. A brilliant dialectician, she even engaged the Emperor Maximinus and his scholarly advisers in debate. She argued with the advisers so well that she was ordered to be torn to pieces on a wheel.

The Birth of Castor and Pollux (detail). Copy after Leonardo da Vinci, 1452–1519

The Betrothal of St Catherine. Hans Memlinc, c. 1433–1494

Martyrdom of St Catherine. Lucas Cranach the Elder, 1472–1553

Divine fire destroyed the wheel. She was then beheaded. Of her many attributes those commonly seen in paintings are the wheel or pieces of it, a sword, a palm – a common symbol in paintings of martyrs – and a scene in which her mystic marriage to the Christ Child is celebrated. She is the patroness of philosophers. Firework makers took her name for the catherine-wheel.

Catherine of Siena, St Born in Siena in 1347 of lower middle-class parents. From early childhood she had visions, celestial conversations, and ecstasies. At the age of seven she decided to dedicate her virginity to Christ with whom she had already contracted a mystical and ecstatic marriage. Her devotion to the poor and sick, and her manifest saintliness were so universally impressive that she ventured into the thorny field of international politics. She essayed the role of peacemaker between the Vatican and its many enemies; but her successes were greater in the spiritual field. She received the stigmata five years before her death at the age of thirty-three, but it was not visible while she was alive. Her emblems are a lily, a book, and sometimes a pierced heart.

St Catherine of Siena (detail). Francesco Vanni, 1563/65–1610

Cecilia, St The source for information about the life of this virgin saint from a Roman patrician family – martyred sometime between the 2nd and 4th centuries – is a document full of romantic fantasy which appeared in the 5th century. It relates that she was a Christian from early childhood and that her marriage to a pagan was never consummated. Her husband was so impressed by her statement that her body was guarded by an angel that he shortly thereafter became a Christian himself. Cecilia survived an attempted suffocation by the enemies of Christianity. She finally died three days after partial decapitation. Supposedly buried in the Catacomb of Callistus, her relics were moved to the Church of St Cecilia in Trastevere hundreds of years later. Since the 14th century she is generally shown with an organ as an attribute. According to the *Golden Legend*, on her wedding day, 'she, hearing the organs making melody, sang in her heart only to God'. This established such

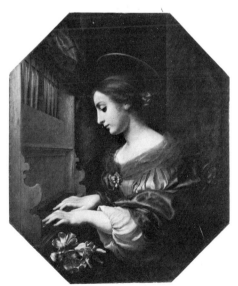

St Cecilia playing the organ. Carlo Dolci, 1616–1686

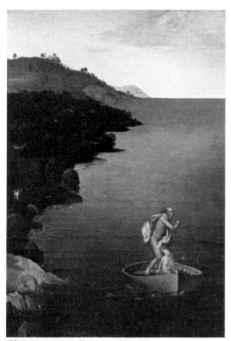

Charon crossing the Styx (detail).
Joachim Patinir, early 16th century

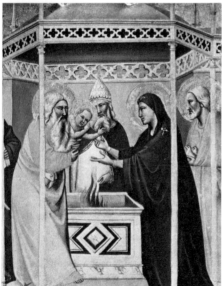

The Presentation in the Temple.
Taddeo Gaddi, 1300–1366

a connection with music that in 1584 she became patroness of the Academy of Music, and of Church music in general.

Centaurs, see *Lapiths and Centaurs.*

Cephalus, see *Aurora.*

Charon The ferryman who transported dead souls across the river Styx which separated the world of the living from the underworld of the dead. Passengers had to pay a toll of one obolus (a penny) without which Charon refused to carry them and they wandered the barren bank of the Styx for ever. The ancient Greeks placed Charon's obolus under the tongue of their dead.

Chios, Massacre at, see *Scio.*

Christ For the birth and childhood of Christ see *Virgin Mary, Annunciation, Adoration of the Shepherds, Circumcision, Flight into Egypt, Baptism* and *Cana.* Other scenes from his life which appear most often in art are listed below in narrative, not alphabetical order.

Presentation in the Temple Painters frequently fused the two separate subjects of the *Presentation in the Temple* and the *Purification of the Virgin.* According to Mosaic law a woman who had given birth to a child could not go to the Temple for a period of thirty-three days. Being a strict Jew, Mary followed the practice. She took the child Christ with her 'to present him to the Lord' (Luke ii, 22). It was here while she sacrificed doves – symbol of purification – that Simeon, a devout old man, and Anna, a prophetess, recognized the special quality of the child. See p. 64.

Among the Doctors Luke ii records that Christ's parents took the twelve-year-old boy to Jerusalem for Passover and lost him there. Three days later they found him in the Temple carrying on a religious discussion with learned rabbis (doctors). To the anxious questions of his parents, the boy made the cryptic reply, 'Wist ye not that I must be about my Father's business?'

In the Desert After his baptism in the Jordan by John the Baptist, Christ went into isolation in the desert to prepare himself for

his ministry. He spent forty days and forty
nights fasting in the wilderness. During this
time he was subjected to a series of three temp-
tations by Satan. The Gospels of Matthew,
Mark, and Luke tell the story of these temp-
tations. First the devil suggested to Jesus that
he alleviate his hunger by turning stones into
bread. Next the devil told Jesus to throw
himself from the pinnacle of the Temple and
have his angels save him to prove he is the
Son of God. Finally Satan took Jesus to a high
mountain from which he could see all the
kingdoms of the world. He offered Jesus
dominion over them. Jesus resisted the temp-
tations and according to Matthew iv, 11:
'Then the devil leaveth him, and, behold,
angels came and ministered unto him.'

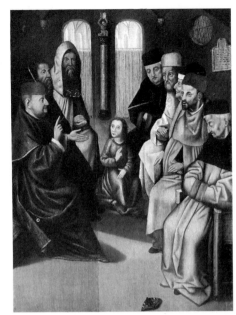

Christ among the Doctors.
After Hieronymus Bosch, 1450–1516

(Below) Temptation of Christ (detail).
Duccio, c. 1255/60–1315/18

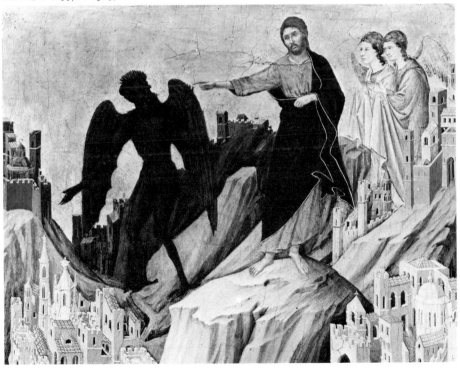

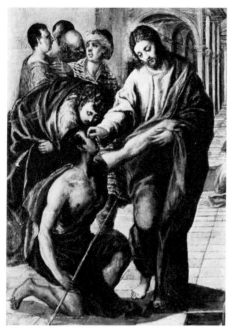

Christ healing the Blind Man (detail).
El Greco, 1541–1614

Healing the Blind The Gospels emphasize that an important part of Christ's mission was the healing of the sick. Among Christ's cures – reports of which reached the imprisoned John the Baptist, and convinced him that Jesus was the Messiah – the healing of the blind was prominent. Matthew ix records one of these miracles: 'The blind men came to him: and Jesus saith unto them, Believe ye that I am able to do this? They said unto him, Yea, Lord. Then touched he their eyes, saying, According to your faith be it unto you. And their eyes opened.'

And the Woman of Samaria John iv, 7–29 relates how Christ on his way from Judaea to Galilee passed through Samaria, a country whose people were on unfriendly terms with the Jews. At Jacob's Well Christ asked a Samaritan woman to draw water for him which at first she refused. In the conversation which followed he revealed to her her whole life and that he was the Messiah.

Walking upon the Water Shortly after the miracle of the feeding of the five thousand with loaves and fishes, Christ went up into the mountains to pray while some of his disciples

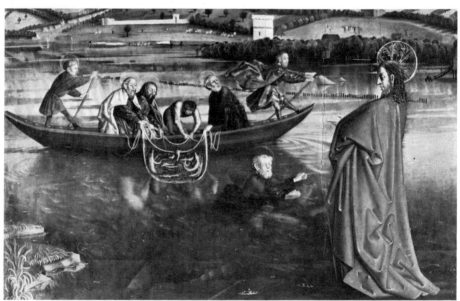

The miraculous draught of fishes (detail). Conrad Witz, 1400/10–1444/46

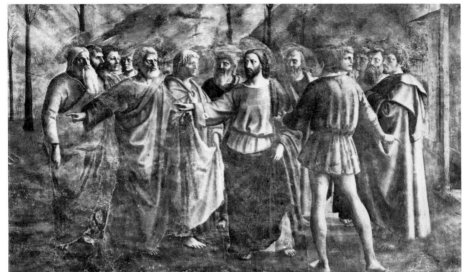

The Tribute Money (detail). Masaccio,
1401–1428(?)

went out on the lake of Galilee in a boat. A
storm came up and, according to Matthew
xiv, 'Christ went unto them, walking on the
sea.' The disciples were troubled but Jesus
reassured them. Peter then tried to walk on
the water but was afraid and began to sink:
'And immediately Jesus stretched forth his
hand and caught him, and said unto him, O
thou of little faith, wherefore didst thou
doubt?' Some modern Biblical scholars hold
that the Greek word *epi* can mean 'by' or
'on', thus diminishing somewhat the miracle.

And the Tribute Money In Capernaum
shortly after the Transfiguration (*q.v.*), tax
collectors raised with Peter the question of
Jesus's taxes. Jesus said to Peter: ' . . . Go thou
to the sea, and cast an hook, and take up the
fish that first cometh up; and when thou hast
opened his mouth, thou shalt find a piece of
money: that take, and give unto them for me
and thee.' (Matthew xvii, 27.) There is another
reference to tribute money in the New Testa-
ment. The spies of the chief priests tried to trap
Jesus into a political offence by asking (Luke
xx, 22), 'Is it lawful for us to give tribute unto
Caesar, or no?' Jesus, aware of the trap,
pointed to the image of Caesar on a penny and
said, 'Render therefore unto Caesar the things
which be Caesar's, and unto God the things
which be God's.'

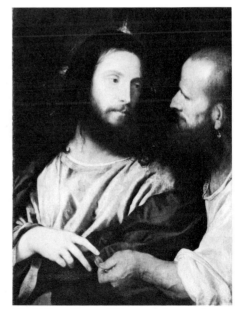

The Tribute Money. Titian, 1487/90–1576

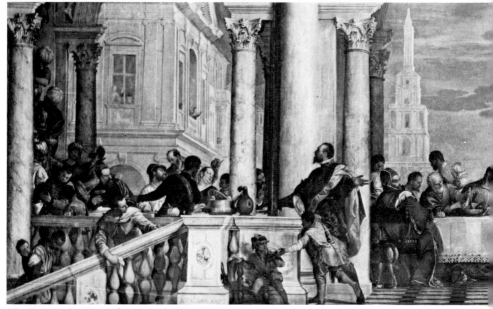

The Feast in the House of Levi. Paolo Veronese, c. 1528–1588

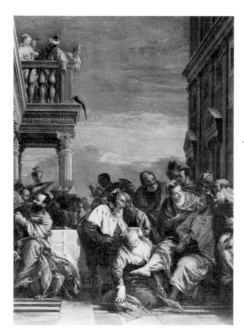

Christ in the House of Simon the Pharisee (detail).
Giovanni Battista Tiepolo, 1696–1770

Levi, Feast in the house of At Capernaum on the Sea of Galilee, Christ took supper in the house of a minor tax collector (publican) named Levi – probably Matthew the Apostle. Present were other tax collectors and people equally despised. To the criticism of the pious and devout, Christ replied, 'They that are whole have no need of the physician, but they that are sick: I come not to call the righteous, but sinners to repentance.' (Mark ii, 17.)

In the House of Simon Luke vii tells how when Christ was dining with Simon the Pharisee a woman 'who was a sinner' came and anointed his feet with ointment. Simon reproached him for receiving her but he replied with the parable of the moneylender and two debtors, the moral of which is that he who has sinned most needs most forgiveness. The woman is not named, but is usually identified with Mary Magdalene (*q.v.*).

Raising of Lazarus, see *Lazarus*.

Entry into Jerusalem Christ's decision to go to Jerusalem for the Passover marks the beginning of the Gospel Passion narrative. He

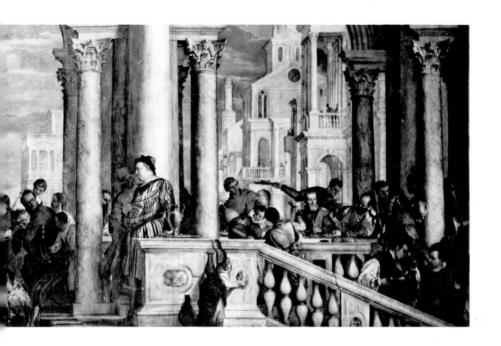

(Below) Christ entering Jerusalem (detail). Giotto, 1266/67–1337

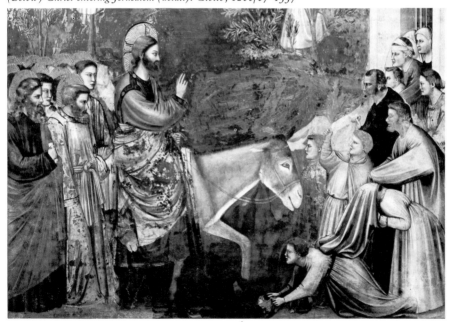

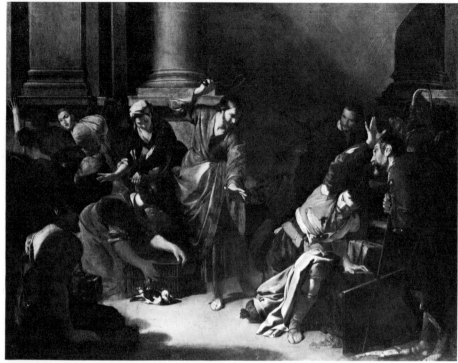

Christ cleansing the Temple. Bernardo Cavallino, 1622–1654

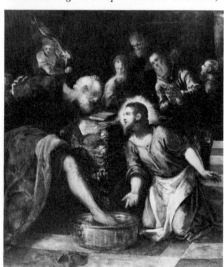

Christ washing his Disciples' Feet (detail).
Tintoretto, 1518–1594

entered the city riding on an ass and was joyfully received by the people, who spread palm branches in the road. This is the origin of Palm Sunday and is frequently represented in art.

Cleansing the Temple All four Evangelists record this dramatic scene. The following is the version of Matthew (xxi, 12 and 13): 'And Jesus went into the temple of God, and cast out all them that sold and bought in the temple, and overthrew the tables of the money changers, and the seats of them that sold doves, and said unto them, It is written, My house shall be called the house of prayer; but ye have made it a den of thieves.' Business directly connected with the rituals of the Temple was acceptable in the outer courts. What infuriated Christ was the exploitation and cheating of simple worshippers.

Washing the Feet In John xiii it is described how during the Last Supper, Christ washed the feet of his disciples as an act of

purification and a lesson in humility: 'If, I, then, your Lord and Master, have washed your feet, ye also ought to wash one another's feet.'

Before Caiaphas and before Pilate When Christ was arrested he was taken first to the Sanhedrin (the Committee of Temple priests) to be examined by Caiaphas and then to the Roman headquarters to be examined by Pontius Pilate. The Gospel accounts of these trials vary in detail, but in art Christ is always portrayed as a figure of divine dignity confronting the meanness and ignorance of men. See also *Ecce Homo*.

Denial of Peter At the Last Supper Christ prophesied that Peter would deny him three times before the cock crowed (i.e. before the next day). While Christ was being examined by the Sanhedrin, Peter waited outside in the courtyard. Three people in the crowd recognized him and asked him whether he was a follower of Jesus, but he had not the courage to admit it. At this moment the cock crowed.

Mocking of As part of the not uncommon phenomenon of mishandling prisoners, Pilate's soldiers, after flagellating Christ, then proceeded to make sport with him. Mark xv describes the events: '. . . they clothed him with purple, and platted a crown of thorns, and put it about his head, and began to salute him, Hail, King of the Jews! And they smote him on the head with a reed, and did spit upon him, and bowing their knees worshipped him. And when they had mocked him, they took off the purple from him, and put his own clothes on him, and led him out to crucify him.' The subject is particularly common in northern European painting of the 15th and 16th centuries, where it becomes a comment on military and religious persecutions. See p. 68.

Betrayal of This is the dramatic scene described by Luke xxii, 47 and 48: 'And he that was called Judas, one of the twelve, went before them, and drew near unto Jesus to kiss him. But Jesus said unto him, Judas, betrayest thou the Son of man with a kiss?' The following symbols often appear in paintings of the Betrayal: two hands filled with money; a rope; a torch; and a human ear. (See *Peter, St.*)

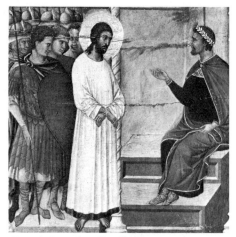

Christ before Pilate (detail). Duccio c. 1255/60–1315/18

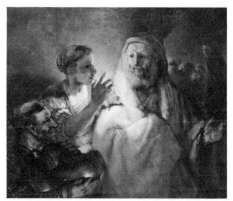

The Denial of Peter. Rembrandt van Ryn, 1606–1669

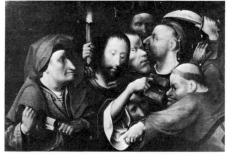

The Betrayal of Christ. Hieronymus Bosch, c. 1450–1516

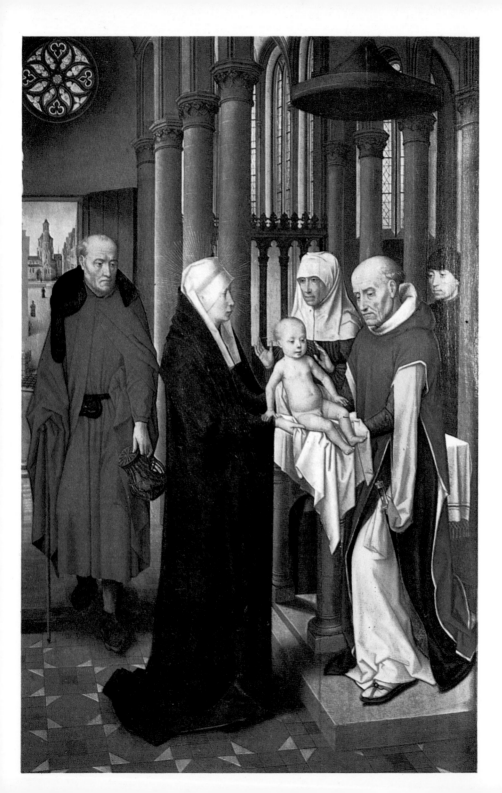

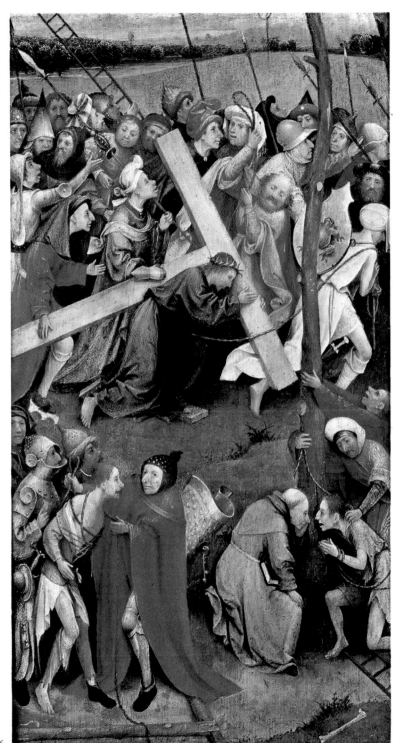

*(Left) The
Presentation in the
Temple. Hans
Memlinc, c. 1433–
1494*

*Christ carrying the
Cross. Hieronymus
Bosch, c. 1450–1516*

Flagellation The scourging of prisoners condemned to death by crucifixion was common at the time of Christ. In ordering the flagellation of Christ (Matthew xxvii, 26) Pilate followed the normal practice of the day. The subject attracted many Renaissance painters because of the possibilities it permitted to depict most graphically a naked or near-naked body being subjected to sadistic indignities.

The Crucifixion The Romans probably acquired this particularly painful technique for executing non-Romans and the worst criminals, mostly slaves, from the Carthaginians who in turn had inherited it from their ancestors the Phoenicians. After the victim had been scourged, his executioners nailed or tied him by his hands to a cross while it lay on the ground or stood in the air. It is thought that Christ was nailed rather than tied to the cross, probably when it lay on the ground. But many painters in order to emphasize his suffering include a ladder in their work to suggest that he was nailed to it when it was already mounted. To hasten death the victim's legs were sometimes broken. This did not happen to Christ. All four Gospels record the Crucifixion, the details varying somewhat. The execution took place on Golgotha, Christ hanging on a cross between two thieves. To assuage his thirst one of the spectators dipped a sponge in sour wine, stuck it on a reed and offered it to Christ. The Crucifixion probably took place at about 9 a.m. Christ died somewhat less than six hours later. (See also *Calvary, Descent from the Cross, Entombment* and *Lamentation*.) See p. 69.

In Limbo One of the most widely held Christian beliefs – incorporated in the various Creeds – is that in the period between his death on the cross and his resurrection Christ descended into Limbo (Hell). The purpose of his journey was to bring salvation to the souls lingering there since the creation of Adam, who indeed is frequently shown in paintings as the first man to emerge through the doors broken down by Christ. The authority for the story, often called the *Harrowing of Hell* (from the Old and Middle English word harrow, to rob), does not rest on any of the four Gospels but comes probably from the apocryphal *Gospel of Nicodemus.*

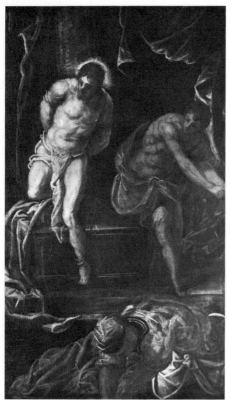

Flagellation (detail). Tintoretto, 1518–1594

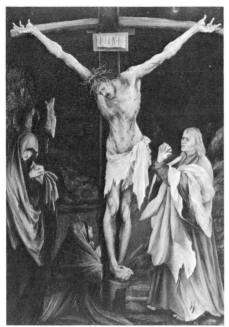

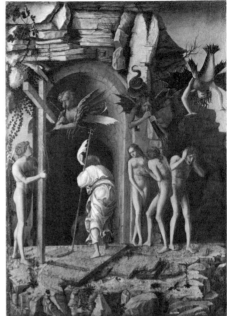

Crucifixion. Mathis Grünewald, c. 1465–1528

Christ descending into Limbo. Giovanni Bellini, c. 1430–1516

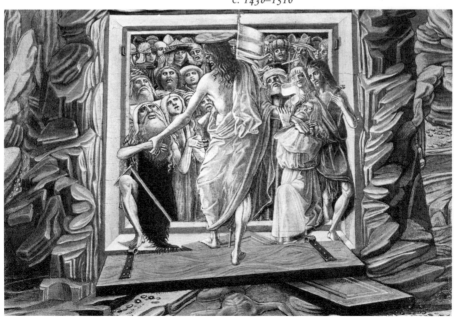

Christ in Limbo (detail). Benvenuto di Giovanni, 1436–c. 1518

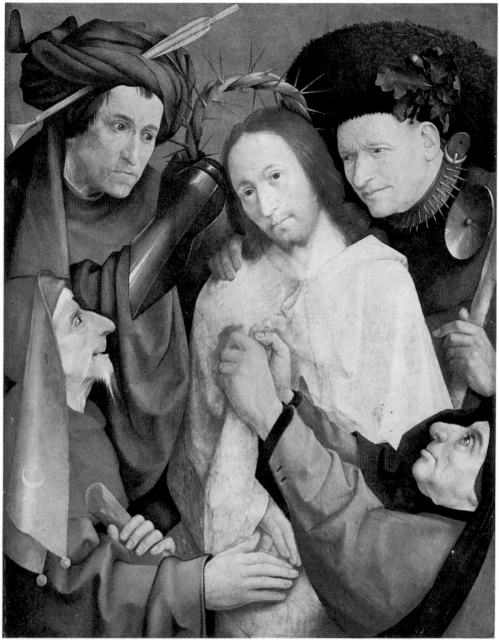

The Crowning with Thorns. Hieronymus Bosch, c. 1450–1516

(Right) Crucifixion. Giovanni Bellini, c. 1430–1516

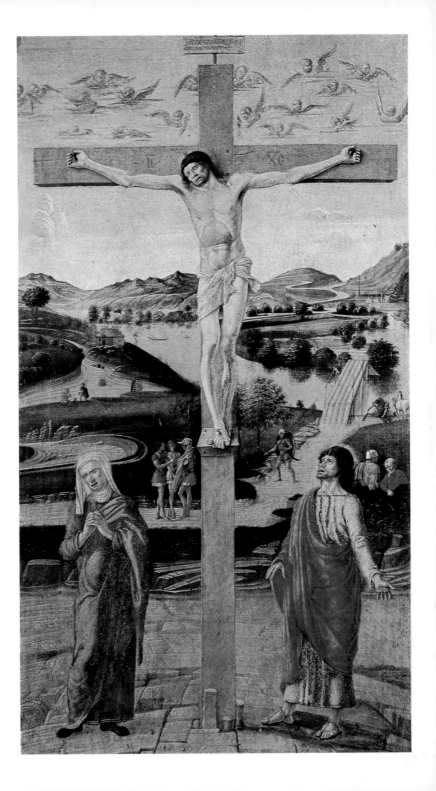

St Christopher (detail). Quentin Massys,
1465/66–1530

(Below) St Christopher. Hans Memlinc,
c. 1433–1494

Christopher, St From *The Golden Legend*,
Christopher appears to have been a good-
natured, hard-working giant of little intelli-
gence coming from southern Palestine. He
once carried a child over a river. The further
he went the heavier the child became and the
more turbulent the river. He barely reached
the other side. There he discovered he had
carried the Christ Child. He subsequently
cleaned up the brothels of several Middle East
cities and was finally beheaded. The patron of
travellers, he is generally depicted carrying a
small child across water using the trunk of a
palm tree as a supporting staff.

Circe Homer relates the adventures of Ulysses
and his men with the great magician Circe,
daughter of the sun god Helius. The beautiful
sorceress touched all visitors – invariably male
– with her magic wand, turning them into
swine. Landing on her island, thought to be
Losinj in the northern Adriatic, Ulysses pro-
tected himself from her magic by taking a
strange drug called *moly*. He forced Circe to

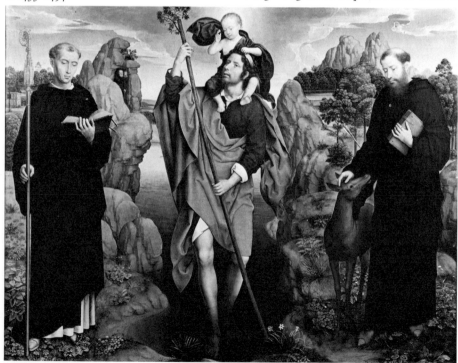

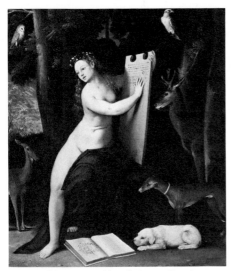

Circe and her Lovers (detail). Dosso Dossi, c. 1479–c. 1542

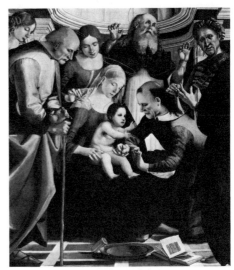

The Circumcision (detail). Luca Signorelli, 1441(?)–1523

give him back his men who were all swine, and almost as an afterthought made love to her. Their son, Telegonus, is said to have killed Ulysses unknowingly and married the widowed Penelope. In *Orlando Furioso* Circe becomes Alcina, the archetype of exquisite seductive woman, and as such appears in Dosso Dossi's painting. The Circe story is probably a symbol for debasing love.

Circumcision According to Jewish ritual, circumcision – evidence of admission to God's covenant with his people – had to be practised on male children on the eighth day after birth. Following this tradition Jesus was circumcised on the appropriate day and given his name (Luke ii, 21). In the earliest days of Christianity the practice of circumcision for non-Jews was abandoned in favour of baptism.

Clare, St This follower of St Francis established an order for the care and education of poor girls, the Order of the Poor Clares. Such was her holiness that the bread supply in her institute miraculously replenished itself. She once repelled Moslem attackers by holding up a pyx. A stay near her tomb was reputed to be effective for the cure of those afflicted with devils. Her usual attributes are a pyx and a lily.

The Death of St Clare (detail). Master of Heiligen Kreuz, early 15th century

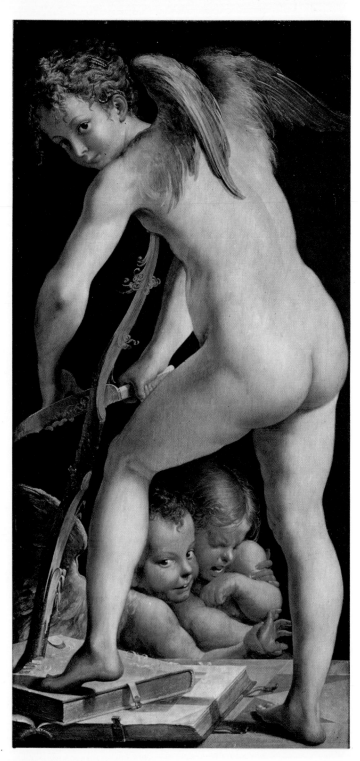

Cupid cutting his bow.
Francesco Parmigianino,
1503–1540

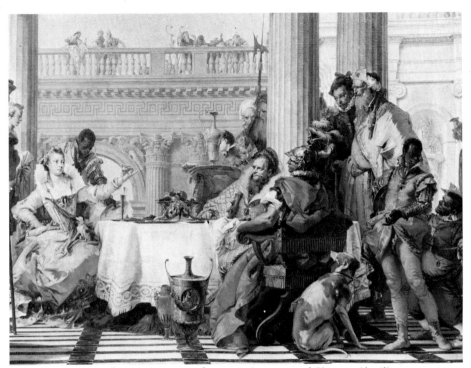

Cleopatra Her real name was Auletes. Daughter of Ptolemy XIII, she became Queen of Egypt about 51 BC. She is known in history as Cleopatra, the title of all Ptolemaic queens. Although of Macedonian origin, she followed the Egyptian custom and married in turn several brothers of whom she rid herself violently. Using her beauty to preserve her throne in an expanding Roman Empire, she became the mistress first of Julius Caesar, then of Mark Antony whom she later married. She is said to have particularly impressed Mark Antony by dissolving one of her pearl earrings in vinegar and drinking it off. Knowing that she was no match militarily for Octavian (Augustus), she tried to ingratiate herself with him by tricking Antony into a suicide pact which only he kept. Seeing that Octavian was immune to her charms, she put an asp into her bosom and died from its bite. To the late Renaissance and Baroque painters she was the very image of the scheming lascivious woman who used sex as a weapon in the struggle for power.

The Banquet of Cleopatra (detail).
Giovanni Battista Tiepolo, 1696–1770

Land of Cockaigne. Pieter Brueghel the Elder,
1525/30–1569

Coriolanus persuaded by his family to spare Rome
(detail). Luca Signorelli, 1441(?)–1523

Cockaigne, Land of The name is thought
to come from the French word for abundance.
The imaginary land of Cockaigne fascinated
late medieval writers who produced a con-
siderable literature describing a heaven, with
no work and unlimited food and drink scat-
tered freely all over the landscape. Brueghel
the Elder's painting (and engraving) with its
emphasis on cakes seems closest to the theory
of the great lexicographer, Littré, that the
name derived from a Latin word for cake.
The imagery of Cockaigne could only have
been produced by a people who had known
back-breaking work and intermittent famine.

Coriolanus Livy ii is the main source for the
story of the legendary 5th-century BC Roman
hero Gnaeus Marcius Coriolanus. Like a true
Roman he put virtue before popularity and his
opposition to public handouts led to his exile.
He collaborated with one of the city's enemies
and the loss of Rome was only prevented by
the intervention and pleas of his mother.

Coronation of the Virgin, see *Virgin Mary.*

Corpus Christi, One of the great Catholic
festivals, celebrated on the first Thursday after
Trinity Sunday. The festival became wide-

spread in the 13th century following the official establishment of the doctrine of transubstantiation whereby the consecrated wafer of the Mass became in fact the flesh and blood of Christ. The feast is now characterized by a splendid procession in which the Host is displayed for general veneration. It is one of the Church's most impressive public displays. The Reformation put an end to the festival in Protestant countries. The procession in all its splendour is seen to perfection in Gentile Bellini's magnificent Venice painting. The miraculous aspect of the festival is shown in Raphael's Vatican painting of the *Mass of Bolsena* where a doubting priest is convinced by the wafer oozing blood. A pelican is frequently incorporated into paintings of *Corpus Christi*, that bird being symbolic because of its alleged habit of feeding its young from the flesh and blood of its own breast.

Cosmas, St and Damian, St Two inseparable Arab brothers who were victims of the Diocletian persecutions of the early 4th

The attempted Martyrdom of Saints Cosmas and Damian with their brothers (detail). Fra Angelico, 1386/87–1455

(Below) Corpus Christi procession in Piazza S. Marco (detail). Gentile Bellini, 1429–1507

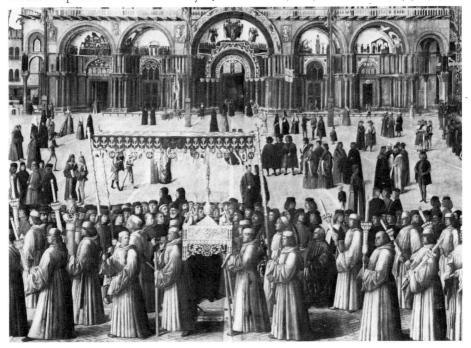

The Finding of the True Cross.
Sebastiano Ricci, 1659–1734

century. They practised miraculous medicine, performing bravura surgical feats such as a successful limb transplant, using the leg of a dead Ethiopian. They treated the sick without charge and are the patrons of physicians and surgeons, barbers, and the Medici family (*Medici*, doctors). After unsuccessful attempts to kill the brothers by drowning, incineration, and stoning, the martyr-makers fell back on their most tried and effective method, decapitation. Their attributes are a surgical instrument, box of ointment, or a mortar and pestle.

Creation, see *Adam.*

Cross, Finding of the True According to tradition, Helena (*c.* 250–*c.* 330) (*q.v.*), the mother of the Emperor Constantine found the pieces of wood which formed the cross on which Christ was crucified during her pilgrimage as an old woman. No contemporary writer supports the story which seems to have become current well after her death.

Cross, Stations of, see *Calvary.*

Cupid (Amor or Eros) Son of Venus (*q.v.*) by either her half-brother Mars, her half-brother Mercury, or her father Jupiter, the classic gods being much given to incest. Cupid was frequently portrayed as a winged boy carrying a bow and arrows. The merest touch of one of his arrows aroused intense love. He shot his arrows somewhat irresponsibly into humans and gods alike. Indeed he even wounded his own mother and caused her grievous harm over Adonis. Cupid never grew up; but this did not stop him from falling in love with Psyche with whom he had assignations in total darkness. Charmed by her midnight lover Psyche could not restrain her curiosity and one night as Cupid slept, lit a lamp and gazed at his beauty. A drop of hot oil fell on him and woke him. He disappeared leaving her inconsolable. Her subsequent troubles – the female equivalent of the *Labours of Hercules* (*q.v.*) – so moved Jupiter that he finally united her to Cupid. See p. 72.

Cythera One of the Ionian islands of Greece. The cult of Venus is said to have been intro-

Venus and Cupid. After Palma Vecchio, c. 1480–1528

duced here by the Phoenicians. Cythera is the place where the goddess is supposed to have come out of the sea (she settled in Cyprus). There is little connection between the atmosphere of classic Cythera and that of the Cytherean 'fêtes galantes' (*q.v.*) of Watteau, bathed as the Goncourt brothers noted in that 'indefinable sadness which is poetic love, the love that contemplates and dreams, modern love with its aspirations and its coronal of melancholy'. If Cythera had not existed, a painter like Watteau would have had to invent it for his bored public who wanted the imagined freedom of the shepherds' life *plus* all the physical comforts of upper-class property-owning society. In Watteau the transience of this dream was probably underlined by his own fatal suffering from tuberculosis.

Embarkation from the Island of Cythera (detail). Antoine Watteau, 1684–1721

D

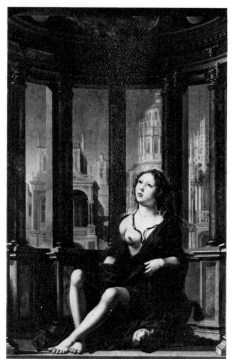

Danaë. Mabuse (Jan Gossaert), early 16th century

Danaë. Titian, c. 1487/90–1576

Danaë The only daughter of Acrisius, King of Argos. Her father locked her up in a brass tower to avert the fate foretold by an oracle that the son she bore would slay him. Jupiter, always on the look-out for good-looking women and undaunted by Danaë's protective residence, visited her as a shower of gold. When her father discovered her pregnancy, suspecting his brother rather than Jupiter, he put her in a chest and threw her into the sea. She was fished up at Seriphos still alive and gave birth to Perseus who later, unknowingly, killed his grandfather with a discus.

Daniel, the Vision of Daniel viii describes the great prophet's vision: 'And, behold, there stood before the river a ram which had two horns ... I saw the ram pushing westward, and northward, and southward ... he did according to his will, and became great ... I was afraid and fell upon my face, but he [the angel Gabriel] said unto me ... behold, I will make thee know what ... the end shall be.'

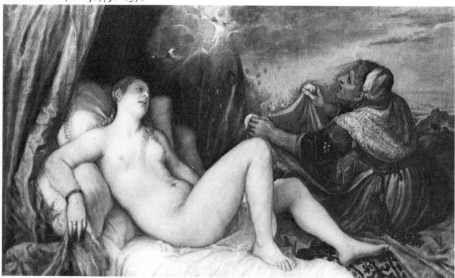

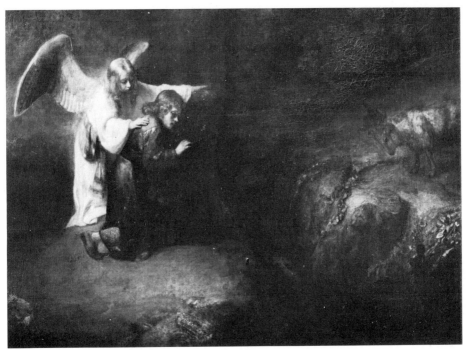

The Vision of Daniel. Rembrandt van Ryn, 1606–1669

In the cryptic form favoured by seers, Daniel is foretelling the universal oppression in store for the Jews. In 17th-century Europe the Book of Daniel – written hundreds of years later than the events foretold in it – had great popularity because of the apparent accuracy of many of its prophecies. As a forecaster of doom, Daniel is particularly remembered for his correct interpretation of the words MENE, MENE, TEKEL, UPHARSIN which appeared on a wall during a feast in which Belshazzar, last King of Babylon, used captured Jewish temple vessels for wine drinking. Daniel explained that the words foretold the fall of Babylon in 539 BC to the Medes and Persians. Daniel is best remembered for his adventures during the Babylonian Captivity, the most spectacular being his imprisonment in a den of lions for alleged disrespect to the king. Daniel vi, 21 relates how he survived when God 'shut the lions' mouths'. The greatly impressed king then gave preferment to Daniel.

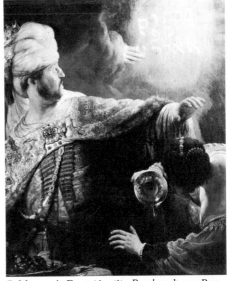

Belshazzar's Feast (detail). Rembrandt van Ryn, 1606–1669

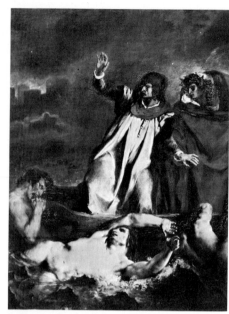

Dante and Virgil in Hell (detail).
Eugène Delacroix, 1798–1863

Dante and Virgil The Florentine poet Dante (1265–1321) in his great poem *La Divina Commedia* chose as his guide to the other worlds, Virgil (70–19 BC), official poet of the Augustan era. For Dante he was not only the author of the influential *Aeneid*, but also a figure of immense importance because his life and thought encouraged him in the belief that the political and moral chaos of 13th-century Guelf and Ghibelline Italy would one day be cleared up. It is the tour under the guidance of Virgil which has the most to say to us. Virgil guided Dante through Hell and Purgatory; but because he lived before Christ and because of Dante's life-long obsession with his love for Beatrice Portinari, he let her be his guide to Paradise.

Daphne, see *Apollo.*

Darius, Family of, before Alexander Darius III (*c.* 380–330 BC) like most Persian emperors spent much of his time holding his vast empire together. A competent soldier, he nevertheless underestimated Alexander of Macedon (*q.v.*), a military genius of great

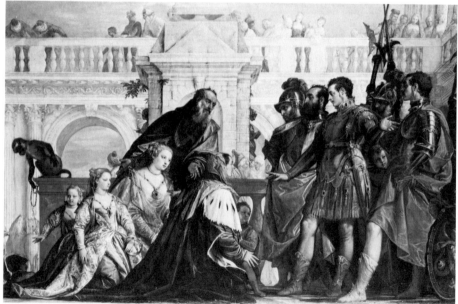

The family of Darius III before Alexander (detail). Paolo Veronese, c. 1528–1588

daring, who in 333 BC inflicted a crushing defeat on his armies at Issus (*q.v.*). This victory gave Alexander the western half of Darius' empire, including Damascus where he captured the Persian baggage train, the mother of Darius, his wife, and his children whom he refused to ransom or return to Darius. Two years later Alexander obtained a decisive victory at Arbela in what is now northern Iraq. The relentless pursuit of Darius ended in the defeated monarch's murder by one of his chieftains. According to the Alexander legend, a concoction of chivalrous fantasy little connected with the true facts, Alexander treated the captured family and followers of Darius with great courtesy.

David, Triumph of, see *David and Goliath.*

David and Goliath The almost universal story of the defeat and death of the giant at the hands of the humble, unknown hero is nowhere better illustrated than in the story told in I Samuel xvii. The Philistine champion, the giant Goliath, issued a challenge to the Israelites. It was finally taken up by David, an obscure young shepherd sent to the battlefield to bring victuals to his warrior brothers. He 'put his hand in his bag, and took thence a stone, and slang it, and smote the Philistine in his forehead, that the stone sunk into his forehead, and he fell upon his face to the earth. . . . Therefore David ran, and stood upon the Philistine, and took his sword . . . and cut off his head therewith. And when the Philistines saw their champion was dead, they fled.'

David and Saul David was the favourite of Saul, first king of Israel, by nature a manic-depressive and often insanely jealous of the young man. A close friendship, however, grew up between David and Saul's son Jonathan, who was able to warn him in advance of his father's murderous intentions. Saul's nervousness was exacerbated by incidents such as that reported in I Samuel xviii when on returning from a victory over the Philistines the women cried out: 'Saul hath slain his thousands, and David his ten thousands.' When Saul's depressions were intense,

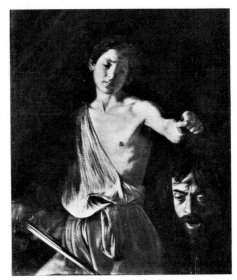

David with the head of Goliath. Caravaggio, 1573–1610

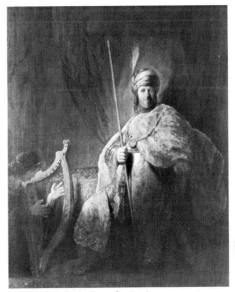

David playing the harp for Saul. Rembrandt van Ryn, 1606–1669

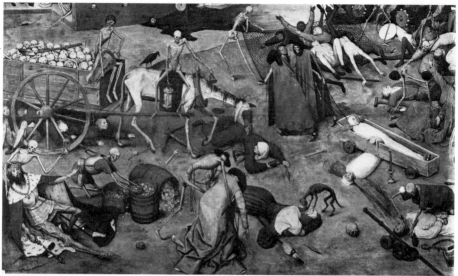

Triumph of Death (detail). Pieter Brueghel the Elder, 1525/30–1569

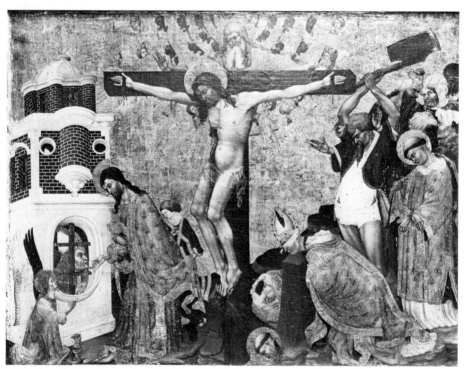

Martyrdom of St Denis. Attributed to Henri Bellechose, active 1415–1440

'David took an harp and played with his hand: so Saul was refreshed, and was well, and the evil spirit departed from him.' Cut off in a battle against the Philistines, Saul killed himself. After the murder of Saul's son, David became king of the Israelites.

Death The medieval mind was fascinated by the image of Death, generally seen as an animated skeleton wielding a great scythe. In Italian art the figure of Death is often merged with that of Time. The Old Testament *Book of Ecclesiastes*, that remarkable meditation on the vanity of life, inspired much of the imagery. The subject of Death the Great Leveller is summarized once and for all in Brueghel's remarkable *Triumph of Death*. A triumph, as seen by Brueghel, not only over the living but over everything that is human. The modern history of concentration camps has made the painting intensely prophetic.

Dejanira, see *Hercules, Labours of.*

Denis, St According to de Voragine's *Golden Legend* St Denis was converted to Christianity by St Paul who gave him visions so that 'he was ravished into the third heaven'. This St Denis (i.e. Dionysus the Areopagite) was later confused with another St Denis mentioned by Gregory of Tours as one of the seven 'bishops' sent to convert Gaul. He was decapitated at Montmartre in Paris in 272 and he is said to have carried his head some six miles, putting it down where the Cathedral of St Denis now stands.

Deposition, see *Descent from the Cross.*

Descent from the Cross All four Gospels describe the treatment of Christ's body after his death on the cross. Luke xxiii records the role played by the major participant in the events, the wealthy Joseph of Arimathea. 'This man went unto Pilate and begged the body of Christ. And he took it down, and wrapped it in linen . . . and the women also, which came with him from Galilee . . . prepared spices and ointments.' Because of the significant role of Joseph of Arimathea, a man of standing, the subject had a special attraction

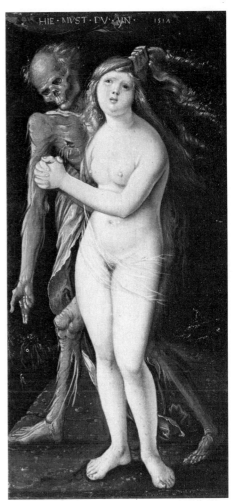

Death and the Maiden. Hans Baldung Grien, 1484/85–1545

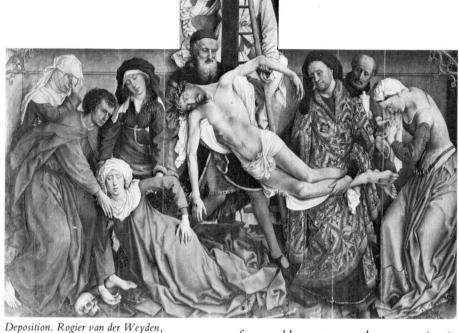

Deposition. Rogier van der Weyden,
1399/1400–1464

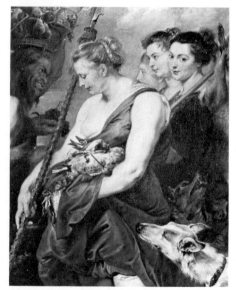

Diana returning home from the Hunt (detail).
Peter Paul Rubens, 1577–1640

for wealthy patrons whose portraits in incongruously rich garb are often to be seen in paintings of this subject. Symbolic objects frequently included in this subject are a ladder, and a skull and cross bones, traditionally held to be those of Adam.

Diana Diana (or Artemis) was the daughter of Jupiter and Latona, and twin of Apollo. This virgin goddess of the hunt was also the moon goddess who protected virgins and women in childbirth. The Greeks in Asia Minor – her cult was highly developed at her temple in Ephesus – had mixed up Diana with a local deity; for here she was a fertility goddess and her statues depict her with multiple breasts. In her cult of chastity she was fanatic, as witness the tragedies of Callisto (*q.v.*) and Actaeon (*q.v.*). Her love for another great hunter Orion (*q.v.*) was frustrated by her jealous brother Apollo who tricked her into killing him. The bereaved Diana had Orion placed among the stars. It is as virgin goddess of the chase that Diana appears in art, generally clad in a tunic, and carrying a bow and arrows.

Dido Sister of the Phoenician king of Tyre, Pygmalion (*q.v.*), she murdered her husband, fled to North Africa, founded Carthage, and became its queen. Archetype of the shrewd Phoenician trader, she bargained with the natives for as much land as she could enclose with the skin of a bull. By cutting the skin into fine strips she secured a large area for Carthage. She and Aeneas (*q.v.*) fell in love but the Trojan deserted her in fulfilment of his divine mission to become the ancestor of the Roman Empire. In despair she stabbed herself on a funeral pyre.

Diogenes Founder of the philosophical school of Cynics, Diogenes (*c.* 412–*c.* 323 BC) was a firm advocate of self-sufficiency, which he practised in a forthright way, living in a barrel. It is said that on being asked by Alexander the Great what he could do for him, he replied that he could get out of his light! He is also said to have wandered through daytime Athens with a lamp looking for an honest man. The Stoic philosophers influenced by Seneca claimed him as a founder.

Dido's Suicide (detail). Liberale da Verona, c. 1445–1526

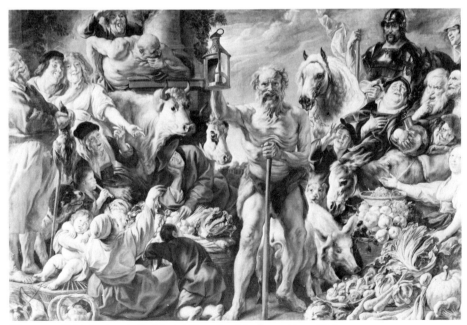

Diogenes with his Lantern in the Market Place. Jacob Jordaens, 1593–1678

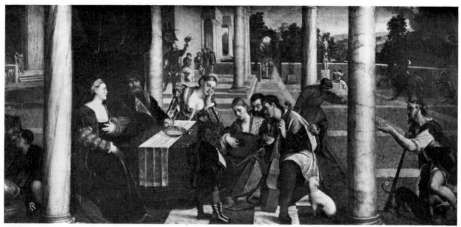

Dives and Lazarus. Bonifazio Veronese, 1487–1553

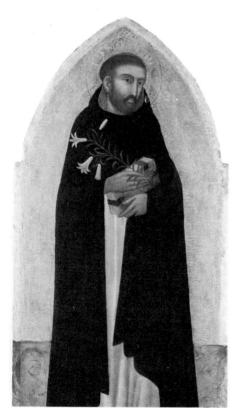

St Dominic (detail). Lippo di Vanni, active 1344–1375

Dives and Lazarus The parable of the rich man (in Latin *dives* means rich) is reported in Luke xvi, 19–31. In this exemplary story, Lazarus the beggar, covered with sores and licked by dogs, could not have even the crumbs which fell from the rich man's table. Both died and the rich man suffering in hell saw Lazarus in Paradise, comforted and protected by Abraham. To punish him for refusing succour to Lazarus on earth, Abraham denied Dives' request for water. Dives' second request that his five brothers be warned of his fate was also refused, Abraham pointing out unhelpfully that 'They have Moses and the prophets' to guide them in their duty to care for the stranger within their gates. Popular belief held that in relating this parable Christ had in mind an actual person. For many centuries there was a house in Jerusalem called *The House of Dives*.

Dominic, St A noble Spaniard who founded in the early 13th century the Dominican Order of Preachers. His activities in southern France contributed to the merciless extermination of the Albigensian heretics. His mendicant order distinguished itself not only by its magnificent scholars such as St Thomas Aquinas but also by its vigorous, even enthusiastic role as the Church's principal Inquisitor. It is said that St Dominic started the widespread use of the

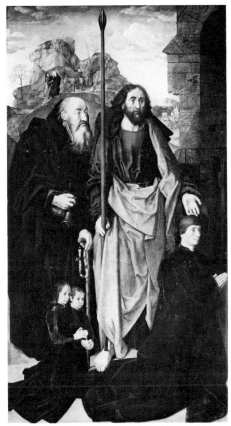

Donors: Tommaso Portinari, his wife and children, with Saints. Hugo van der Goes, active 1467–1482

rosary which is one of his attributes. In paint-
ing he is sometimes shown with a dog holding
in its mouth a flaming torch, his mother
having dreamed of giving birth to such. His
commonest emblem is the lily.

Donor or Patron Man or family who com-
missioned a painting – usually an altarpiece –
for a church in northern Europe. In the 15th
century, particularly, this had three great
advantages. First the donors obtained spiritual
merit for the decoration of the House of God.
Then, by having the painter incorporate in his
painting portraits of themselves and members

of their family paying homage to the Virgin Mary and the Christ Child, they obtained great social prestige and enhanced themselves temporally. Finally, if their judgment was good, by commissioning a painter like Hugo van der Goes, or Botticelli they had a fair chance of achieving a sort of immortality. Thus Tommaso Portinari, the representative of the Medici banking interests in Bruges, in the late 1470s, commissioned Hugo van der Goes to paint a triptych with the *Adoration of the Shepherds* (*q.v.*) as the centre panel. Portinari had the painter include portraits of himself and his two young sons Antonio and Pigello in the left panel of the work, in the company of their patron saints, St Thomas and St Antony Abbot. His wife and daughter appear in the right wing panel with their patron saints, Margaret and Mary Magdalene.

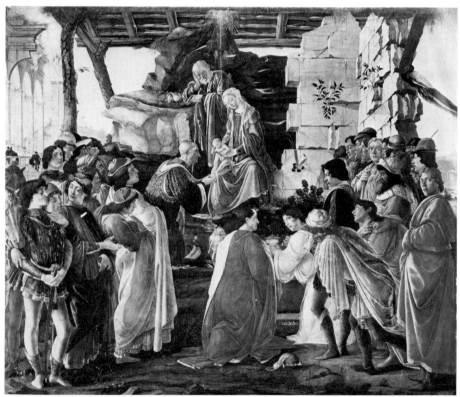

Adoration of the Magi. Sandro Botticelli, c. 1445–1510

With due modesty the donor and his family are much smaller figures than their holy companions. No such modesty troubled the Medicis when Botticelli was commissioned to paint his *Adoration of the Magi* for an altar in Santa Maria Novella, Florence (now in the Uffizi). The three kings are thought to be portraits of Cosimo the Elder, Piero di Cosimo, and Giovanni di Cosimo. Lorenzo the Magnificent appears on the left with a sword, Botticelli on the extreme right, and most of the spectators are members of the Medici court. There could be no more convincing proof of the power and authority of the Medici family than this work in which the Holy Family has become virtually another possession of the enormously rich merchant-banker-moneylender politicians of Tuscany.

Dormition, see *Virgin Mary*.

Dorothea, St A Cappadocian victim of the Diocletian persecutions. Her martyrdom is remembered particularly for its colourful sequel. Theophilus, an official of the court which condemned her, asked her to send him fruit and flowers from the garden of Paradise. After her death a child called at his house with a basket of apples and roses. The unsettled Theophilus quickly became a Christian. Her attribute is understandably a basket of fruit and flowers and she is patroness of florists, also of brides, brewers, and midwives.

Dulle Griet (Mad Meg) Some scholars think that *Dulle Griet* or *Mad Meg* is one of the furies (Meg is possibly a shortening of *Megaera* or Fury). Brueghel the Elder uses the image of a harridan to summarize all the shrewish, witch-like qualities which can exist in women when driven to desperation. Pursued, she pursues. The verbal fire which can come out of the mouths of such harridans may be the reason for the custom in some countries of naming cannons as 'Mad Meg'. It is significant that Brueghel painted his *Dulle Griet* during the greatest outburst of witch-hunting in Western history.

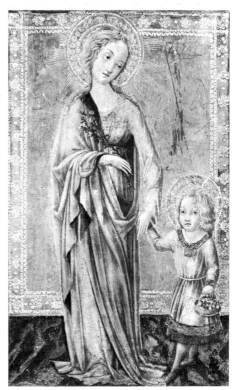

St Dorothea and the Infant Christ.
Francesco di Giorgio, 1439–1501/2

Dulle Griet (Mad Meg) (detail).
Pieter Brueghel the Elder, 1525/30–1569

E

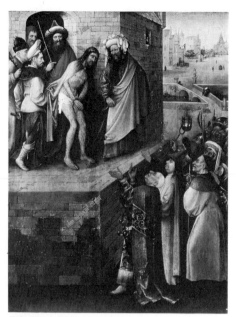

Ecce Homo. Hieronymus Bosch, c. 1450–1516

Ecce Homo (Behold the Man) These words were spoken by Pontius Pilate and referred to Christ. The competent administrator, Pilate, could find Christ guilty of no offence but as an archetype bureaucrat he wished to avoid all troublesome responsibility, and turned the problem of Christ over to the Jewish high priests. John xix tells how Jesus was brought forth in front of a crowd 'wearing the crown of thorns, and the purple robe. And Pilate saith unto them, Behold the man!' If Pilate thought the sight would arouse pity he was quickly corrected by the high priests shouting 'Crucify him.'

Echo Echo was one of the nymphs, minor tutelary deities of mountains, valleys, forests, and grottoes, who frequently made up the retinue of gods and goddesses. She was attached to Juno and was a fascinating, if incessant talker. On one occasion she used her gift for talking to divert Juno while Jupiter was making love to her sister nymphs. Juno discovered this treachery and arranged that henceforth Echo's speech would shrink to

(Below) Echo and Narcissus (detail).
Nicolas Poussin, 1594–1665

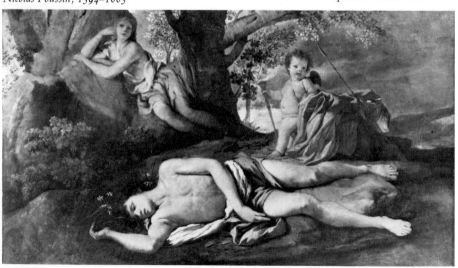

repeating the last few words she had heard. Her love for the beautiful Narcissus (*q.v.*) ended sadly. She followed him in a forest when he was lost, and her seemingly fatuous repetition of his calls for help, drove him away for ever. She went into a decline, withered away until only her voice remained, always repeating the last word.

Eden, Garden of According to Genesis ii, after creating the world, and Adam (*q.v.*) '... the Lord God planted a garden eastward in Eden ... and out of the ground made ... to grow every tree that is pleasant to the sight and good for food'. The location of Eden seems to be somewhere between the Tigris and Euphrates in modern Iraq. Until their Expulsion (*q.v.*) Eden was the home of Adam (*q.v.*) and Eve. The idea of the first home of man being a garden is an understandable myth of a people in a hot arid land.

Elijah The Hebrew prophet of the 9th century BC is best remembered for his successful effort to show that his god Jehovah was more powerful than Baal, the god of the two Phoenician rulers Ahab and his queen Jezebel. In a dramatic competition on Mount Carmel Jehovah ignited Elijah's altar but Baal could not get his priest's altar alight. 2 Kings ii describes Elijah's equally dramatic departure from life. 'And it came to pass ... there appeared a chariot of fire, and horses of fire ... and Elijah went up by a whirlwind into heaven.'

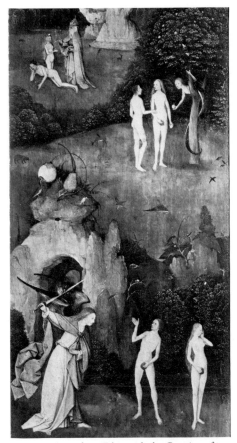

The Expulsion from Eden with the Creation of Eve and the Temptation in the background (detail). Hieronymus Bosch, c. 1450–1516

Elijah taken up in a chariot of fire. Giovanni Battista Piazzetta, 1682–1754

St Elizabeth of Hungary (detail).
Bartolomé Estebán Murillo, 1617–1682

Elizabeth, St This 13th-century saint from Bratislava was the daughter of King Andreas II of Hungary. After the death of her husband *en route* to the Crusades, she devoted herself so vigorously to fasting and good works that she died at the age of twenty-four. Like St Casilda she had the magic gift of turning bread into roses. She performed this feat when her suspicious husband found her carrying an apron of bread to the poor. Because of her great care for the oppressed, defenceless and down-trodden, she became the favourite saint of the Germans. Patroness of beggars, bakers, and lacemakers, her name is invoked against toothache.

Emmaus, Supper at Immediately after the Resurrection when the disciples discovered the body of Jesus gone from the sepulchre, Cleopas and an unnamed disciple met Christ on the road to Emmaus, a village on the distant outskirts of Jerusalem. Notwithstanding his conversation with them, they did not recognize him until after they invited him to supper with them in Emmaus. Then, as Luke xxiv, 30–31 reports, '. . . as he sat at meal with them, he took bread, and blessed it, and brake, and gave to them. And their eyes were opened and they knew him: and he vanished out of their sight.'

(Below) The Supper at Emmaus (detail).
Caravaggio, 1573–1610

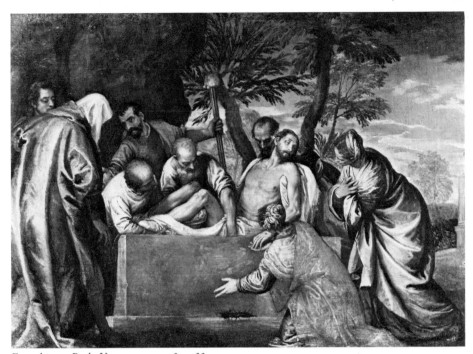

Entombment. Paolo Veronese, c. 1528–1588

Entombment The burial of Jesus was arranged by Joseph of Arimathea (*cf. Descent from the Cross*) a wealthy member of the Sanhedrin, the supreme political council of the Jews, but a secret sympathizer of Jesus. He used a new rock tomb – his own according to Matthew xxvii, 60 – and after the traditional Jewish manner of anointing the corpse (John xix, 39–40), placed it in the Sepulchre whose entrance was sealed with a rock. Paintings of the event frequently include a pot of ointment, and some of the symbols of the Passion, a hammer, nails, crown of thorns, spear, ladder, scourge, sponge, etc. Painters of *The Three Maries at the Sepulchre* assume that these are the same three Maries mentioned by John in xix, 25 as standing by the cross '. . . his mother, and his mother's sister, Mary the wife of Cleophas, and Mary Magdalene.' There is no direct evidence of this in the Gospels. Matthew mentions only two Maries at the Sepulchre (xxviii, 61). See p. 97.

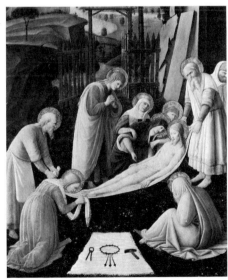

Entombment (detail). Attributed to Fra Angelico, 1386/87–1455

Martyrdom of St Erasmus. Dieric Bouts, c. 1415–1475

Esther and Ahasuerus (detail). Jacopo del Sellaio, c. 1441–1493

Erasmus, St This victim of the persecutions in the time of Diocletian and Maximilian is best remembered for the gruesome tortures to which he was subjected in the countryside near Rome. His tormentors were unsuccessful in trying to destroy him with lead mallets, immersion in brimstone and oil, forcing him to drink boiling pitch, rosin and oil, roasting in a copper casserole, and finally using a windlass to wind his entrails out of his body. According to the *Golden Legend* he thereafter died a natural death. He is patron of sailors and his attribute is the windlass or capstan. He is invoked against colic, birth-pangs, and danger at sea.

Erminia, see *Tancred.*

Eros, see *Cupid.*

Esther and Ahasuerus After the Persian King Ahasuerus, or Xerxes (485–465 BC) had rid himself of his Queen Vashti for disobedience, he tried out all the nubile virgins and finally chose a beauty named Esther (Hadassah) and married her in 478 BC. Xerxes' vizier, Haman, persuaded the king that the Jews were a troublesome minority. He paid a large sum into the royal treasury for the right to plunder and slaughter the Jewish community. Esther's relative Mordecai, a prominent member of the Jewish community who had rendered Xerxes valuable services in the past, persuaded her to intervene with Xerxes. Although an unsummoned appearance in the royal presence was punishable by death, the brave Esther entered the king's private rooms. She informed Xerxes that she was Jewish and he was so enchanted by her beauty and intelligence that he cancelled the plans for the pogrom. Esther and Mordecai turned the tables on Haman who was hanged on the gallows the ex-vizier had erected specially for Mordecai. The tale is still read today during the Jewish celebration of Purim and although full of contradictions, has long served as an archetype Jewish survival story.

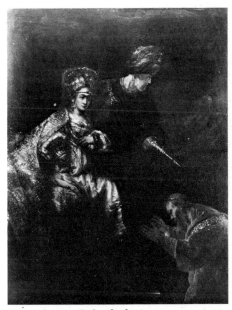

Haman begging Esther for forgiveness. Rembrandt van Ryn, 1606–1669

Et in Arcadia Ego, see *Arcadia.*

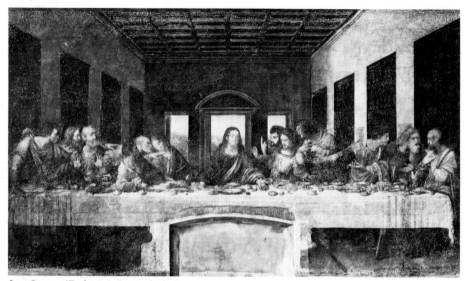

Last Supper (Eucharist). Leonardo da Vinci, 1452–1519

Rape of Europa (detail). Paolo Veronese,
c. 1528–1588

Eucharist The Eucharist or Communion of the Lord, the most sacred of all Christian sacraments, has its origin in the last supper presided over by Christ the night before he was crucified. The events immediately following his prediction of his betrayal by Judas (*q.v.*) are told in Mark xiv, 22–24. 'And as they did eat, Jesus took bread, and blessed, and brake it, and gave to them, and said, Take, eat: this is my body. And he took the cup, and when he had given thanks, he gave it to them: and they all drank of it. And he said unto them, This is my blood of the new testament, which is shed for many.' See p. 100.

Europa Europa, daughter of a Phoenician king, was another of Jupiter's exotic seductions. He appeared to the young girl as a handsome docile bull, and she mounted his back and wound round his horns the flowers she had been gathering. He suddenly took off for Crete, where changing body yet again he took the form of an eagle and ravished her. Some stories say that the tree which sheltered their love-making was rewarded by becoming evergreen. The product of Europa's union with Jupiter was Minos, who became king of Crete. See p. 101.

Entombment. Michelangelo Buonarroti, 1475–1564

Vision of St Eustace. Antonio Pisanello, c. 1395–1455

Eustace, St The legend holds that Eustace was one of the Emperor Trajan's generals. His conversion to Christianity followed his discovery, when hunting on the outskirts of Rome, of a stag with a crucifix between its antlers. The general, his wife Theopista, and his two sons refused to pay obeisance to the pagan gods of Rome and were martyred by being roasted in a brazen bull. His attributes are a crucifix, a stag, and an oven.

Eve, Creation of, see *Adam*.

Expulsion from the Temple, see *Christ, Cleansing of the Temple*.

F

Fates Among the weird sets of triplets pro-
duced by Jupiter's union with Themis, goddess
of Law, were the Three Fates. These three
sisters were: Clotho who spun the thread of
life; Lachesis who measured it; and Atropos
who relentlessly cut it off with her shears.

Faun, see *Satyr.*

Feast of the Gods Ovid's *Metamorphoses*
and *Fasti* were the source of inspiration of
many Renaissance painters. A subject such as
The Feast of the Gods which came straight from
the *Fasti* provided an opportunity for painters
such as Bellini and Titian to flatter their
aristocratic and patrician patrons by setting
them in a sort of Olympian picnic scene in the
guise of gods, frequently indulging in quasi-
erotic play.

The Three Fates. Sodoma, 1477–1549

*Feast of the Gods (detail). Giovanni Bellini,
c. 1430–1516*

Last Supper. Dieric Bouts, c. 1415–1475

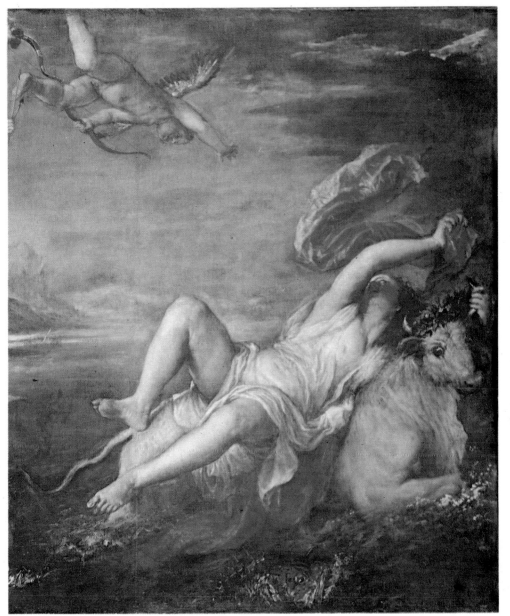

Rape of Europa (detail). Titian, c. 1487/90–1576

Fête Champêtre (detail). Antoine Watteau, 1684–1721

Concert Champêtre (detail). Giorgione,
c. *1476/78–1510*

Fête Champêtre The source and inspiration of the subject of the *Fête Champêtre* which became popular in mid-18th-century France, was Giorgione's late-15th- or early-16th-century work, the *Concert Champêtre*. Probably a purely poetic or imaginary idea, it provided an opportunity for an artist to paint for his wealthy or aristocratic patrons an erotically tinged picnic scene, set in a beautiful landscape, suffused with tenderness.

Flight into Egypt Matthew ii relates that when the brutal Herod (*q.v.*) learned from the Magi (*q.v.*) that a child was born in Bethlehem who would become King of the Jews, he ordered a massacre there of all young children in order to rid himself of that threat. An angel warned Joseph of the danger in a dream. The Holy Family left hurriedly by night for Egypt where they stayed for about two years. In the background of many northern paintings of the *Flight into Egypt* can be seen the miraculous growth of wheat, obstructing the pursuit of the Holy Family by Herod's soldiers. As they pass, pagan statues fall off their pedestals. In another dream an angel told Joseph that Herod was dead. The Holy Family returned and settled in Nazareth.

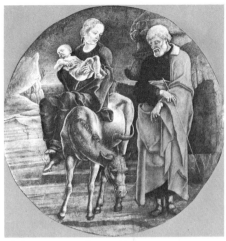

Rest on the Flight into Egypt (detail).
Gerard David, c. 1460–1523

Flight into Egypt. Cosimo Tura, active 1451–1495

Massacre of the Innocents (detail). Sebastien Bourdon, 1616–1671

The Flood: collecting the animals for the Ark. Jan Brueghel the Elder, 1568–1625

St Francis preaching to the birds. Bonaventura Berlinghieri, active 1235

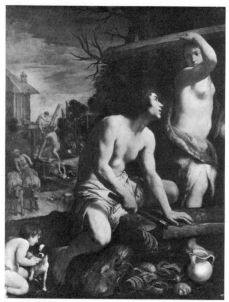

The Building of the Ark. Guido Reni, 1575–1642

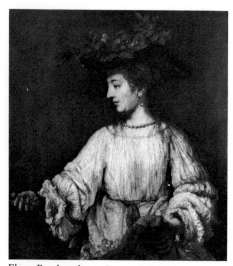

Flora. Rembrandt van Ryn, 1606–1669

Flood When, according to Genesis vi, 'God saw that the wickedness of man was great in the earth', he regretted his error and said, 'I will destroy man whom I have created from the face of the earth.' He wavered in his decision when he saw the righteous (six-hundred-year-old) Noah, and ordered him to build a large wooden ship and collect aboard it his family and pairs of all living creatures. Genesis vii and viii describe the ensuing rains and the Flood which lasted for about one year and wiped out all life on earth. When the waters subsided, the denizens of the Ark landed on Mount Ararat, and God ordained the rainbow as a symbol of his agreement not to repeat the Flood. See p. 109.

Flora The Greek and Roman goddess of flowers. The Romans celebrated her festival on 1 May. Ovid's *Metamorphoses* and *Fasti* were the inspiration for paintings of Flora by late Renaissance and early Baroque painters such as Poussin. Figures who kill themselves or who are destroyed by the gods, metamorphose into flowers: Ajax into a pink; Adonis (*q.v.*) into the anemone; Klytriax into the heliotrope; Narcissus, Crocus, and Hyacinth into the flowers which bear their names, etc. They are allegories of the constant death and rebirth in nature.

Florian, St This victim of the Diocletian persecutions was martyred by being thrown into the river Enns with a stone tied to his half-flayed body. The monastery at Schärding in Austria is said to be built over his tomb. The saint is patron of Upper Austria and Poland, invoked against floods and fire.

Fornarina, La One of the many beautiful women in the short life of Raphael – he died when only thirty-seven. We can see from the portrait of *La Fornarina* (the Baker's daughter), why Vasari said of her, 'Among so many beautiful, the most beautiful. . . .' Whether or not the work is by Raphael, it is an excellent example of a new type of private High Renaissance symbol representing affluence and power – erotic treasure. See p. 108.

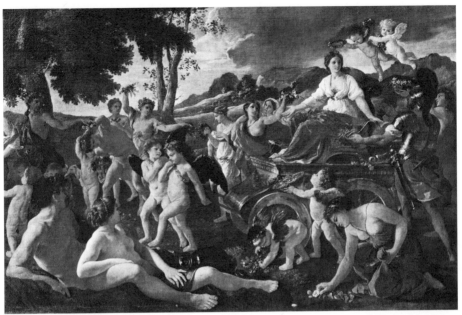

Triumph of Flora (detail). Nicolas Poussin, 1594–1665

Recovering the body of St Florian (detail). Albrecht Altdorfer, c. 1480–1538

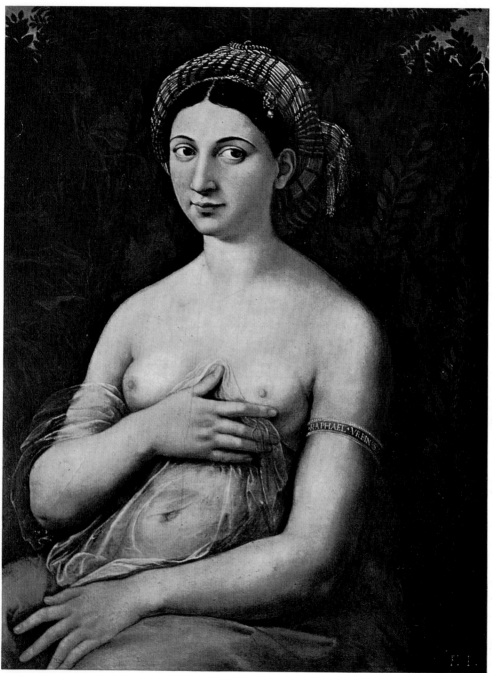

La Fornarina. Raphael, 1483–1520

Francis of Assisi, St This son of a wealthy
Assisi cloth merchant was born *c.* 1181. At the
age of twenty he was captured by the Peru-
gians, and his illness during his captivity
suddenly turned him away from his pleasure-
loving life. A few years later he renounced his
earthly goods and devoted himself to the poor,
the maimed, and the leprous. He then cele-
brated – as Dante records – his nuptials with
his beloved spouse, the Lady Poverty. His
example gradually attracted followers. Pope
Innocent III is said to have given Francis his
support after dreaming that the tottering
Lateran was being held up by the 'Poor Man
of Assisi'.

In 1211 he started his order of Friars Minor
which was strengthened when Clare (*q.v.*)
joined him. He visited Egypt but had no
success in converting the Moslems. The
Christmas custom of devotion to the Crib to
celebrate the Nativity is said to have been

*St Francis renounces his earthly father (detail).
Sassetta, 1392(?)–1450*

St Francis in ecstasy (detail). Giovanni Bellini, c. 1430–1516

St Francis receiving the Stigmata (detail). Jan van Eyck, active 1422–1441

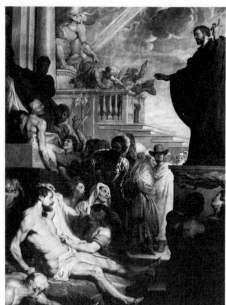

Miracles of St Francis Xavier (detail).
Peter Paul Rubens, 1577–1640

introduced by him. Such was his love of animals and birds that he asked the Emperor to legislate to provide for them as well as for the poor. While keeping a forty-day fast in the mountains he received the stigmata. His mortification of his body – he always referred to it as Brother Ass – so weakened him that this most attractive of all saints died at the age of forty-five. He was never ordained a priest. He is patron of animals, which, with birds, are among his attributes. See p. 105.

Francis Xavier, St A Basque of noble parents, born in 1506. After meeting St Ignatius Loyola (*q.v.*) in Paris and forming with him and several others the Society of Jesus, he decided on missionary work in the Far East. He lived and worked for a number of years on the west coast of India, the Moluccas, Malacca, and Japan where he preached in Japanese. He died *en route* to China and is buried in Goa. The Church considered him the greatest missionary since the Apostles. His attributes are a torch, a flame, a cross, and a lily.

G

Gabriel One of the three archangels, from the topmost hierarchy of the heavenly host. Gabriel appears twice in the Old Testament – both times to Daniel – and twice in the New Testament, once to Zacharias to announce that his wife will bear John the Baptist, and the second time as the Angel of the Annunciation (*q.v.*) to Mary. Among the Christians he is the Angel of Mercy and St Michael is the Angel of Judgment. Among the Jews he may destroy as well as bless. Thus it is Gabriel as Angel of the Redemption who destroys Sodom.

Galatea In classical mythology there are two Galateas. The first was one of the fifty Nereids or sea-nymphs. Her beauty attracted Polyphemus (*q.v.*), the one-eyed Sicilian giant. He courted her unsuccessfully by sending impressive but unusable gifts of bears and elephants. In a jealous rage he killed her herdsman lover Acis by smashing him with a rock. Acis became a river.

The second Galatea was the ivory statue made by the Cypriot sculptor Pygmalion, who fell in love with it. Venus, pitying him, brought it to life.

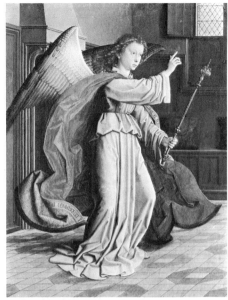

Archangel Gabriel. Gerard David, c. 1460–1523

Acis and Galatea. Nicolas Poussin, 1594–1665

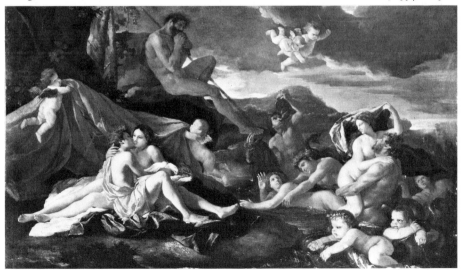

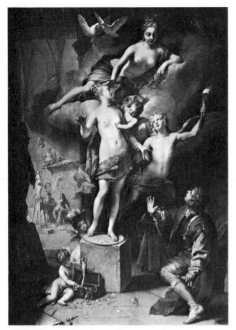

Pygmalion and Galatea. Raoux, 1677–1734

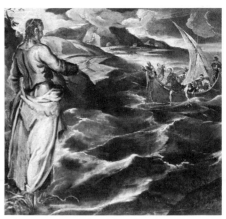

Christ at the Sea of Galilee (detail). Tintoretto, 1518–1594

Galilee, Christ at the Sea of Both miraculous draughts of fishes take place in the Lake of Galilee (Gennesaret or Tiberias). The first occurred during the early ministry of Christ when he persuaded the reluctant Simon called Peter to cast out nets once more. He did this and his catch was great. Christ tells him, 'henceforth thou shalt catch men' (Luke v, 10). The second incident took place after the Resurrection. Christ told his fishermen disciples who had had no luck to cast their nets on the right side of the boat. John xxi reports that 'they were not able to draw it for the multitude of fishes'.

Ganymede Ganymede, the most beautiful Trojan boy, was snatched up into the air by Jupiter disguised as an eagle. Flown to Olympus he became cup-bearer to the gods, and also, it is said, bedfellow of Jupiter. Robert Graves notes the popularity of the myth in Greece and Rome as providing religious justification for pederasty.

Garden of Love This subject inspired a series of painters: Cranach, Giorgione, Rubens, Watteau, Manet. Under different titles they treated the same theme whether it was called *The Golden Age, Concert Champêtre, Garden of Love, Fête Champêtre, Déjeuner sur l'Herbe*. In these works the painter is concerned entirely with sexual love, expressed in the

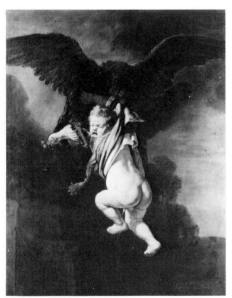

Ganymede being carried off by the eagle. Rembrandt van Ryn, 1606–1669

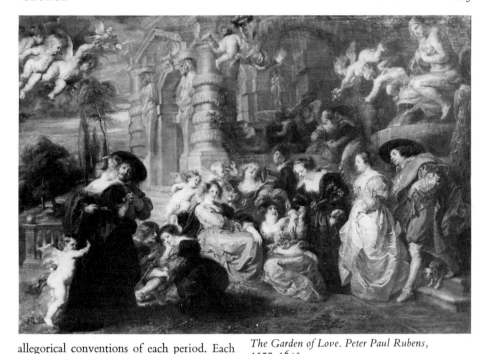

allegorical conventions of each period. Each
work represents a significant forward move
to break away from existing sexual taboos.
Rubens sets his elegantly dressed, upper-class
men and women in a shrine of Venus. Hover-
ing around the flirtatious group are *amoretti* in a
frenzy of activity. There is less nature visible
in the background of Rubens' painting than in
those of Watteau, but it is every bit as
aphrodisiac. It was indeed a unique subject
which allowed painters to make some of the
most lyric and tender love paintings in post-
classical art.

George, St There is little reliable information
about St George, patron saint of England.
The stories collected in the *Golden Legend* first
introduced him as a sort of Christian Perseus
slaying the dragon. Through this heroism he
saved the life of the Princess of Silene in Libya.
The sceptical Gibbon in the *Decline and Fall*
claims that St George was a pork-contractor
who meddled in Church politics. His cult was
brought to England by returning Crusaders.
He is patron of army officers and his attribute
is a red cross on a shield.

*The Garden of Love. Peter Paul Rubens,
1577–1640*

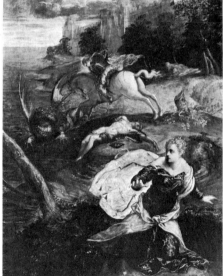

*St George and the Dragon (detail). Tintoretto,
1518–1594*

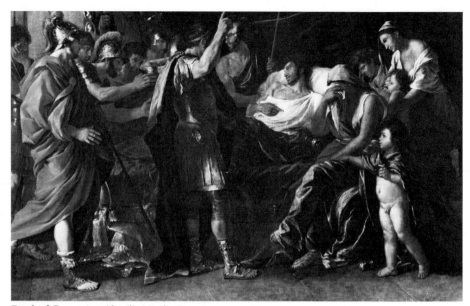

Death of Germanicus (detail). Nicolas Poussin, 1594–1665

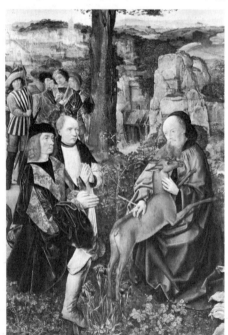

St Giles and the Hind (detail). Master of St Giles, active c. 1500

Germanicus Julius Caesar Germanicus (15 BC–AD 19), a relative by marriage of Augustus, was a popular Roman general, very active on the Rhine (hence his name). Tiberius adopted him as successor under pressure from Augustus. Germanicus died suddenly at Antioch. He was thought to have been poisoned at the order of the jealous Tiberius. His somewhat psychotic son, Caligula, succeeded Tiberius. The contrast between the clean-living Germanicus – a hero of Tacitus – and his corrupt relatives made him an illustrious example to later Stoics.

Gethsemane, see *Agony in the Garden.*

Giles, St A 7th-century Greek who found Gaul a more fruitful place for spiritual development than his native Greece. He lived a hermit's life in a forest near Nîmes, his only company a hind. He built a Benedictine monastery near his retreat which had become famous through his miracles and good works. His burial place had a great attraction for medieval pilgrims. He always appears in painting with his hind. He is the patron of cripples and blacksmiths.

Gilles One of the characters introduced into France in the 16th century by the Italian Theatre of the *Commedia dell'arte* (see *Italian Comedians*). He seems to be closely related to Pierrot and appears in paintings without a mask, his face flour-white, wearing a loose white peasant blouse. He is soft-hearted, over-sensitive, and generally unhappy.

Golden Calf According to Exodus xxxii, while Moses was on Mount Sinai, communing with Jehovah, discipline broke down among the Israelites, who persuaded their high priest Aaron to make them a Golden Calf, the worship of horned beasts being common among their neighbours. They danced around it in adoration but Moses discovered their idolatry when he came down with the tablets of the Ten Commandments. He destroyed the idol and, to impress on the people the magnitude of their guilt, had the tribe of Levi butcher three thousand of the guilty.

Gilles (detail). Antoine Watteau, 1684–1721

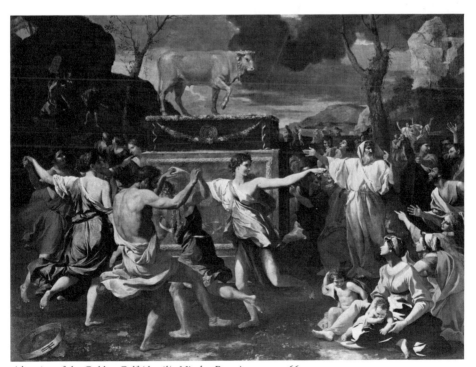

Adoration of the Golden Calf (detail). Nicolas Poussin, 1594–1665

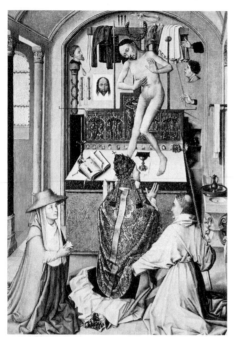

Mass of St Gregory (detail). Master of Flémalle, 1378/79–1444

Golden Gate, Meeting at, see *Virgin Mary.*

Goliath, see *David.*

Gordian Knot, see *Alexander.*

Gregory, St One of the greatest of the early Church Fathers, St Gregory was born into a Roman patrician family about AD 540. A missionary voyage interested him in the conversion of the English. He sent St Augustine of Canterbury to continue the work he had hoped to start. He became Pope in 590. His forthright defence of Rome against northern invaders without help from the Emperor in Constantinople was a major factor in the development of Papal independence and authority. He was the founder of the Papacy as a great temporal as well as spiritual power. His name is associated with Gregorian Chant or Plainsong. He is sometimes shown in art with a dove which according to legend brought him divine inspiration for his writings by whispering in his ear. He is also shown with Christ appearing on the altar as he celebrates Mass.

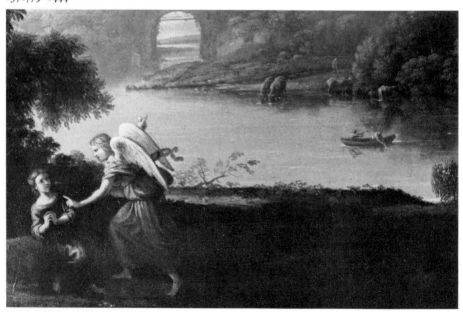

Hagar and the Angel (detail). Claude Lorraine, 1600–1682

H

Hagar In Genesis xvi Abraham's wife Sarah, distressed at her childlessness, put forward her servant Hagar for Abraham's attention. The eighty-six-year-old man fathered a child on Hagar. Her subsequent arrogance got her driven out into the wilderness where she bore Ishmael, considered by the Arabs as the ancestor of all Bedouins. Genesis describes Ishmael as a 'wild man: his hand will be against every man, and every man's hand against him'.

Heaven, see *Paradise.*

Hector Eldest and noblest of King Priam of Troy's fifty sons, Hector was the mainstay of the Trojans in their ten-year war with the Greeks. His killing in battle of Achilles' friend Patroclus infuriated Achilles, who in turn slew him and dragged his corpse round the walls of Troy three times. He was mourned by his beautiful and heroic wife, Andromache. Her considerable sufferings, which she bore with great nobility – her young son Astyanax was hurled from the walls of Troy by Ulysses and she was taken as a slave-woman by the Greek Neoptolemus – inspired tragedies by Euripides and Racine.

Helen of Troy Leda's (*q.v.*) encounter with Jupiter (*q.v.*) disguised as a swan produced two eggs, from one of which emerged Helen, who grew into the most beautiful woman in the world. Married to Menelaus, King of Sparta, she was abducted by the Trojan, Paris (*q.v.*), to whom she had been promised by Venus (*cf. Paris, Judgment of*). This abduction was the cause of the ten-year Trojan War.

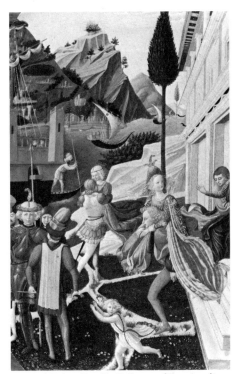

Rape of Helen (detail). Follower of Fra Angelico, mid 15th century

Hector. Jacques-Louis David, 1748–1825

*St Helena's Vision of the Cross. Paolo Veronese,
c. 1528–1588*

Helena, St The mother of the Emperor
Constantine (*q.v.*) was originally an innkeeper
from a small city in Asia Minor. She was con-
verted to Christianity through the influence
of her son, after his victory over Maxentius.
She became a great church builder and at an
advanced age visited Palestine where she is
supposed to have discovered the remnants of
the true cross (*q.v.*) on which Christ was
crucified. Always popular in England, local
legend claimed her as British. Her attribute is
the cross. She is patroness of dyers.

Hell As a subject for Renaissance and pre-
Renaissance painters, Hell was the place of
everlasting punishment after death, inhabited
by Satan, devils, and sinners. The few refer-
ences to it in the New Testament – mostly in
Matthew – suggest a climate dominated by
perpetual fire. Revelation xxi, 8 is the sole
source of specific information: '...the fearful,
and unbelieving, and the abominable, and
murderers, and whoremongers, and sorcerers
and idolaters and all liars, shall have their part
in the lake which burneth with fire and
brimstone...'. The pictorial concept of Hell
was based on a mixture of beliefs incorporat-
ing imagery from the classic Hades, from
Sheol or Gehenna of the Old Testament, where
dead sinners were burnt by unquenchable
fire, and medieval literature such as the *Vision
of Tundale*, and above all from Dante's *Inferno*.

Hell: the Fall of the Rebel Angels. Pieter Brueghel the Elder, c. 1525/30–1569

Hercules and Omphale. Bernardino Pintoricchio, c. 1454–1513

Hera, see *Juno.*

Hercules This most popular of all the figures of classical mythology (*Heracles* in Greek) was sired by Jupiter on the mortal Alcmene by impersonating her absent husband Amphitryon. As a punishment for killing his own children in a Juno-inspired fit of madness, he was ordered by the oracle at Delphi to carry out Twelve Labours imposed by Eurystheus, King of Mycenae. They were: 1 Slaying the Nemean Lion whose hide he afterwards wore. 2 Killing the Hydra of Lerna. As he severed this water-snake's heads, he cauterized the bleeding necks to prevent re-growth. The beast's gall was used thenceforth to poison his arrows. 3 Capturing the Ceryneian stag after a one-year chase. 4 Capturing the wild boar of Erymanthus. 5 Clearing the Stymphalian Marshes of their human-eating birds. 6 Cleansing the stables of King Augeas of their thirty-year accumulation of manure from several thousand oxen by diverting two rivers through them. 7 Capturing the mad Cretan bull. 8 Capturing the carnivorous mares of Diomedes who was then fed to them. 9 Capturing the girdle of Hippolyta, Queen of the Amazons. 10 Stealing the cattle of the monster Geryon. 11 Bringing back the Golden Apples of the Hesperides, killing on the way Antaeus, son of the earth goddess, by strangling him as he held him off the earth from whence came his strength. 12 Dragging up from Hades the multi-headed dog Cerberus.

Hercules and Antaeus. Hans Baldung Grien, 1484/85–1545

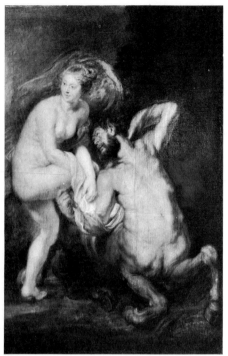

Nessus and Dejanira. Peter Paul Rubens, 1577–1640

The Hercules legend contains hundreds of other adventures, including his sexual intercourse with the fifty daughters of Thestius in one night, his serving as a wool-spinning slave to Queen Omphale, and ending with his marriage to Dejanira who caused his death. Hercules asked the centaur Nessus to carry Dejanira across a river. In mid-stream the agile Nessus tried to rape her. Hercules slew him with a Hydra-poison arrow. The dying Nessus gave Dejanira some of his blood as a love charm. Later needing to retain Hercules' love, she dipped his shirt in the magic blood. When Hercules donned it, he was consumed by a deadly inner fire. Jupiter carried him off to Olympus as an immortal.

Hermaphroditus and Salmacis The son of Mercury (*q.v.*) and Venus (*q.v.*) was courted by a water nymph named Salmacis. His rejection of her advances spurred her to a super effort. Catching Hermaphroditus bathing in her pool she held him so fast that their bodies fused into a composite, part male and part female.

Hermes, see *Mercury.*

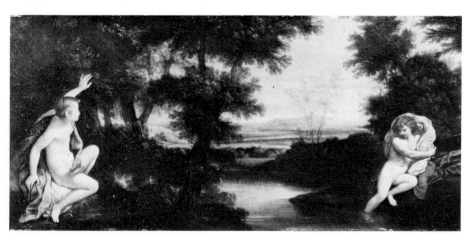

Salmacis and Hermaphroditus. Francesco Albani, 1578–1660

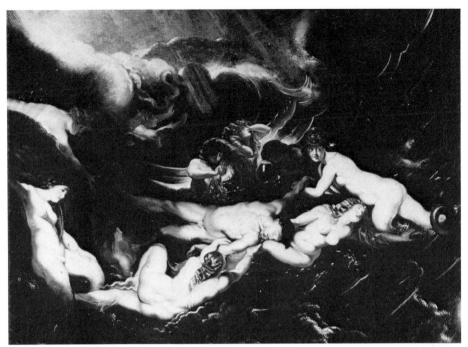

Hero and Leander (detail). Peter Paul Rubens, 1577–1640

Hero and Leander The story comes to us
from an obscure 6th-century writer named
Musaeus. His poem describes the nightly swim
of Leander across the narrow Hellespont
between Abydos and Sestos for an assignation
with Hero. One stormy night Hero's guiding
torch was extinguished and Leander drowned.
Hero then threw herself into the sea.

Herod Herod the Great (73–4 BC) was the
best known of a powerful Jewish (or rather
Idumaean) family. This Tetrarch of Judea was
a bloodthirsty man whose multiple killings
included two sons and most of his own family.
While there is no contemporary record of the
Massacre of the Innocents at Bethlehem, such
an act could well have fitted his character.
(See *Flight into Egypt.*) He must have had con-
siderable political skill. During his seventy
murderous years which coincided with the
great political upheavals ushering in the Roman
Empire, he consistently retained Roman
support.

*The Banquet of Herod (detail). Masolino,
c. 1383/84–1447(?)*

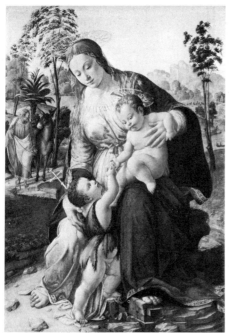

Holy Family In general, pictures of the Holy Family show the Virgin Mary, Joseph, and the child Jesus. Not infrequently there is added to this basic group St Anne (*q.v.*), the mother of the Virgin Mary, the infant John the Baptist, and a lamb as a symbol of Christ ('Behold the Lamb of God, which taketh away the sins of the world', John i, 29). The attributes of Joseph are sometimes a flowering rod or staff, and carpenters' tools. He is the patron of carpenters, married couples, house-hunters, and pioneers.

(Below) Holy Family with St John. 15th-century Florentine

The Holy Family. Nicolas Poussin, 1594–1665

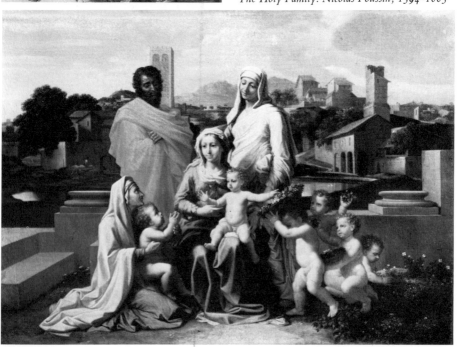

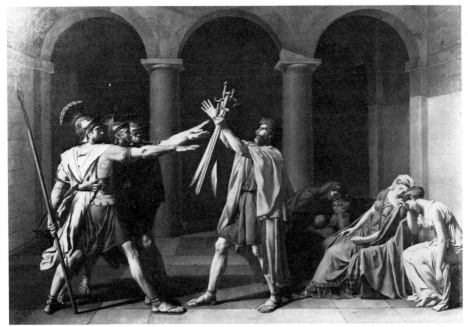

Oath of the Horatii. Jacques-Louis David, 1748–1825

Horatii, The oath of the This subject comes from the story in Livy, made popular by Corneille's *Horace*. Because of their oath to their virtuous father, three Roman champions, the Horatii, fight to the death the three champions of a neighbouring city. Such were the demands of loyalty to Rome that they did this even though related to their adversaries by marriage.

Hubert, St This heir to the Duchy of Aquitaine was born *c*. AD 656. As a young man he lived in what is now Belgium. A great huntsman, one Easter Friday morning instead of going to church he set out for the hunt. The stag he was pursuing turned and revealed a crucifix between its antlers. A voice told him he would go to Hell if he did not live a better life. He took the advice to heart, became active in the Church, sought martyrdom but ended up as bishop of Liège. He is patron of hunters and mathematicians.

Hydra, see *Hercules*.

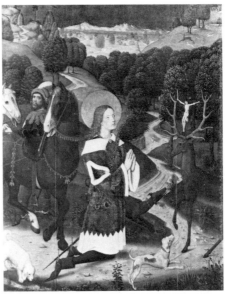

Conversion of St Hubert. 15th-century Flemish school

I

Fall of Icarus (detail). Pieter Brueghel the Elder,
1525/30–1569

Icarus Icarus was the son of Daedalus, a distinguished Athenian craftsman who had been taught by Minerva. He helped his father build the Labyrinth for King Minos of Crete. Later Minos imprisoned them in the Labyrinth because Daedalus had helped Minos' wife couple with a white bull. They escaped by fixing wings to their shoulders with wax and flying away. Icarus flew too close to the sun which melted his wax. He fell into the sea and drowned near Samos, off the coast of what is now Turkey. The waters of this region are now known as the Icarian Sea.

Ignatius Loyola, St The founder of the Society of Jesus (Jesuits) was born of a noble family of Spain in 1491. His interest in the spiritual life started when he was thirty, during

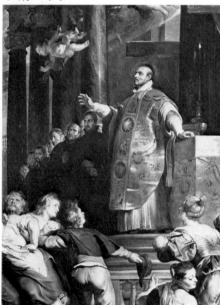

Miracle of St Ignatius Loyola (detail).
Peter Paul Rubens, 1577–1640

Adoration of the name of Jesus (detail). El Greco,
1541–1614

his convalescence recovering from a war wound. According to his autobiography, at that time he had a vision of the Virgin Mary and Child which was so purifying that 'never again was there the least consent to any carnal thought'. He formed the Society of Jesus in 1534 with Francis Xavier (*q.v.*) and other companions. The chief interest of this great mystic was in missionary work and in teaching. He produced a book of *Spiritual Exercises*, still in wide use. He died at the age of sixty-five. The idea of Jesuits as soldiers of Christ, very active in the Counter-Reformation, was a post-Ignatian development. His attributes include a dragon under his feet, the monogram IHS (*q.v.*), and a heart pierced by nails.

IHS The contracted monogram for the first three Greek letters for Jesus. St Bernardino of Siena (*q.v.*) gave the monogram wide publicity. St Ignatius Loyola (*q.v.*) adopted it, and it became the emblem of the Society of Jesus. The monogram has been erroneously confused with the phrases *In Hoc Signo*, and *Jesus Hominum Salvator*.

Ildefonso, St A 7th-century Spanish saint whose book on the Virgin Mary started the cult of the Mother of God in Spain. He became archbishop of Toledo in 657. One of the most popular saints in Spain, he appears frequently in painting, receiving his chasuble from the Virgin Mary.

Immaculate Conception This refers not to the circumstances of Christ's birth but to those of the Virgin Mary's. The dogma holds that 'the Blessed Virgin Mary, from the first instance of her conception, was . . . preserved from all stain of Original Sin'. This means that the Virgin Mary's conception by her mother St Anne (*q.v.*) was immaculate and miraculous. The formal announcement of the doctrine 'steadfastly believed by all the faithful' for centuries, was made only in 1854, but had gradually built up throughout the Middle Ages on the basis of such Biblical texts as Luke i, 28. See *Virgin Mary*.

Innocents, Massacre of the, see *Flight into Egypt.*

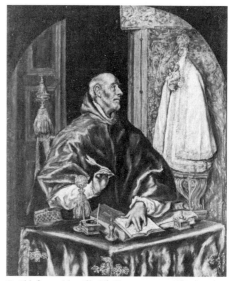

St Ildefonso (detail). El Greco, 1541–1614

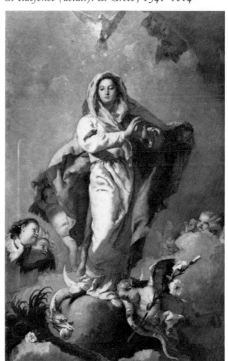

The Immaculate Conception. Giovanni Battista Tiepolo, 1696–1770

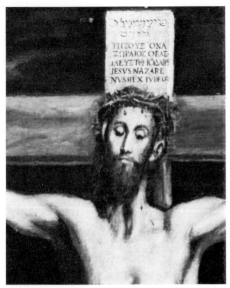

Crucifixion (detail). El Greco, 1541–1614

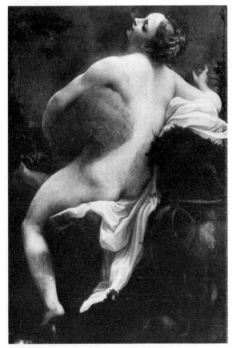

*Io embraced by Jupiter in the form of a cloud
(detail). Antonio Correggio, 1487/88–1534*

INRI John xix relates that 'Pilate wrote a title, and put it on the cross. And the writing was JESUS OF NAZARETH, THE KING OF THE JEWS ... and it was written in Hebrew, and Greek, and Latin.' INRI are the initials of the first letters of the words of the Latin text *Iesus Nazarenus Rex Iudaeorum*.

Io Ever on the look-out for beautiful girls, Jupiter took the form of a cloud and coupled with Io. Discovered – as always – by Juno, he turned Io into a heifer and was forced to give her to Juno as a present. Juno set the hundred-eyed Argus to guard the heifer, Jupiter sent Mercury to recover Io. Mercury put Argus to sleep with his flute playing and then cut off his head. Juno put the hundred eyes of Argus into the peacock's tail and sent a gadfly to torment Io wherever she went. Io retained the form of a heifer until her arrival in Egypt when she gave birth to a son.

Isaac The most important events in the life of Isaac which appear in painting are as follows:
 Birth of Isaac Genesis xviii relates the visit to Abraham of three men (angels representing Jehovah), who after receiving hospitality predict the birth of a child to the aged Abraham and Sarah. The result was the birth of Isaac.
 Sacrifice of Isaac To test Abraham's faith, Jehovah, in Genesis xxii, orders Abraham to sacrifice his beloved boy. His heart firm, notwithstanding the touching question of the child, 'Where is the lamb for a burnt offering?', he proceeds with the divine purpose but at the last moment an angel appears – in painting it is frequently St Michael – and Abraham discovers a ram caught in a thicket which he can sacrifice as a substitute for Isaac.
 Isaac and Rebecca Genesis xxiv tells at length how Isaac sent a servant to find him a bride in Chaldea. The first girl who offers him water at a well is to be Isaac's bride. It is Rebecca. The union is hastened by her brother Laban when he sees the rich gold gifts the servant had given Rebecca.

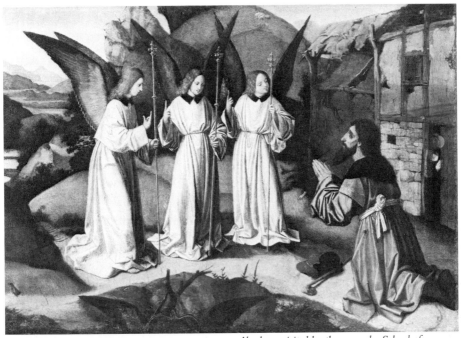

*Abraham visited by three angels. School of
Antonello da Messina, c. 1430–1479*

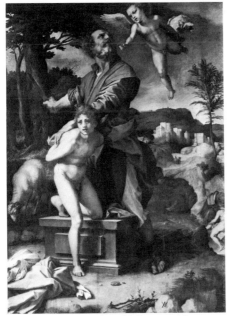

Sacrifice of Isaac. Andrea del Sarto, 1486–1530

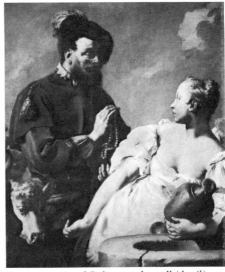

*Isaac's servant and Rebecca at the well (detail).
Giovanni Battista Piazzetta, 1683–1754*

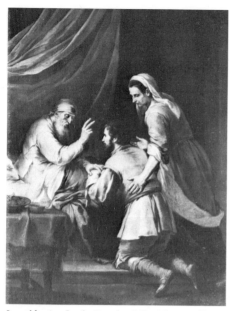

Isaac Blessing Jacob In Genesis xxvii Rebecca bears twin sons to Isaac, Esau and Jacob. By a trick Rebecca secures Isaac's death-bed blessing and right of succession for her favourite, Jacob, by covering his arms and neck with goat skin to impersonate his hirsute elder brother Esau. Earlier, Esau, the hunter-Bedouin type, had sold his birthright to the smarter, more civilized Jacob, for a mess of pottage.

Ishmael, see *Hagar*.

Issus, Battle of the Of the three battles Alexander the Great (*q.v.*) fought against Darius III, his resounding victory at Issus in 333 BC marked the beginning of the end of Persian power. Choosing a terrain suitable for his outnumbered troops, in the mountains above what is now the Gulf of Alexandretta in southern Turkey, Alexander destroyed the bulk of the Persian forces. Napoleon, who saw himself as a sort of latter-day Alexander, was fascinated by the Macedonian's exploits and kept Altdorfer's imaginary painting of the battle – stolen from Bavaria – in his bathroom.

Isaac blessing Jacob. Bartolomé Esteban Murillo, 1617–1682

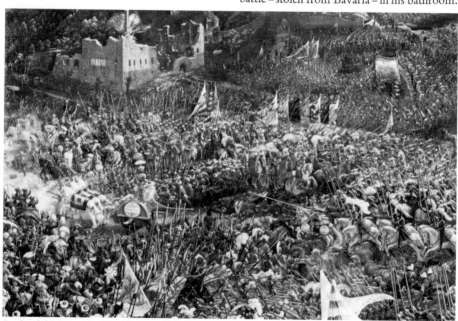

Battle of the Issus (detail). Albrecht Altdorfer, 1480–1538

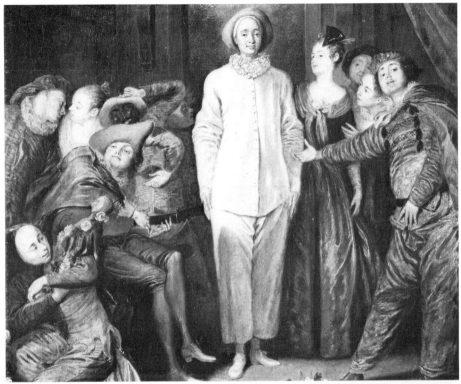

Italian Comedians (detail). Antoine Watteau,
1684–1721

(Right) Mezzetin. Antoine Watteau, 1684–1721

Italian Comedians The Italian *Commedia dell'arte* or 'theatre of the professionals' reached its high point in Italy in the 16th and 17th centuries. Its main characteristics were an outline plot and a dialogue improvised by the actors playing stock characters such as Harlequin, Pierrot or Gilles (*q.v.*), the Doctor, Mezzetin, Colombine, Pantaloon, etc. Companies of *commedia* players travelled all over Europe and greatly influenced the development of the Western theatre. Very popular in France, the company of Italian comedians was banned from 1697 to 1716 for offending the sanctimonious Mme de Maintenon.

J

Jacob Almost half of Genesis covers the life and times of Jacob, father of the twelve tribes of Israel. Among events in his life which inspired paintings are the following:

Dream of Jacob Genesis xxviii, 12 tells how in a dream Jacob saw 'a ladder set up on the earth, and the top of it reached to heaven: and behold the angels ascending and descending on it.' The dream reached its climax with Jehovah promising Jacob that his descendants would be his chosen people.

Jacob, Laban, Leah, and Rachel Like his father Isaac, Jacob sought a wife in Chaldea. When he arrived at Hanan, the place of his uncle Laban, he met Rachel tending sheep and fell in love with her. He agreed to serve Laban

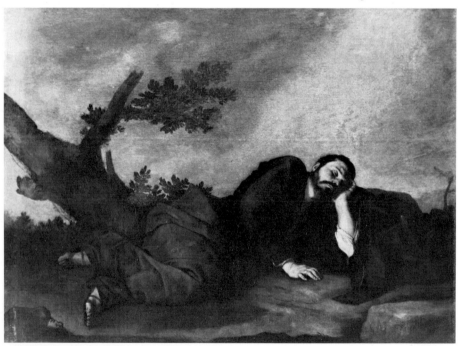

Dream of Jacob. José de Ribera, 1591–1652

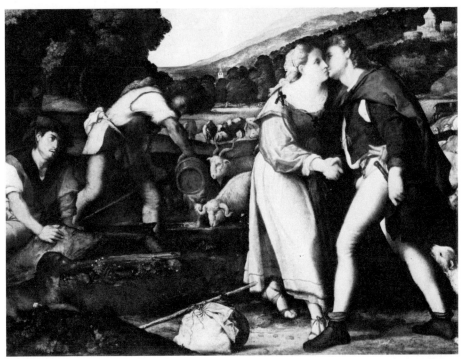

The Meeting of Jacob and Rachel (detail). Palma Vecchio, 1480–1528

for seven years to have her. 'They seemed unto him but a few days, for the love he had to her.' (Genesis xxix, 20.) But Laban cheated him. After a conversationless wedding night Jacob found in the morning he was married to the older but less beautiful 'tender-eyed' Leah. He served another seven years and was finally able to marry Rachel as his second wife. See p. 133.

Jacob Wrestling with the Angel After a final peaceful settlement with the difficult Laban, Jacob left for Canaan with his wives, children, and livestock. *En route*, at Penuel, he spent a whole night wrestling with a being who later revealed himself as an angel of the Lord from whom he received a blessing as further evidence of the favour he enjoyed in the eyes of Jehovah. The angel told him his name henceforth would be Israel because he had striven with both God and men, and prevailed. Jacob-Israel died at the age of 147 years.

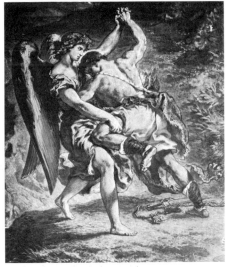

Jacob wrestling with the Angel.
Eugène Delacroix, 1798–1863

St James the Greater. Simone Martini and assistants, c. 1284–1344

St James the Less (detail). Master of St Francis, active second half of 13th century

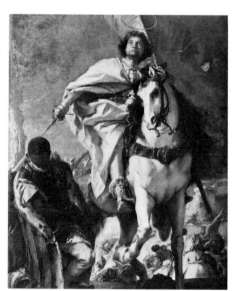

St James the Greater (detail). Giovanni Battista Tiepolo, 1696–1770

James, St (the Greater) One of the disciples closest to Christ – he, John, and Peter are the three disciples always shown apart from the others during the Agony in the Garden (*q.v.*). They were also present at the Transfiguration (*q.v.*). According to a legend dating from the 7th century Herod Agrippa had James murdered after his return from Spain. His body is supposed to be buried at Compostela, which became one of the greatest pilgrimage centres in Europe. He is the patron saint of Spain, also of furriers. His attributes include a pilgrim's staff, a wallet, and a shell.

James, St (the Less) Little is known of this Apostle who is said to have been a close relative of Christ. He is mentioned (Acts xv) as presiding over the Council of Jerusalem and (Acts xxi) instructing Paul how to demonstrate his loyalty to the practices of Judaism. He was martyred by being thrown down from the Temple and beaten to death with a fuller's club. His attribute is the fuller's club.

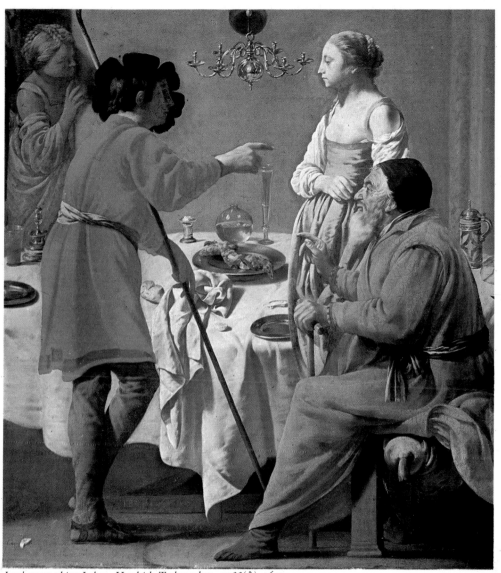

Jacob reproaching Laban. Hendrick Terbrugghen, 1588(?)–1629

Januarius, St (Gennaro) A 4th-century
martyr about whom little is known. Some of
his dried blood is preserved in the Naples
cathedral. The vessel containing the blood is
exhibited four times a year and liquefaction is
recorded for certain of these occasions. This
phenomenon apparently went unnoticed until
1389 when mention was first made of it. The
saint's attribute is a flask. He is the patron of
goldsmiths and is invoked against eruptions of
Vesuvius. See p. 136.

Jason Jason's uncle Pelias promised to return
him the kingdom in Thessaly, of which he
had deprived him during his minority, if he
brought back from Colchis at the eastern end
of the Black Sea a golden fleece guarded by a
dragon. Jason agreed, secured fifty Greek
heroes including Hercules, Theseus, and
Orpheus to help him, built a fifty-oared ship,
the *Argo*, and set off.

*Jason and the Argonauts (detail). A follower of
Pesellino, mid 15th century*

After the usual assortment of adventures which showed up the skill, bravery, stupidity, and weakness of his companions, Jason finally reached the kingdom of Aeëtes who owned the golden fleece. Aeëtes agreed to give him the golden fleece if he performed certain tasks which were apparently impossible. Jason invoked the help of Medea, the king's daughter who had fallen in love with him. Medea had magical powers. Yoking up two fire-breathing bulls, Jason ploughed and sowed a field with dragons' teeth which sprouted fierce soldiers whom he had to fight and kill. It is said that while Orpheus charmed the dragon, Jason stole the golden fleece and escaped with Medea (*q.v.*). His marriage with her was an unmitigated disaster. The story of the golden fleece is thought to concern a 13th-century BC joint trading venture in search of gold by Greek maritime towns. The journey was probably up the Adriatic rather than into the Black Sea.

Jerome, St The most learned of the Four Church Fathers was born *c.* 342 of prosperous parents on the Dalmatian coast. He translated the Bible into Latin, the lingua franca of the day. He travelled widely in the Middle East, spent some years as a desert hermit, and finally settled in Bethlehem in a monastery which his devoted companions established there. He was an irascible man much given to violent controversy. The *Golden Legend* put into wide circulation many colourful stories about the saint. He is probably the only male saint to appear in church wearing women's clothes, his spiteful fellow students having placed them in his cell in the darkness. The story of his lion was specially popular with painters. A lion is said to have limped into his monastery, frightening all but the saint, who removed the thorn from its paw. It was thereafter his constant companion. As the monks insisted it should work like everyone else in the monastery, it led out Jerome's ass to collect firewood each day. The ass was stolen and the monks accused the lion of eating it. But the lion found the ass and brought it back with the robbers. The saint's attributes are the lion or the cardinal's hat. See p. 137.

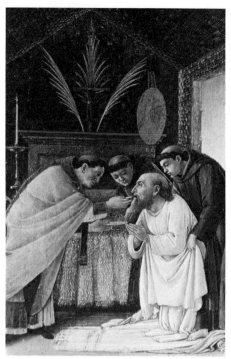

Last Communion of St Jerome (detail).
Sandro Botticelli, c. 1445–1510

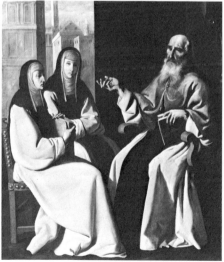

St Jerome with St Paula and St Eustochium (detail). Francisco de Zurbarán, 1598–1664

Martyrdom of St Januarius. Luca Giordano, 1632–1705

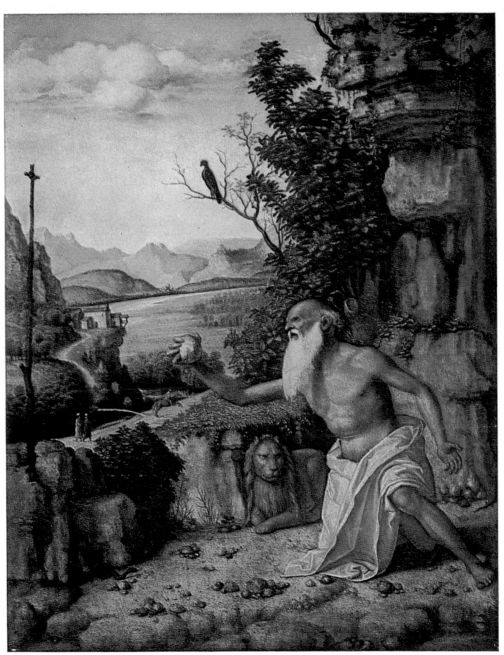

St Jerome in a landscape. Giovanni Battista Cima, 1459/60–1517/18

Jethro's Daughters, Moses and Fleeing from the killing of an Egyptian overseer who had been harassing Israelite workers, Moses sought refuge among the Jehovah-worshipping Midianites, in the area west of what is now Elath, the Israeli port on the Red Sea. In a dispute over the use of a well, Moses helped the seven shepherdess daughters of Jethro against the hostile shepherds. As a reward one of these daughters, Zipporah, married him. The fight of the shepherds around the well was used by Mannerist painters to show naked bodies in violent conflict. See p. 141.

Joachim and Anne, see *Virgin Mary.*

Job The book of Job – generally considered the literary masterpiece of the Old Testament – tells the story of the wager between Satan and Jehovah concerning Job's piety and faith, and whether it could survive material loss. Despite the loss of his extensive property, his children, and his health, and the hollow explanatory

Satan smiting Job with sore boils. William Blake, 1757–1827

arguments of three maddening friends, he never wavered. Jehovah, vindicated in his judgment, restored him to greater prosperity.

John the Baptist, St Generally considered to be the last Prophet of the Old Testament, he foretold the coming of Christ, the Messiah whom he later baptized (*cf. Baptism*). Christ considered that 'Among those that are born of women there is not a greater prophet.' (Luke vii, 28.) His rash criticism of Herod (*q.v.*). for murdering his brother and marrying the widow Herodias, got him arrested. It is said that Herod promised Herodias's daughter Salome (*q.v.*) a gift. Prompted by her mother she asked for the head of John the Baptist. The decapitation, and delivery of the head on a salver at a banquet were popular subjects with painters. John is the first saint of the New Testament. In painting he often appears as he was described in Matthew iii, 4: 'John had his raiment of camel's hair, and a leathern girdle about his loins: and his meat was locusts and wild honey.' He also appears carrying a lamb and a scroll with the words '*Ecce Agnus Dei*' (Behold the Lamb of God – John i, 36). He is the patron of missionaries, many cities, including Florence, and tailors.

Decapitation of John the Baptist (detail).
Juan de Flandes, active 1496–c. 1519

John, St Three separate men – the Apostle, the Evangelist, and the author of Revelations – were combined in later legend and given a continuous biography. John, the brother of James the Greater (*q.v.*), was the youngest of the Apostles. The New Testament (his own Gospel) described him as 'the disciple whom Jesus loved'. He looked after the Virgin Mary following Christ's death on the cross. Exiled to Patmos he is said to have written there the Book of Revelation. According to legend he escaped death from immersion in boiling oil. An attempt to poison him failed, the poison turning into a snake. He died at Ephesus at a great age. His attributes are an eagle, a chalice with a serpent emerging from it, and a Book of the Gospel. See p. 140.

Jonathan, see *David*.

Joseph, St, see *Holy Family*, and *Flight into Egypt*.

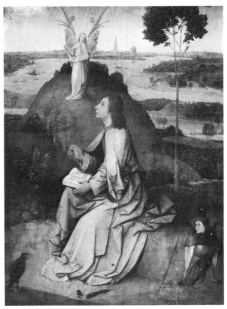

St John at Patmos (detail). Hieronymus Bosch,
c. 1450–1516

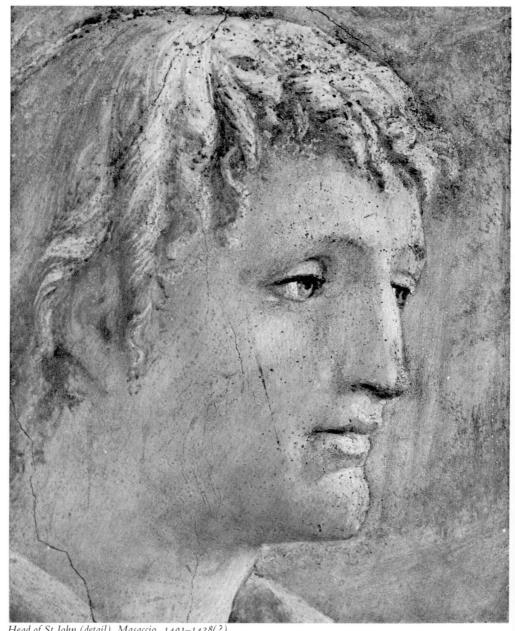

Head of St John (detail). Masaccio, 1401–1428(?)

Moses defending the daughters of Jethro. Giovanni Battista Rosso, 1494–1540

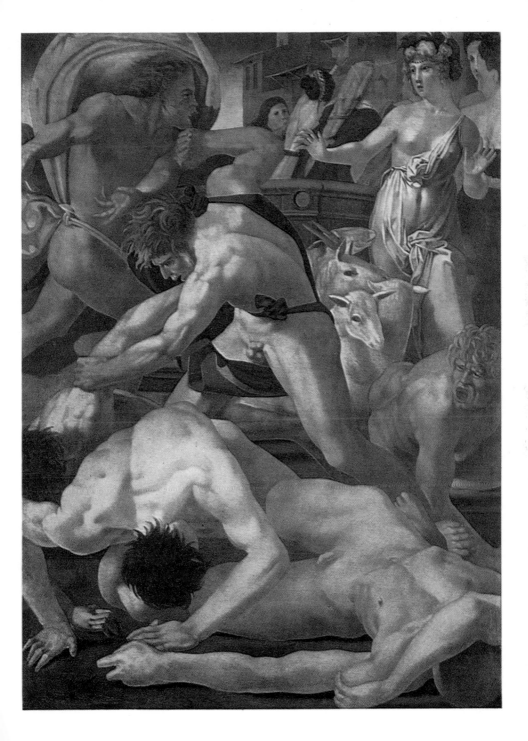

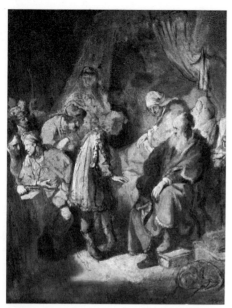

Joseph relating his dreams. Rembrandt van Ryn,
1606–1669

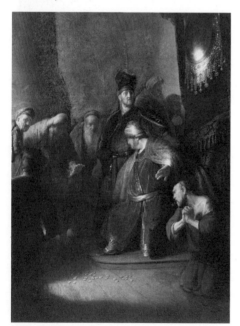

Judas returning the thirty pieces of silver (detail).
Rembrandt van Ryn, 1606–1669

Joseph The story of Joseph, favourite son of
Jacob and Rachel, is told in Genesis. His ten
jealous elder brothers sold him into slavery.
They told old Jacob that a wild animal had
eaten him, showing him the 'coat of many
colours' which they had stained with animal
blood. In Egypt Joseph became the trusted
slave of an officer named Potiphar whose wife
falsely accused him of attempted rape. Joseph
went to prison where he developed his gift for
dream interpretation. His explanation of
Pharaoh's dreams of the seven lean cattle and
seven lean ears of corn consuming the seven
fat cattle and seven fat ears of corn resulted in
his appointment as food minister. Storing the
harvests of seven good years he saved the
Egyptians, and his own people, by covering
the food deficit of a seven-year drought. His
brothers, without recognizing him, came to
Egypt to beg food. Before revealing himself
he played a trick on them by hiding a silver
goblet in the sack of the youngest, Benjamin,
and accusing him of theft.

Judas Iscariot The only one of the Apostles
– he was the treasurer – who came from Judea.
According to Luke xxii, 3, 'Then entered Satan
into Judas surnamed Iscariot' and he agreed to
betray Jesus to the Sanhedrin for thirty pieces
of silver (mentioned only by Matthew).
Repenting of his treachery he unsuccessfully
tried to give the money back. Aghast at his
crime, he hanged himself. Judas' appearances in
painting are in scenes of the Last Supper,
where he is generally shown apart from the
others, and at Gethsemane, kissing Christ to
identify him to the Temple police.

Judith and Holofernes The story of Judith,
a young widow of Bethulia in north Palestine,
is told in an Old Testament book not univer-
sally accepted as genuine. Holofernes, a
Babylonian general, had almost secured the
surrender by siege of Bethulia. Judith made
her way secretly through the siege lines and
won the confidence of Holofernes. She then
made nightly visits to his tent. One night when
he had fallen into a drunken sleep, she seized
her chance and decapitated him. The dis-
couraged and leaderless Babylonians were then
routed by Judith's compatriots. See p. 144.

Juno Wife (and sister) of Jupiter, and Queen of Heaven. In Greek mythology she is Hera. Her best-known appearance, naked or nearly so, is in the *Judgment of Paris* (*q.v.*). But she is the moving force behind the events in many mythological scenes, following up the multiple infidelities of Jupiter and wreaking vengeance on his victims or their children, *viz* Semele, Callisto (*q.v.*), Io (*q.v.*), Antigone, Hercules (*q.v.*), Bacchus (*q.v.*), etc. Appropriately her absolute fidelity to Jupiter made her the ideal protectress of marriage and women. She sent the hundred-eyed Argus to spy on Io (*q.v.*), but Jupiter slew him and Juno put his eyes in the tail of her peacock.

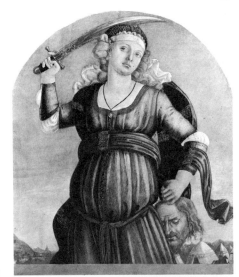

Judith with the head of Holofernes.
Matteo di Giovanni, c. 1435–1495

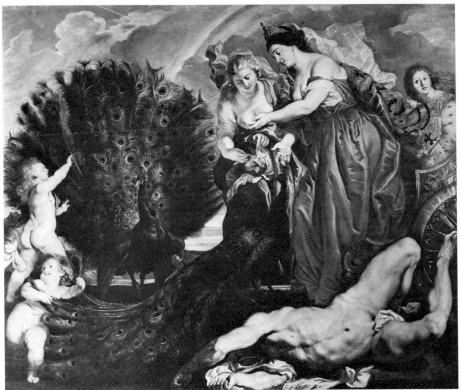

Juno and Argus. Peter Paul Rubens, 1577–1640

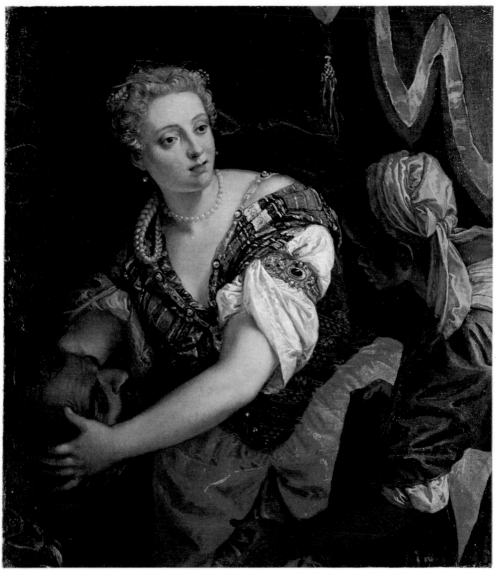

Judith with the head of Holofernes. Paolo Veronese, c. 1528–1588

Jupiter As an infant, Jupiter's life was pre-served from his child-devouring father, Cronus or Saturn (*q.v.*). His mother Rhea, the Great Mother Goddess, hid him among nymphs. He was suckled by a goat named Amalthea whom he later immortalized by placing her among the stars as Capricorn. When he came to manhood he ousted his father and became greatest and most powerful of all the gods. Jupiter, or Zeus, as he was known to the ancient Greeks, is the supreme symbol of the civilizing and ethical force, and the inspirer of laws. His enormous energy – he controlled lightning and other natural phenomena – was recognized by the Greeks as sexuality in its broadest, most creative and liberating sense: hence the vast number of his love affairs (see *Antiope, Europa, Ganymede, Io*). It was the highly imaginative eroticism of these adulterous adventures which fascinated Renaissance and post-Renaissance painters. What the ancient Greeks emphasized is that these unions produced gods and goddesses who are symbols of those humanizing features which distinguish men from the other animals. Thus, as the mythologues remind us, his liaison with Themis produced the Seasons and the Three Fates (*q.v.*); with Mnemosyne, three Muses; with Eurynome, the three Graces or Charities, and so on.

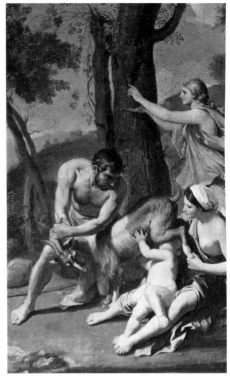

The Nurture of Jupiter (detail).
Nicolas Poussin, 1594–1665

L

Lamb, Mystic The idea of the lamb as a sacred ritual animal comes to us from Judaism. As a sacrificial symbol of Christ – it appears frequently with blood pouring from its breast into a chalice – it is one of the most persistent symbols in Western painting. Its Biblical authority is immense and frequent, from Isaiah liii, 7, 'He is brought as a lamb to the slaughter', to John i, 29 '. . . John seeth Jesus coming unto him, and saith, Behold the Lamb of God, which taketh away the sin of the world', to reach a climax in the Revelation of St John with its twenty-eight references to the lamb. In painting the lamb appears often as an attribute of John the Baptist, but also of St Agnes (*q.v.*), because of the pun on the Latin word for lamb, *agnus*.

Adoration of the Mystic Lamb (detail of the central panel of altarpiece). Hubert and Jan van Eyck, completed in 1432

Lamentation The Lamentation is generally a variant of the Crucifixion scene (*q.v.*). At the foot of the cross stand some or all of the persons the Gospels mention as being present: the Virgin Mary, Mary the mother of St James the Less, Mary Magdalene, and St John who had been asked by Christ to care for his mother. Sometimes the scene is indistinguishable from a *Pietà* (*q.v.*). Not infrequently the donors (*q.v.*) or patrons who commissioned works got their portraits included with the group.

Laocoön The war between the Greeks and Trojans involved the gods, many of whom were partisans of one side or the other. Laocoön, a Trojan priest of Apollo, warned his countrymen against the wooden horse left by the apparently retreating Greeks. His 'I fear the Greeks particularly when they bring gifts' (*Aeneid*) was answered by Minerva sending two large serpents which destroyed Laocoön and his two sons. This cleared the way for the entry into Troy of the wooden horse, which disgorged its Greek soldiers who then destroyed the city which had resisted them for ten years.

Laocoön. El Greco, 1541–1614

(Below) Lamentation (detail).
Hugo van der Goes, c. 1440–1482

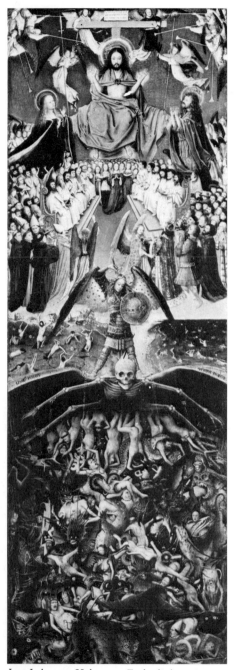

Last Judgment. Hubert van Eyck, died 1426

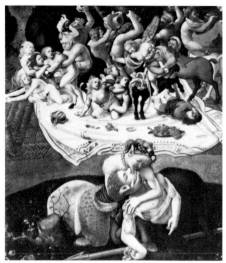

Battle between the Lapiths and Centaurs (detail). Piero di Cosimo, c. 1462–after 1515

Lapiths and Centaurs, Battle between
Homer and Ovid are the source for the story of the great battle at the wedding of King Peirithous between the Lapiths, a wild people from Thessaly, and the Centaurs, equally wild creatures, half-horse, half human. (They were one of Jupiter's weirdest experiments, being the final product of a union between a mortal and a cloud shaped like Juno.) At the wedding, a drunken Centaur tried to rape the bride. In the ensuing battle the Centaurs were driven out of Thessaly. Not all Centaurs were lustful and drunken: sober ones such as Chiron were the teachers of such heroes as Achilles (*q.v.*).

Last Judgment Both the Old and New Testaments foresee the end of the world when, as Matthew xxv relates, Christ the supreme magistrate will judge the quick and the dead, separating 'his sheep from the goats'. Man, only too aware of the human condition, has always been more precise about Hell than about Heaven. Many painters, therefore, concerned particularly about their didactic task, have concentrated on the torments of the damned. The Church encouraged this, often for political purposes, to demonstrate that whatever the worldly rank of the sinner, only the Church could intercede for them.

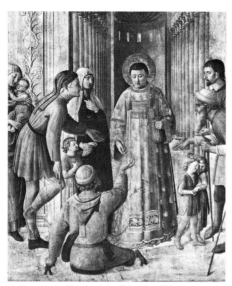

St Lawrence distributing alms (detail).
Fra Angelico, 1386/87–1455

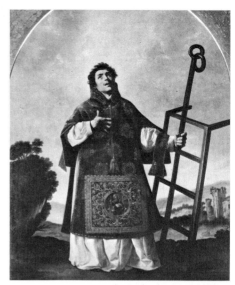

St Lawrence. Francisco de Zurbarán, 1598–1664

Last Supper, see *Eucharist.*

Lawrence, St A 3rd-century Spanish treasurer of the Church who was martyred in Rome. Ordered to turn over the Church treasures to authority – he had already distributed everything to the poor – he presented the officials with the poor, the halt, and the blind. He was killed by being roasted on a griddle. The *Golden Legend* claims that during his torture he called out to his executioners, 'Thou hast roasted that one side, turn that other, and eat.' His attribute is the gridiron and he is often shown with money, which he distributed to the poor. He is the patron of cooks.

Lazarus The story of the raising of Lazarus from the dead is told in John xi. In the small town of Bethany, Jesus had three followers, Mary, Martha, and their brother Lazarus. The sisters sent a message to Jesus that their brother was very ill. When Christ came to Bethany Lazarus was already dead. Martha said: 'By this time he stinketh: for he hath been dead four days.' But at the tomb, Christ 'cried with a loud voice, Lazarus, come forth. And he that was dead came forth.'

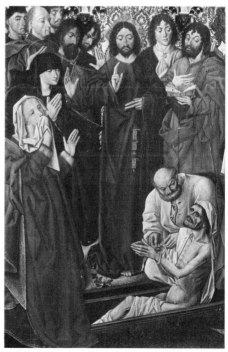

Raising of Lazarus (detail). Nicolas Froment, active 1450–1490

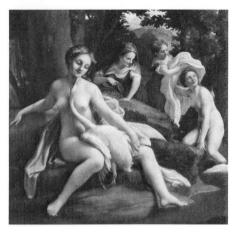

Leda with the Swan (detail). Antonio Correggio,
c. 1494–1534

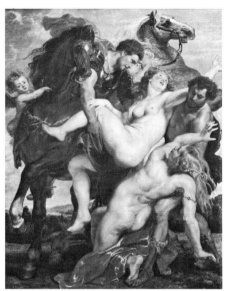

Rape of the Daughters of Leucippus (detail).
Peter Paul Rubens, 1577–1640

Leda In his predilection for exotic couplings,
Jupiter turned himself into a swan and made
love to the beautiful Leda, daughter of
Thestius, and wife of a Spartan king. She
subsequently gave birth to two eggs. Out of
one hatched Pollux and Helen (*q.v.*) and out
of the other Castor and Clytemnestra.

Leucippus brother of Tyndarus, king of
Sparta. He had two daughters who were
carried away (the original meaning of 'raped')
on their wedding day by their cousins Castor
and Pollux (*q.v.*).

Liberty Leading the People The revolution
of 1830 which overthrew the restored
Bourbon monarchy and enabled the French
bourgeoisie to exercise power less fettered by
the restrictions of the old system inspired one
of the last but greatest allegorical paintings.
Delacroix sympathized with the people of
Paris who did the fighting for the bourgeoisie
in the 1830 revolution and commemorated
the events in a large painting. He inserted in a
realistic barricade scene, cluttered with dead
and dying, the romantic figure of Liberty, a
handsome Junoesque figure, carrying a rifle

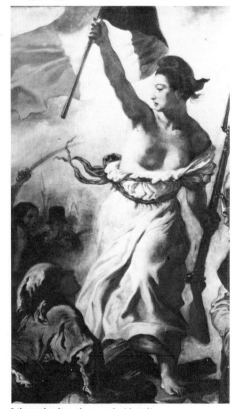

Liberty leading the people (detail).
Eugène Delacroix, 1798–1863

and the republican tricolour as she leads the attack. The picture was bought by the French bourgeois government but not exhibited for years.

Limbo, see *Christ in Limbo.*

Longinus, St Tradition holds that Longinus was the name of the centurion who was present at Christ's Crucifixion. He pierced Christ's side with his lance, and as he died, said, according to Mark xv, 39, 'Truly this man was the Son of God.' He lived in Caesarea and was martyred there. His death was most Christian. He promised that his martyrdom would restore the sight of the blind official who had condemned him. On recovering his sight that official immediately became a Christian. The attribute of Longinus is a lance.

Lot Lot, nephew of Abraham, was a prosperous herdsman who settled in Sodom, one of five cities of the Dead Sea region. Genesis xviii and xix tell the story of the fate of Sodom, Gomorrah and the other three wicked cities. Lot offered hospitality in Sodom to two travelling angels. During the night, following what seemed to be a weird local custom, some of the population tried to rape Lot's guests. Lot offered his daughters instead, but all were saved by the angels temporarily blinding the

St Longinus. Detail from Crucifixion. Andrea Orcagna, c. 1308–1368

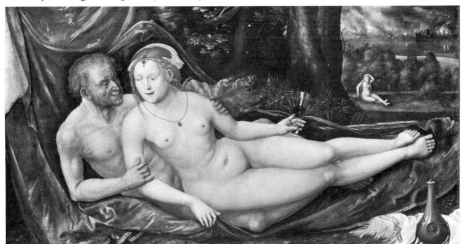

Lot and his daughters. Albrecht Altdorfer, c. 1480–1538

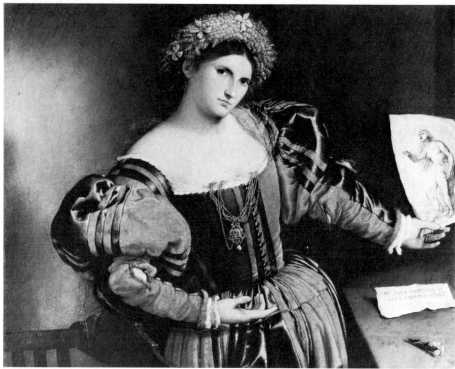

Lucretia. Lorenzo Lotto, c. 1480–1556/57

would-be ravishers. Warned by the angels to flee and not look back, Lot left Sodom for the mountains with his wife and two daughters. The cities of the plain were then obliterated by brimstone and fire. Lot's wife looked back and was turned into a pillar of salt. Later in the mountains, the daughters, in order to have children, made Lot drunk and committed incest with him.

Lucretia This legendary model of early Roman womanly virtue was the wife of an official. During his absence a son of Tarquin, the King of Rome, raped her. Revealing her defilement to her husband and father, she killed herself. Her relatives thereupon overthrew the monarchy of the Tarquins and established the republic.

Lucy, St A virgin of Syracuse in southern Sicily who was martyred during the Diocletian persecutions in the early 4th century. Denounced by her pagan fiancé, like Agatha,

the saint of neighbouring Catania, she escaped the horrors of a brothel. She also survived incineration but was finally decapitated. Her relics are distributed all over Europe. She is patroness of the blind, and her attributes are a lamp, a sword, and frequently a pair of human eyes. It is said that her eyes so attracted a suitor that for fear this might do him harm, she plucked them out and sent them to him. She is invoked against eye diseases and sore throat.

Luke, St The Evangelist-author of the third Gospel and the Acts of the Apostles, was a non-Jewish physician, and a friend of St Paul. He was born in Antioch, probably into a prosperous Greek family. According to the legend he was a painter and appears as such in Flemish works, painting the Virgin Mary. A number of churches claim to have works painted by him. His attribute is a winged ox. He is patron of doctors, butchers, and painters.

St Lucy. Francesco del Cossa, c. 1435–1477

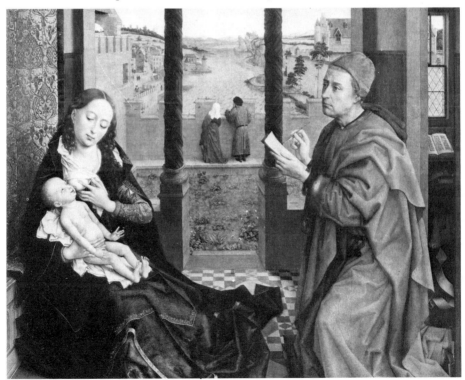

St Luke painting the Virgin (detail). Rogier van der Weyden, 1399/1400–1464

M

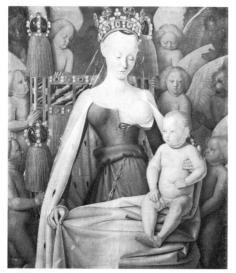

Madonna and Child. Jehan Fouquet,
c. *1420–1481*

Madonna and Child Perhaps the most popular subject in Renaissance painting, particularly in Italy, it has no special connection with any Biblical text. The Virgin Mary and the infant Jesus held in her arms, or lying on her lap, are displayed alone, or in a group which may include angels, saints, and donors (*q.v.*). Sometimes the Virgin and Child are portraits of the donor's wife and child or even the painter's mistress. Frequently displayed are symbol objects, *viz.* the apple as fruit of salvation, the pear as symbol of Christ, the cherry as fruit of delight of the blessed, the egg and butterfly standing for the resurrection and rebirth, and the shell as a symbol of pilgrimage. In Italy the scallop shell was often the shape of the receptacle for baptismal water. The subject of the Madonna and Child has a history which dates from the Byzantine period to the

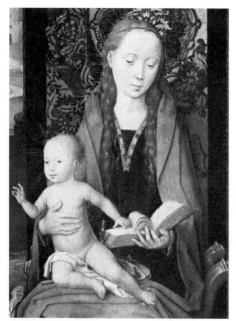

Madonna and Child (detail). Hans Memlinc,
c. *1430/35–1494*

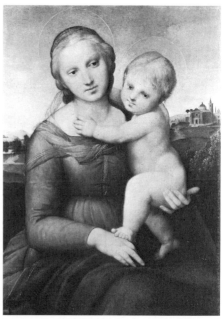

Madonna and Child. Raphael, 1483–1520

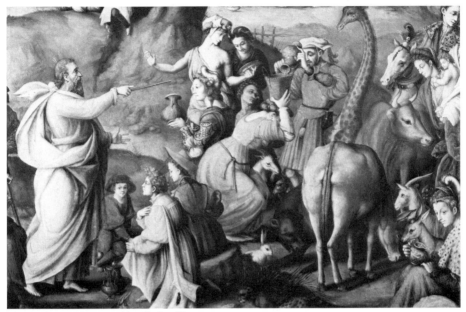

The Gathering of Manna (detail). Bacchiacca, 1495–1557

19th century. Given the elemental human nature of the subject it supplies at any one time a telling index of the relation between religious thought and humanism.

Man of Sorrows, see *Agony in the Garden.*

Manna, Gathering of Exodus xvi and Numbers xi describe *Manna,* the food which fell from heaven and fed the Israelites during their forty years wandering in the desert after they left Egypt. *Manna* looked like coriander but its taste varied from 'wafers made with honey' to 'fresh oil'. It fell daily, except on the Sabbath, and was the Israelites' main diet. Some researchers believe *Manna* was an edible, sugary exude from a desert plant; others that it was a sort of edible lichen.

Manoah Manoah was the father of Samson. Judges xiii tells the exemplary story of how strict adherence to the Jewish dietary laws and proper offerings to Jehovah overcame his wife's sterility so that she eventually gave birth to the phenomenally strong Samson.

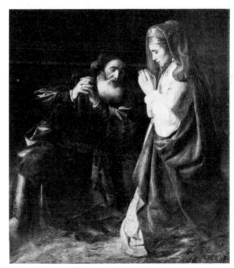

The offering of Manoah (detail). Rembrandt van Ryn, 1606–1669

St Margaret (detail). Francisco de Zurbarán,
1598–1664

Martyrdom of St Mark (detail). Tintoretto,
1518–1594

Marat, Death of Marat (1743–93), a Swiss
from Neuchâtel, studied medicine in France.
He practised in London, and later very suc-
cessfully in Paris. He finally established him-
self as an influential republican political figure,
and during the Revolution edited *L'Ami du
Peuple.* He was assassinated by Charlotte
Corday, who believed him to be a monster of
wickedness, as he sat writing in his medicinal
bath. The famous painting by his friend David,
who had talked with him the day before his
death, marks a high point in classic realism.
It is one of the finest and most powerful
political paintings ever made, and had the
explicit purpose of keeping alive the memory
of a revolutionary hero. See p. 157.

Margaret, St A virgin martyr from the
Antioch region – known in the Near East as
Marina – who died during the Diocletian
persecutions. Rejecting the attentions of a
Roman prefect, he denounced her as a
Christian. She survived incineration, boiling
water, and being swallowed by a dragon. She
escaped this latter hazard when the cross she
was wearing grew bigger and finally split the
dragon open. She met her death in the
classical martyr's way, being decapitated. Her
attributes are a cauldron and a dragon. She
sometimes appears in painting as a shepherdess.

Mark, St The Evangelist-author of the
second Gospel. His mother was a prosperous
friend of Christ and it is thought that the Last
Supper (*q.v.*) took place in her house in
Jerusalem. Mark travelled widely in the
Mediterranean and was with Peter in Rome.
He is thought to have founded the Church in
Alexandria where he was bishop. Legend has
him martyred by being dragged through the
streets of Alexandria. His remains were
removed from Alexandria in 829 to St Mark's
in Venice, whose patron he became. His
attribute is a winged lion.

Mars Mars, or Ares, the god of war, was one
of the three children of Jupiter and Juno. His
father's opinion of him is quoted in the *Iliad:*
'Of all the gods who live in Olympus, thou
art the most odious to me, for thou enjoyest
nothing but strife, war and battles.' Among

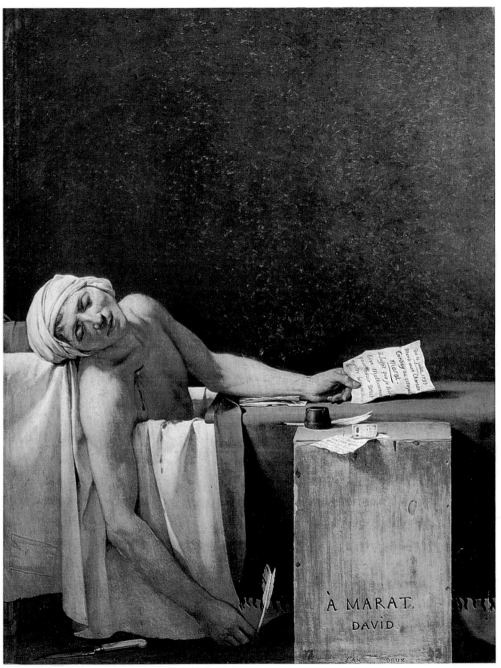

The death of Marat. Jacques-Louis David, 1748–1825

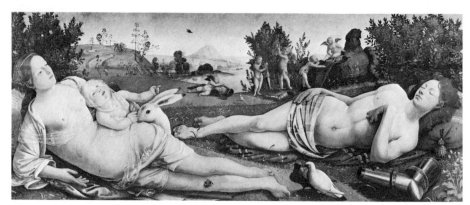

Venus and Mars. Piero di Cosimo,
c. 1462–1521(?)

the rational Greeks his bluster and strength
were often a cause of ridicule. A favourite
story tells how his ugly brother Vulcan sus-
pected him of carrying on an illicit affair with
his wife Venus. Vulcan made a fine net and
with it captured Mars and Venus fornicating.
He exhibited the captives to the gods of
Olympus, causing great laughter. The more
serious and war-minded Romans treated Mars
as one of their most revered gods.

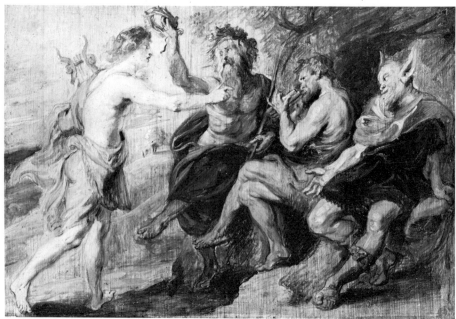

Apollo and Marsyas. Peter Paul Rubens, 1577–1640

Marsyas The tale of the satyr Marsyas is a superb illustration of hubris. Ovid in his *Metamorphoses* tells how Apollo accepted Marsyas' challenge to a contest on the reed pipes. Midas (*q.v.*) was one of the judges and awarded the victory to Marsyas. Apollo punished Midas by giving him ass's ears but reserved a special and terrible punishment for Marsyas. He hung him from a pine tree and flayed him while he was alive.

Martha and Mary Bethany sisters, referred to in John xi, whose brother Lazarus (*q.v.*) was raised from the dead by Christ. Tertullian and other early Church Fathers identify the Mary of Bethany with Mary Magdalene (*q.v.*), but this is not accepted by many Biblical scholars. In describing Christ's visit to the two sisters, Luke (x, 38–42) portrays Martha as a practical, industrious woman, and Mary as more easy-going. They became *exempla* of the active and contemplative life. See p. 160.

Martin, St A 4th-century son of a Roman soldier who came originally from what is now Hungary. He became Christian when his regiment was moved to Gaul. Here he performed his act of heroic charity by dividing his winter cloak into two and giving one half to a shivering beggar. After great missionary activities among the local heathens, he eventually became bishop of Tours. He is one of the earliest non-martyred saints. His sanctuary was sacked by the Protestants in 1562 as a politico-religious gesture. His attribute is a cloak. See p. 161.

Mary, see *Virgin Mary.*

Mary of Egypt, St A 4th-century prostitute from Alexandria who solicited business among the pilgrims *en route* to Jerusalem. Mystically prevented from entering a Jerusalem church, prayer to the Virgin Mary and a promise to give up her whore's life overcame the invisible obstruction and she became very devout. For many years she lived in the Syrian Desert as a female hermit and is reputed to have walked across the waters of the Jordan to take Holy Communion. She died in the desert and

St Mary of Egypt. Quentin Massys, 1464/65–1530

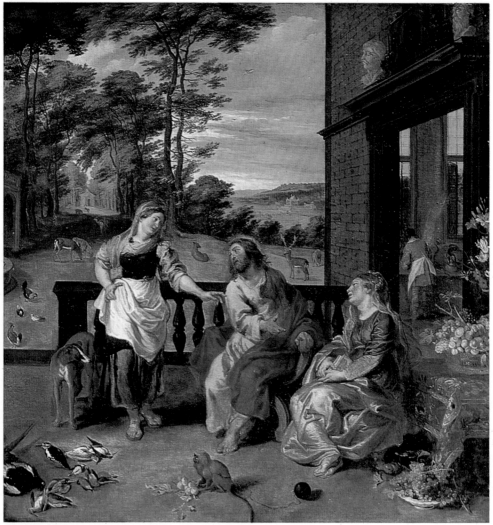

Christ in the House of Martha and Mary. Peter Paul Rubens, 1577–1640

*St Martin and the
Beggar. El Greco,
1541–1614*

Mary Magdalene. Titian, c. 1487/90–1576

The Calling of St Matthew (detail).
Marinus van Roymersvaele, 1497–1567

her grave was dug by a monk and a lion. Her attributes are three loaves of bread and she is sometimes shown in painting wearing nothing but long hair.

Mary Magdalene, St Her name probably came from that of her native town of Magdala near the west side of Lake Galilee. It is also suggested that the Hebrew name means 'adultress', and tradition has it that she was the repentant prostitute who anointed Jesus' feet (*cf. Christ in the House of Simon the Pharisee*). She is also reported by Luke as having had seven devils driven out of her. Referred to frequently in the Gospels, she was present at many critical events and places including the foot of the Cross, the Entombment (*q.v.*) and was first witness of the Resurrection (*cf. Noli me tangere*). She is said to have died in Ephesus where she lived with the Virgin Mary. French tradition claims that she proselytized in Marseilles and converted Provence. Her attribute is the ointment jar, used in the anointing of Christ's feet.

Massacre of the Innocents, see *Flight into Egypt.*

Matthew, St The Apostle and Evangelist-author of the first Gospel, he was originally a tax gatherer or publican of Capernaum. His other name was Levi, and Christ attended a feast in his house (see *Levi*). He was present at the Ascension (*q.v.*). His travels were wide and took him to Ethiopia, the south Caspian region, and to Persia. There is much ecclesiastical dispute as to whether he was martyred, and where. His attribute is a winged man, or angel. He is patron of bankers and tax collectors.

Maurice, St A legendary saint who was martyred at the end of the 3rd century. He and the Theban legion he commanded were sent on a mission to persecute Christians. On refusing to do this, the legion was twice decimated and then wiped out at Agaunum, now Saint-Maurice, in the Swiss Rhône Valley. He is usually shown as a soldier in armour, holding banner, lance, and sword. He is patron of infantry and is invoked against religious intolerance. See p. 164.

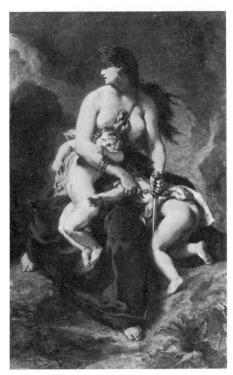

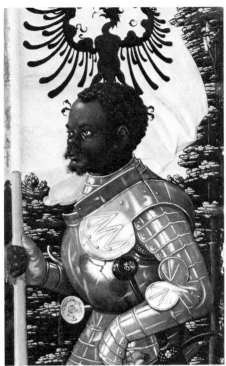

Medea The magician daughter of King Aeëtes of Colchis. After helping Jason (*q.v.*) to get the golden fleece, she fled with him, delaying her pursuing father by cutting up her brother and throwing pieces into the path of his ship. After a few years of marriage Jason abandoned Medea and their children to marry a Corinthian princess. As a friendly gesture Medea sent the new bride a present of a dress. When her unfortunate successor donned the garment, it burst into flames and killed her. Medea then slaughtered her children and left for Athens in a chariot drawn by winged dragons.

St Maurice (detail). Hans Baldung Grien, 1484/85–1545

(Left) Medea. Eugène Delacroix, 1798–1863

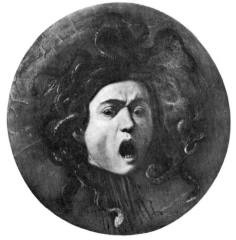

Medusa Medusa had once been a beautiful young girl but foolishly thought her hair was as beautiful as Minerva's. She was punished for her presumption by having her hair turned into hissing snakes. Her appearance was then so frightful that anyone looking at her was turned to stone. She was later killed by Perseus (*q.v.*).

Medusa. Caravaggio, 1573–1610

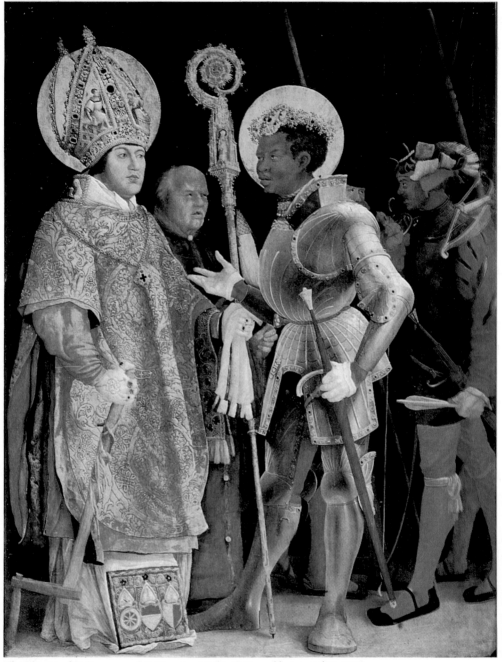

The Meeting of St Erasmus and St Maurice. Mathis Grünewald, c. 1470/80–1528

(Right) Mercury instructing Cupid before Venus. Antonio Correggio, c. 1494–1534

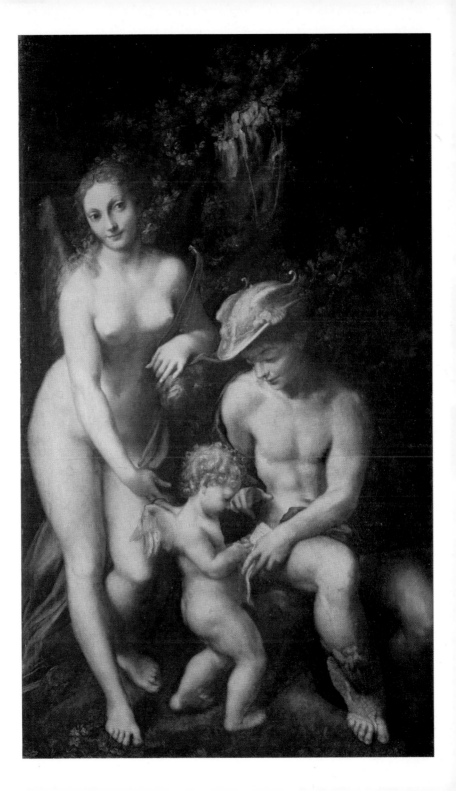

The Raft of the Medusa. Théodore Gericault,
1791–1824

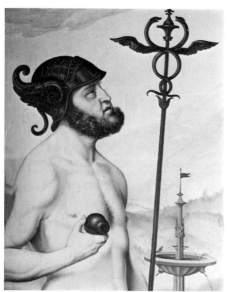

Mercury (detail). Hans Baldung Grien,
1484/85–1545

Medusa, Raft of the In 1816 a French
military transport frigate, the *Medusa*, sank
off the African coast. The officers escaped in a
lifeboat, leaving the crew on a raft which they
towed for several days until it broke loose.
Of the 150 men on the raft only fifteen were
alive when it was sighted about two weeks
later. Géricault chose for his subject the period
immediately before the rescue. To prepare his
painting he undertook fantastic naturalistic
research, including the reconstruction and
launching in the sea of a model of the raft, and
the study in hospitals of men dying. Reacting
against the official painters who glorified
Napoleon's squandering of human lives,
Géricault chose a subject which provided an
opportunity to use new techniques of realism
to depict the truth about anguish and pain.

Mercury Son of Jupiter and Maia, the Roman
god of commerce. He is identical with the
Greek god Hermes and was the special protec-
tor of thieves and burglars. He was also the
patron of any activity requiring skill and
manual dexterity. Messenger of the gods, in
addition he accompanied the souls of the dead
on their last journey. The fruit of his affair with
his half-sister Venus was Hermaphroditus who

developed into half-man, half-woman. The Cupid who appears with Mercury and Venus in Correggio's painting is not his child, but was Venus' son by Mars. See p. 165.

Mezzetin, see *Italian Comedians.*

Michael, St He is the Archangel-warrior in charge of the Heavenly Host which defeated Satan and his hordes. This is referred to in Revelations xii, 7: 'And there was war in heaven: Michael and his angels fought against the dragon.' In Hebrew his name means 'Who is like God?' He is the guardian angel of Israel. Among the early Christians he was the protector of the sick and he later became the protector of soldiers, and Christians in general. He has made many appearances in Western Europe. His attributes are a pair of scales – to weigh souls – and a sword, and he is invoked in battle and in peril at sea. See p. 168.

Midas Apollo punished Midas, King of Phrygia, for judging Marsyas (*q.v.*) his superior in music, by giving him ass's ears. A more generous gift from Bacchus (*q.v.*) was equally unfortunate. To repay the kindness of Midas in helping the drunken Silenus (*q.v.*) find his way back to his friends, Midas was granted his wish that whatever he touched, turned to gold. He had to beg Bacchus to take back his gift as even his food turned to gold. To rid himself of his gift, he had to wash in the river Pactolus whose sands in ancient times were said to be gold-bearing.

St Michael (detail). Domenico Ghirlandaio, 1449–1494

Midas and Bacchus (detail). Nicolas Poussin, 1594–1665

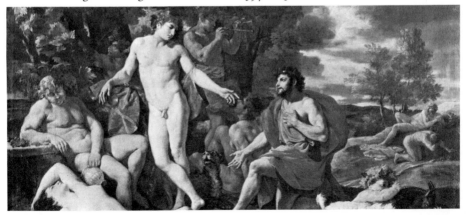

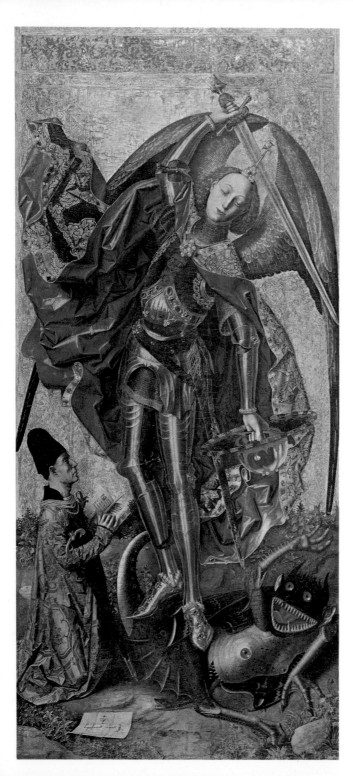

St Michael. Bartolomé Bermejo, active 1474–1495

Origin of the Milky Way (detail). Tintoretto, 1518–1594

Milky Way, Origin of The road taken by the gods to Jupiter's palace was called the Milky Way. A Byzantine legend provides one explanation of its origin. Jupiter, anxious that his son Hercules (*q.v.*) by the mortal Alcmene should get off to a good start in life by drinking goddess milk, hid the baby in Juno's bed. Awakened by the tugging at her nipple, Juno leapt up so that milk exploded into the sky, creating the Milky Way.

Minerva Minerva, the Roman equivalent of Athena, was the virgin goddess of wisdom, industry, household arts, and civilization in general. She was the protectress of many heroes such as Achilles (*q.v.*) and Ulysses (*q.v.*). Her birth was unusual even for a child of Jupiter. Jupiter swallowed her pregnant mother, Metis, because he feared that their child might carry on the family tradition and supplant him as he had supplanted his own cannibalistic father, Saturn (*q.v.*). Jupiter's subsequent headache was treated drastically by Vulcan, who split open his skull. Minerva sprang fully armed from the cleft.

Minerva (detail). Tintoretto, 1518–1594

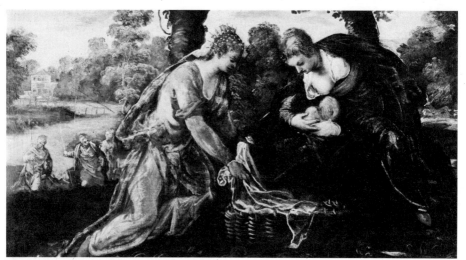

The Finding of Moses. Tintoretto, 1518–1594

*Moses and the burning bush. Domenico Feti,
1589–1624*

Miraculous Draught of Fishes, see *Galilee,
Christ at the Sea of.*

Moses The sources for the principal events in
the life of Moses, the greatest Jewish lawgiver,
who led the Israelites out of Egypt into the
promised land, are in Exodus, Numbers, and
Deuteronomy.

Finding of Moses He was born in Egypt,
somewhere between the 15th and 13th cen-
turies BC, at a time when Pharaoh feared the
power of the Israelites. His mother saved him
from an Egyptian massacre of Hebrew first-
born by putting him in a wicker basket and
floating him on to the Nile. One of Pharaoh's
fifty-nine daughters found the child and com-
passionately adopted him. Brought up as an
Egyptian, he never forgot his Hebrew origin.
In his hot-tempered youth he killed an
Egyptian ill-treating Israelite workers and fled
to the land of Midian where he married
Zipporah, one of Jethro's daughters (*q.v.*).

Moses and the Burning Bush Exodus iii,
2 records that while working for Jethro as a
herdsman 'the angel of the Lord appeared unto
him in a flame of fire out of the midst of a
bush: and he looked, and, behold, the bush
burned with fire, and the bush was not con-
sumed.' Jehovah then told him to bring the
children of Israel out of Egypt 'unto a land
flowing with milk and honey'.

Moses before Pharaoh Pharaoh's re-
fusal to let the Hebrews leave Egypt was over-
come by a series of natural and unnatural
disasters such as water turning to blood, and
plagues of frogs, lice, flies, boils, fiery hail, and
locusts. The final persuader was a lethal plague
which slew all Egyptian first-born but passed
over the Hebrews. Pharaoh finally concluded
that Egypt would be safer without the
Hebrews.

**Departure of the Israelites, and pas-
sage of the Red Sea** Pharaoh's heart hard-
ened when he considered the economic conse-
quences of the Hebrew departure – *Exodus* xii,
37, with perhaps some exaggeration, suggests
a departing multitude of about two million
people with livestock. The Egyptian army set
out in pursuit and caught up with the Israelites

*Moses and Aaron before Pharaoh.
Félix Chrétien, c. 1500/10–1579*

Crossing of the Red Sea (detail). Cosimo Rosselli, 1439–1507

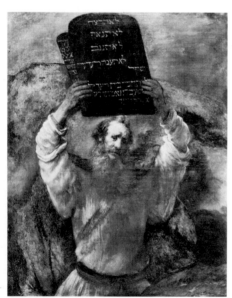

Moses with the Ten Commandments.
Rembrandt van Ryn, 1606–1669

at the Red Sea. With Jehovah's help, Moses parted the waters and the Hebrews passed to the other side on dry land. As for the pursuing Egyptians, Exodus xiv, 28 relates that 'the waters returned, and covered the chariots, and the horsemen, and all the host of Pharaoh that came into the sea after them: there remained not so much as one of them.'

The forty years wandering of the Israelites During their desert years Jehovah provided the Israelites with quails, or part-ridges, and *Manna (q.v.)*. Drinking-water was provided by Moses' striking springs from rocks. His religious and social indoctrination of the Israelites – a system of beliefs and practices known as the Mosaic Law – reached its climax when he ascended Mt Sinai and Jehovah gave him two tablets of stone on which were inscribed the Ten Command-ments. On his descent with the stone tablets he found his people dancing around the Golden Calf *(q.v.)*. In his anger he broke the stone tablets, burnt the idol, and slaughtered three thousand Hebrews to restore discipline. Later, to keep the lesson fresh, brazen serpents destroyed other backsliders.

The Promised Land Not permitted to enter the Promised Land because his faith in Jehovah had not been total, he was given a distant view of it from Mt Pisgah and shortly thereafter died at the age of 120. Paintings of subjects from the life of Moses occur frequently from the end of the 15th to the end of the 17th centuries.

Muses The nine Muses formed part of the retinue of Apollo and inhabited Parnassus. Their names and fields of competence were: Clio (History), Euterpe (Music or Lyric Poetry), Thalia (Comedy), Melpomene (Tragedy), Terpsichore (Dancing), Erato (Lyric and Love Poetry), Polyhymnia (Hymns and Mimic art), Urania (Astronomy), and Calliope (Epic Poetry). They often appear in painting with their attributes. Thus Thalia carries a mask, Polyhymnia sucks a finger, and Calliope holds a stylus and tablet.

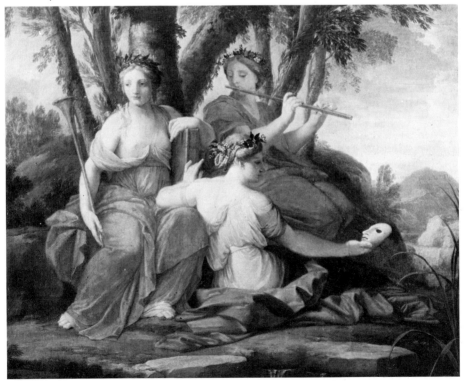

The Muses Clio, Euterpe and Thalia (detail). Eustache Le Sueur, 1617–1655

N

Narcissus Narcissus brought grief to many men and women (*cf.* Echo) by coldly spurning their advances. Finally his vanity was his own undoing. The gods answered the prayers of a thwarted nymph – some say a male suitor – and they condemned Narcissus to know the pains of unreciprocated love. He fell in love with his own reflection in a mountain pool and the lack of response drove him to suicide. From his blood sprang the plant narcissus. Its active chemical principle gives us our word *narc*otic.

Nathan Admonishing David, see *Bathsheba.*

Nativity, see *Adoration of the Shepherds.*

Narcissus. Follower of Giovanni Antonio Boltraffio, c. 1466/67–1516

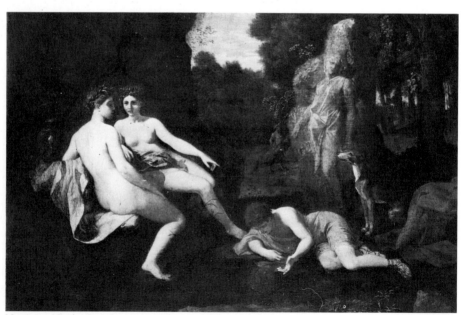

Narcissus. Nicolas Poussin, 1594–1665

Nausicaa Homer relates the last adventure of Ulysses before he finally reached his home in Ithaca. Nausicaa, a princess of Scheria – possibly Corfu – was helping her attendants with the family laundry when she discovered the naked Ulysses, freshly cast up from the sea after his disastrous eight-year misadventure with Calypso. Her father, the king, offered Ulysses the hospitality of his kingdom, a sort of early but charming Utopia. After he recuperated, Nausicaa's friendly people heaped him with presents and took him to his home in nearby Ithaca. Apollodorus, Samuel Butler, and Robert Graves consider that the *Odyssey* was written by a woman and that Nausicaa is a self-portrait of the authoress.

Neptune Neptune – Poseidon in Greek mythology – was swallowed at birth by his father Cronus. His younger brother, Jupiter, rescued him by inducing in Cronus a vomiting fit. On the death of Cronus he became god of

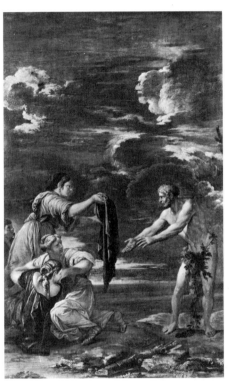

Odysseus and Nausicaa. Salvator Rosa, 1615–1673

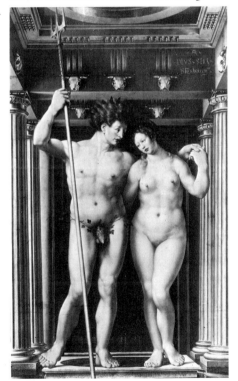

Neptune and Amphitrite. Mabuse (Jan Gossaert), active 1503, died c. 1533

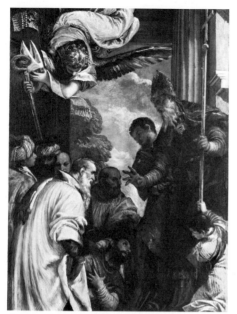

Consecration of St Nicholas (detail).
Paolo Veronese, c. 1528–1588

the sea and water. He married a Nereid named Amphitrite (*q.v.*). By another union, and they were numerous, he was the father of Polyphemus (*q.v.*) and of the winged horse Pegasus. Among the Romans he was the patron of the race-course. In art he is almost invariably portrayed holding a trident.

Nessus, see *Hercules, Labours of.*

Nicholas, St (of Myra or Bari) Little is known about this 4th-century saint from Asia Minor who was imprisoned during the Diocletian persecutions. He performed several charitable acts, such as secretly supplying three bags of gold as a dowry for three girls who would otherwise be reduced to prostitution, restoring to life three boys killed by a wicked butcher, and saving a ship from shipwreck. He was bishop of Myra where he died. His remains were stolen by Italian merchants in 1087 and brought to Bari where from time to time they exude an oily substance supposed to have medicinal value. A great web of legend grew up round his name. He is the saint who

The Charity of St Nicholas. Pietro Candido, c. 1548–1628

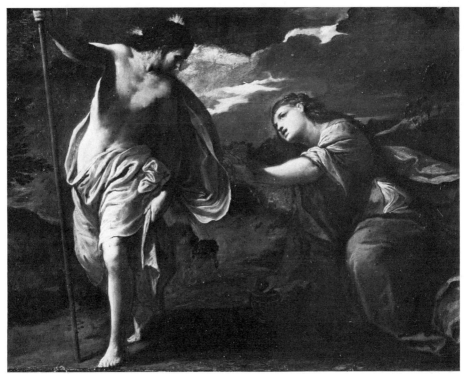

Noli me tangere. Lo Scarsellino, 1551–1620

in German-speaking Switzerland, the Nether-
lands, and Germany brings presents to children
on 6 December. In other countries he has been
identified with Santa Claus. He is understand-
ably patron of children, but also of travellers,
bankers, merchants, and pawnbrokers. His
attributes include the three balls used as a
pawnbroker's sign, which are thought to stand
for the three bags of gold.

Noah, see *Flood.*

Noli me tangere The phrase is Latin for *do
not touch me* and according to John xx, 17 was
uttered by Jesus in the garden to Mary Magda-
lene (*q.v.*), the first person to whom he
appeared after the Resurrection (*q.v.*). The
phrase is meant to signify that from hence-
forth the relation between humans and the
Son of God would be spiritual and not
physical.

*Noli me tangere. Antonio Correggio,
c. 1494–1534*

O

Odalisque The French corruption of a Turkish word for a female slave or concubine in the seraglio of the Sultan of Turkey. The word seems first to have come into use in the late 17th century. Byron in *Don Juan* (6, xxix) gave publicity to the term and the occupation. The subject had a particular attraction for French painters (Delacroix, Ingres, Renoir, Matisse) during the period of expanding French colonialism in North Africa.

Oedipus and the Sphinx The Delphic oracle told Laius, King of Thebes, that his son would kill him and marry his mother, Jocasta (Laius's wife). Accordingly he abandoned his son Oedipus at birth. Shepherds saved the child and gave it to King Polybus of Corinth who adopted it. Years later, concerned about his origin, Oedipus consulted the Delphic oracle who repeated the dire prediction. Fearing that he would kill his presumptive father, Polybus,

Odalisque. Pierre-Auguste Renoir, 1841–1919

he hastily left Corinth. On the road he met a stranger who disputed his right of way, and in the ensuing quarrel he killed him. Unknowingly he had killed Laius, his true father. Travelling on, he encountered near Thebes a monster called the Sphinx, half-lion and half-woman, who killed passers-by unable to answer her riddle. When Oedipus answered correctly, the Sphinx committed suicide. The grateful Thebans made Oedipus king and he married Jocasta, his mother. After Thebes was devastated by plague, Oedipus was commanded by Apollo to find the murderer of Laius, and discovered the truth. His mother hanged herself and Oedipus tore out his eyes. He wandered off, cared for by his devoted daughter, Antigone.

Omphale, see *Hercules.*

Original Sin, see *Adam and Eve, Temptation and Fall.*

Orion A giant, the joint son of Jupiter, Neptune and Mercury, maliciously blinded by Oenopion, King of Chios, whose daughter he was wooing. He recovered his eyesight by gazing at the sunrise, to which he was led by placing a man on his shoulders to direct him. His later career included many notable exploits, and after his death he was turned into a constellation.

Oedipus and the Sphinx. Gustave Moreau, 1826–1898

Orpheus Orpheus, a Thracian son of the muse Calliope and perhaps Apollo, was the most interesting and civilized of all the Greek heroes. He mastered the lyre and sang to such perfection that according to Ovid's *Metamorphoses* he could charm wild animals, trees, and even rocks. When he accompanied Jason (*q.v.*) and the Argonauts, his music enabled them to pass the dangers of the Sirens and charm the dragon guarding the golden fleece. His wife Eurydice, escaping from a would-be seducer, trod on a snake, was bitten and died. Orpheus descended to Hades and with his music charmed Queen Proserpina into letting Eurydice return to earth provided he did not look back at her on the journey. Approaching the light he could not resist looking to see if she followed. She immediately became a shadow and returned

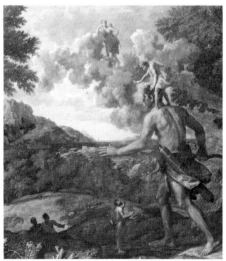

Blind Orion searching for the Rising Sun (detail). Nicolas Poussin, 1594–1665

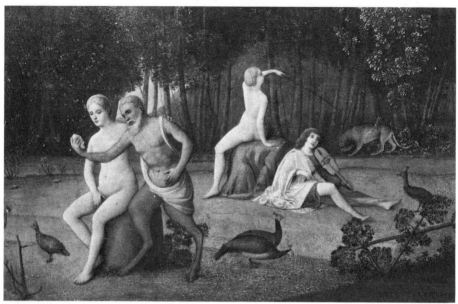

Orpheus (detail). Giovanni Bellini, c. 1430–1516

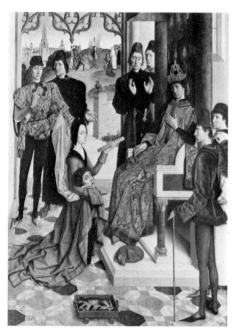

Judgment of the Emperor Othon (detail). Dieric Bouts, c. 1415–1475

to Hades for ever. According to Ovid, Orpheus met his end by being torn to pieces by Maenads because he scorned their advances. A mystic Orphic cult developed in 6th-century Greece and spread to southern Italy where it influenced the Pythagoreans. It was one of those semi-religious and philosophical cults of the eastern Mediterranean which provided such a receptive atmosphere for the spread of Christianity. The hero figure of the cult was killed violently and then resurrected. Participation in the mysteries was said to save sinners from punishment after death. Orpheus and his cult fascinated Renaissance intellectuals.

Othon (Otto), Judgment of the Emperor
The legend of the Judgment of the Emperor Othon attracted northern European painters of the 15th century seeking a subject connected with Justice. It is said the Empress had accused a respected citizen of rape when he rejected her advances. The Emperor had him decapitated. The incensed widow took extreme measures to prove his innocence. She held his head in one hand and a red-hot brand

in the other. His innocence insulated her from being burnt. The guilty Empress had no such protection when the Emperor ordered her to be burned at the stake.

Ovid among the Scythians Publius Ovidius Naso (43 BC–*c*. AD 17) was a fashionable highly gifted poet and man-about-town at the beginning of the Roman Empire. Author of elegant erotic poetry (*The Art of Love*), he also produced works of enormous value to scholars from the Renaissance onwards because of their wealth of information on Greek and Roman life and thought. These were the *Fasti*, or calendar of Roman festivals, and the *Metamorphoses*, or Greek myths. Banished suddenly, and without stated reason – probably a scandal concerning a grand-daughter of Augustus – he spent his last nine years in exile at Tomi, near present-day Constanza on the Rumanian Black Sea coast. The Romantics saw Ovid's exile as a poignant early example of the antagonism between poetry and society as it exists.

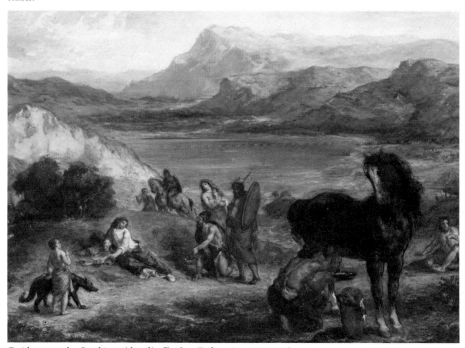

Ovid among the Scythians (detail). Eugène Delacroix, 1798–1863

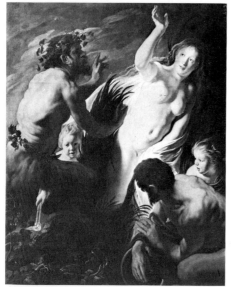

Pan and Syrinx. Jacob Jordaens, 1593–1678

P

Pan The parentage of Pan is not clear. From the representations of him with the horns, beard, legs and connected equipment of a goat there might be truth in the legend that he was sired on a country-girl by Mercury disguised as a goat, or that Mercury, undisguised, sired him on the goat, Amalthea, wet-nurse of Jupiter. He was a phallic, fertility deity and protected livestock and shepherds, although he was not above frightening them (hence the word *panic*). He lived in Arcadia and not on Olympus with the other gods. Pan's attempt to rape the nymph Syrinx was foiled by a river

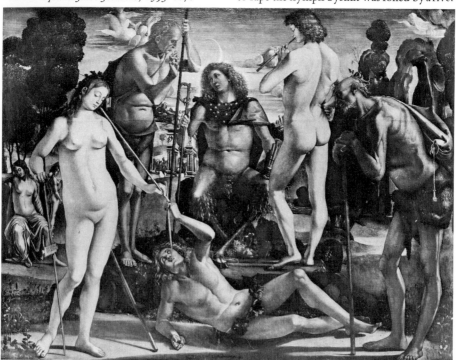

Pan. Luca Signorelli, c. 1441/50–1523

Paradise Garden (Hortus Conclusus). Anon c. 1415

god changing her into reeds. From the reeds
Pan made the Syrinx or Pan-pipes.

Paradise The word comes to us from the
Persian, via the Greek and the Hebrew. The
Greek translation of Garden of Eden (*q.v.*) in
Genesis ii, was *paradeisos*. This comes from the
Hebrew or Aramaic *pardes* which in turn
came from the Old Persian *pairidaeza*. It
originally signified an enclosed park or
pleasure garden. Most painters held to this
garden idea and portrayed a landscape of great
physical beauty as a dwelling place for the
righteous, where they enjoy peace and com-
plete freedom from all earthly cares. But as a
subject the whole idea seemed less visually
stimulating to Renaissance and pre-Renais-
sance painters than Hell.

Paradise (detail). Benozzo Gozzoli,
c. 1421–1497

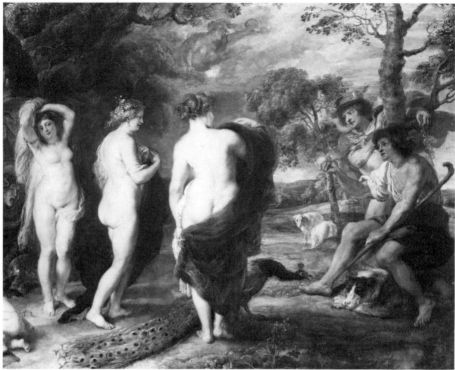

Judgment of Paris (detail). Peter Paul Rubens, 1577–1640

Judgment of Paris (detail).
Niklaus Manuel Deutsch, c. 1484–1531

Paris, Judgment of Paris was the youngest of the fifty sons of Priam, King of Troy, the city whose destruction he eventually caused. It came about as follows. The uninvited guest, at an Olympian wedding, Eris or Discord, threw into the assembly a golden apple inscribed 'For the Fairest'. It was claimed by Juno (*q.v.*), Minerva (*q.v.*), and Venus (*q.v.*). Jupiter did the sensible thing and left the decision to the mortal, Paris. The decision was foregone. The bribes offered by Juno and Minerva were as nothing to Venus' offer of Helen, the most beautiful woman in the world. The subsequent seduction of Helen from her husband Menelaus, King of Sparta, started the

Trojan War and ended with the total destruction of Troy and Paris' own death.

Parnassus A chain of mountains in Phocis, north of the gulf of Corinth in central Greece. The oracle of Delphi was situated on the southern side of the mountain peak, which was over eight thousand feet high. The whole area was sacred to Apollo and was the residence of the Muses (*q.v.*). Poets and musicians came there for inspiration.

Passion The episodes which took place between Christ's entry into Jerusalem and his Entombment are called the Passion. See *Christ*. There are an enormous number of symbols of the Passion, the commonest appearing in painting being the following: *Anemone*, the red spots on the petals standing for blood; the *Cock*, because of Peter's denial of Christ three times before it crowed; the *Carbuncle* because of its blood red colour; *Coins* because of their connection with Judas's betrayal; *Dice* because they were used to gamble for Christ's coat; the *Dandelion* because of its bitter taste; an *Ear* because Peter cut one off during the arrest of Christ; *Chains* which were used to bind Christ during the Flagellation; the *Goldfinch* which was reputed to eat *Thistles* and *Thorns* from which Christ's *Crown* was made; a *Hand* to represent the slapping of Christ's face; the *Lance* or *Spear* which was used to pierce Christ's side; *Nails*, used to pin Christ to the Cross; a *Pillar*, to which Christ was fettered when scourged; a *Poppy* because of its blood red colour; Christ's seamless *Robe*, gambled for by the soldiers at the Crucifixion; a *Scourge* used for Christ's flagellation; *Pliers* used to withdraw the nails; a *Sponge* which was dipped in vinegar and offered to Christ on the Cross; a *Torch* used to light the way of the Temple police coming to arrest Christ; and a *Towel*, used by Pilate to dry his hands.

Paul, St Born in Tarsus of a prosperous Jewish family, in what is now southern Turkey. By profession he was a tentmaker. Probably a Pharisee, his conversion to Christianity came when he was *en route* to Damascus to persecute the Christians there.

Parnassus. Andrea Mantegna, c. 1430/31–1506

*Conversion of St Paul. Niccolo dell'Abbate,
c. 1509–1571*

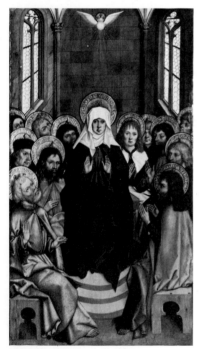

*Pentecost. Bartolomé Zeitblom,
1455/60–1518/22*

He was temporarily blinded by a great flash of light, and a voice asked: 'Why persecutest thou me?' He then became an active missionary, travelling widely in the Mediterranean. A powerful figure, he dominates the *Acts of the Apostles*. His *Epistles* had a fundamental influence on the development of Christianity. He was arrested in Jerusalem for causing a riot, and, being a Roman citizen, after a time was sent to Rome for trial. On the way he was shipwrecked in Malta, where he miraculously escaped being bitten by a poisonous snake. He was acquitted in Rome but was later martyred in the time of Nero at the place now known as *Tre Fontane*. In painting, his headless torso is sometimes shown spouting three streams of blood. His attributes are a book, a sword for his martyrdom, and a viper being thrown into a fire.

Pentecost A Jewish festival (*The Feast of Weeks*), held fifty days after the Passover, was taken over by the Christians and given a totally different significance. On that day the Apostles had come together and as Acts ii, 2–4 reports, 'suddenly there came a sound from heaven as of a rushing mighty wind, and it filled all the house where they were sitting. And there appeared unto them cloven tongues like as of fire, and it sat upon each of them. And they were all filled with the Holy Ghost, and began to speak with other tongues, as the Spirit gave them utterance.' The Apostles were just on the point of starting their great proselytizing activity. In some countries as part of the celebration of this festival, rose petals used to be dropped on the congregation from the ceilings of churches as a symbol of the descent of the Holy Ghost.

Persephone, see *Proserpina.*

Perseus That Perseus had the archetypal life of a hero is not surprising. His father and grandfather seven times removed were the same person, Jupiter. His mother Danaë (*q.v.*) was fertilized by Jupiter raining gold on her. His foster-father planned to seduce Danaë and sent Perseus to fetch the snake-infested head of the Medusa (*q.v.*). Perseus forced the horrible Graeae sisters to reveal the home of the

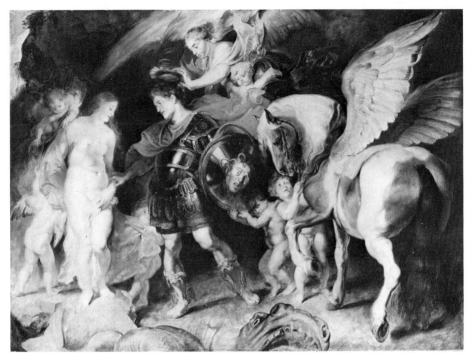

Perseus and Andromeda. Peter Paul Rubens, 1577–1640

Medusa by withholding from them the single eye and tooth they shared. With the help of Mercury and Minerva he safely engaged the Medusa and cut off her head which he then presented to his foster-father, petrifying him and saving his mother's honour. On that return journey he found that Neptune had sent a sea-monster to terrorize Ethiopia. When Perseus arrived, the king's daughter Andromeda had been chained up to a rock as a sacrifice to assuage the monster's appetite. Perseus slew the monster and married Andromeda.

Peter, St The senior of the Apostles, also called Simon, came from a humble family of Bethsaida on the Sea of Galilee where he worked as a fisherman. He was married. Christ early recognized his strength by calling him Peter, the Aramaic, Greek and Latin equivalents of which all mean 'rock'. He and his brother Andrew (*q.v.*) left their profession when Christ said, 'Follow me, and I will make you fishers of men.' Peter was the leader of

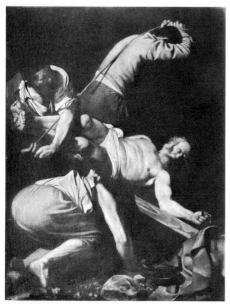

Martyrdom of St Peter. Caravaggio, 1573–1610

the Apostles, or closest disciples, from the earliest days. He appears at the most important happenings: the raising of Jairus' daughter, the Transfiguration (*q.v.*), the Agony in the Garden (*q.v.*), and he caught the fish with the coin in its mouth, needed to pay the tribute (*q.v.*). His premier position was signalled by Christ's statement, quoted by Matthew xvi, 18 and 19 '. . . thou art Peter [rock], and upon this rock I will build my church: and the gates of hell shall not prevail against it. And I will give unto thee the keys of the kingdom of heaven: and whatsoever thou shalt bind on earth, shall be bound in heaven: and whatsoever thou shalt loose on earth shall be loosed in heaven.' This is the basis for the primacy among Roman Catholics of the Bishop of Rome, the Pope. The claim is not accepted by most other churches. Peter's irresolute character was revealed during Christ's Passion (*q.v.*). First he drew a sword and cut off the ear of one of the arresting party. Later in the night, he denied three times that he knew Christ. During his imprisonment by Herod Agrippa

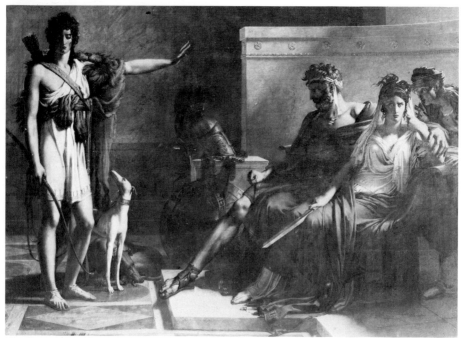

Phaedra and Hippolytus. Pierre-Narcisse Guerin, 1774–1833

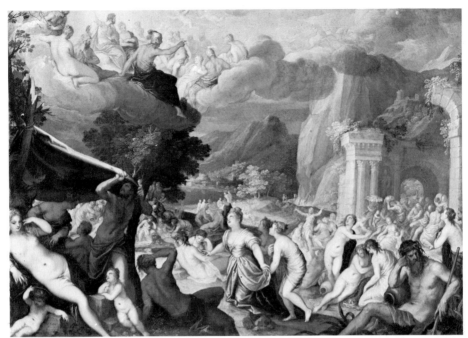

Fall of Phaeton. Hans Rottenhammer, 1564–1625 (Phaeton in the clouds upper right)

he was released by an angel. He went to Rome and was martyred during the time of Nero. It is said that he specifically requested to be crucified upside down. His execution is supposed to have taken place where St Peter's now stands. His main attribute is two keys.

Phaedra and Hippolytus The disastrous marriage of Theseus (*q.v.*) to Ariadne (*q.v.*) was followed by his equally disastrous marriage to Phaedra, whom the Athenian hero had met in Crete. Phaedra fell in love with Hippolytus, Theseus' son by an even earlier marriage, but the youth rejected her unseemly advances. The enraged Phaedra told Theseus that Hippolytus had tried to seduce her. Theseus sought the help of Neptune to punish the lad. One of Neptune's sea monsters caused Hippolytus' chariot horses to bolt, dragging the young man to his death. Phaedra hanged herself.

Phaeton This son of Helius, or Phoebus, the sun god, borrowed his father's sun chariot to impress his friends. He was unable to control the horses and the runaway sun chariot nearly

Philemon and Baucis (detail).
Rembrandt van Ryn, 1606–1669

Gathering of the ashes of Phocion (detail).
Nicolas Poussin, 1594–1665

scorched up the earth. The earth was saved by Jupiter destroying Phaeton with a thunderbolt. According to legend Phaeton's bolting sun chariot came so close to Africa that the heat created the Sahara Desert and darkened the natives.

Philemon and Baucis Ovid in his *Metamorphoses* tells the exemplary tale of Philemon and Baucis, a simple peasant couple who offered hospitality beyond their humble means to Jupiter and Mercury travelling incognito. The gods rewarded them, first by making their wine-jug ever-replenishing, and then by saving either from the sadness of the other's death by having them metamorphose in extreme old age into an elm and an oak, growing side by side.

Phocion, Funeral of The followers of Stoic philosophy held up as a model of virtue the life and death of Phocion, an Athenian general of the 4th century BC. His stern character, his high principles, and his rejection of every honour made him unpopular with many elements in the democratic assembly in Athens. They eventually got him convicted on a false charge of treason for which he was executed. Burial not being permitted in Athens, his widow had him cremated in Megara and brought the ashes back quietly to Athens to await an official burial when the political climate changed.

Pietà The second last episode in the Passion (*q.v.*) is known as the *Pietà*. Often the scene is a Lamentation (*q.v.*) over the dead Christ by the Virgin Mary, Mary Magdalene, and others. It took place between the Deposition (*q.v.*) and the Entombment (*q.v.*). The characteristic *Pietà* shows the dead Christ lying across the lap of the weeping Virgin Mary, who may be surrounded by mourners, including incongruously the wealthy donors (*q.v.*) or patrons who commissioned the painting. See p. 205.

Polyphemus Polyphemus, the Cyclops, was a son of Neptune (*q.v.*) and a nymph. His odd appearance – he had but one eye set in the middle of his forehead – and his partiality for human flesh, made him quite unattractive. This had blighted his courting of Galatea (*q.v.*). He lived in a cave near Etna with a great herd of sheep. On his travels Ulysses sought his help but Polyphemus responded by eating several of his men and imprisoning the rest in his cave. Ulysses made him drunk and destroyed his eye with a red-hot pole. He and his men escaped from the cave, hanging to the underside of Polyphemus' sheep. Neptune punished Ulysses with storms for the rest of his travels.

Pietà. Ercole Roberti, c. 1448/55–1496

Ulysses deriding Polyphemus (detail). J. M. W. Turner, 1775–1851

Pilate washing his hands (detail). Dirck Baegert, active 1476–1515

Pontius Pilate Luke iii, 1 records that Pontius Pilate was the Roman Procurator of Judea in the fifteenth year of the reign of the Emperor Tiberius. He served about ten years in Judaea. A competent bureaucrat wishing to avoid unnecessary trouble he bowed to the will of local power and delivered Christ in whom he had found no fault to crucifixion. He 'washed his hands before the multitude, saying, I am innocent of the blood of this just person'. (Matthew xxvii, 24.) According to legend he committed suicide or became a Christian and was martyred by Tiberius (unlikely as that Emperor predeceased him) or by Nero. Another legend has it that he lived and died in retirement in the quiet Rhône town of Vienne where a pyramid supposedly erected over his tomb is still to be seen.

Poseidon, see *Neptune*.

Presentation in the Temple, see *Christ, Presentation in the Temple*.

(Below) Primavera. Sandro Botticelli, c. 1445–1510

Death of Procris. Piero di Cosimo, c. 1462–1515

Primavera The Renaissance courtier-philo-
sopher-poets in the Medici entourage were
fascinated by classic mythology and even more
by the interpretations of ancient Neo-Platonist
philosophers. The scene portrayed in Botti-
celli's famous *Primavera* is clear enough.
Visible in the painting are Zephyr, the nymph
Chloris, the Three Graces (*q.v.*), flower-clad
Primavera, Cupid, Mercury, and Venus as a
sort of mother figure. But the significance of
the subject-matter of the painting is less clear
and is much disputed by scholars. It seems now
to be accepted that the painting's literary
inspiration came from Apuleius, and from
Marsilio Ficino, the leading Platonist of the
Medici circle who spent much time trying to
reconcile Neo-Platonism and Christianity.
The central figure of the allegory – Venus
Genatrix – is possibly part of the philosophical
attempt to reconcile a particular aspect of the
Greek Aphrodite or Venus (*q.v.*) as mother
symbol with the Christian concept of the
Virgin Mary.

Procris, Death of Procris, a daughter of the
King of Athens, married Cephalus, a son of
Mercury. Aurora (*q.v.*) failed in her attempted
seduction of Cephalus but left behind a legacy
of mistrust. The return of Cephalus to Procris
had been hastened by her gift to him of a
marvellous hunting dog called Lelaps, and a
javelin which always found its mark. The
jealous Procris spied on Cephalus when he
hunted. One day he threw his unerring javelin
at what he thought was an animal in a thicket.
He accidentally killed the watching Procris.

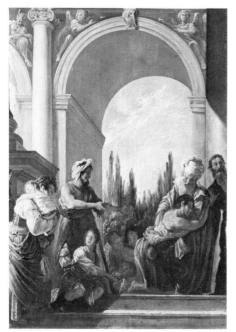

Return of the Prodigal Son. Domenico Feti,
1589–1624

Prodigal Son Luke xv, 11–32 relates the parable of the prodigal son. The younger of two sons asked for and received from his father his share of the estate. In a far country he quickly used up his patrimony in wild living. After suffering hard times the wastrel returned home, telling his father, 'I have sinned against heaven, and in thy sight, and am no more worthy to be called thy son.' But his father was so pleased to have him back, he ordered the fatted calf to be killed for a great welcome-home feast. The hard-working, serious elder brother, angry at the unfairness of it all, refused to join in the festivities. But the father comforted him, saying, 'It was meet that we should make merry, and be glad: for this thy brother was dead, and is alive again: and was lost, and is found.'

Prometheus Prometheus, one of the Titans defeated in the power struggle with Jupiter, was a brilliant inventor. He created the first man from clay and water and, to make his life bearable, stole fire for him from heaven. Jupiter, fearful that his power would also be threatened by the development of men, tried to wipe them out with a great flood. He then hit on the more effective device of creating a

Prometheus creating Man. Piero di Cosimo, c. 1462–1515

Rape of Proserpina (detail). Niccolo dell'Abbate, c. 1509–1571

beautiful woman, Pandora, and setting her loose among men with her magic box which when opened unleashed every affliction known to mankind. Jupiter punished Prometheus by chaining him to a rock in the Caucasus and sending each day an eagle to eat his immortal liver.

Proserpina Demeter, goddess of agriculture and her half-brother Jupiter were the parents of Proserpina. The beautiful young girl attracted the attentions of her uncle Pluto, or Hades, god of the Underworld. Pluto abducted her and made her his queen. This so upset Demeter that she lost all interest in life, neglected her divine duties so that nature became sterile and no crops grew. To bring this to an end, Jupiter sent Mercury to retrieve Proserpina. Pluto agreed to relinquish Proserpina but as a parting gift gave her a magic pomegranate which brought her back to him for three winter months. In Christian liturgical art an open pomegranate revealing its seeds is a symbol of the Resurrection (*q.v.*).

Psyche and Amor, see *Cupid.*

Purification, see *Virgin Mary.*

Pygmalion, see *Galatea.*

Pyramus and Thisbe The tale of the un-
happy lovers, Pyramus and Thisbe, comes to
us from Ovid's *Metamorphoses.* Their parents
who lived in Babylon were hostile to their
love. Through a crack in the wall of their
neighbouring houses, the children plotted a
midnight meeting. In getting to the rendez-
vous Thisbe, escaping from a lion, dropped
her scarf. Pyramus discovered the scarf, torn
and bloodied by the lion, and assumed Thisbe
had been killed. He thereupon stabbed him-
self to death. Thisbe then discovered the dead
Pyramus and killed herself with his sword.

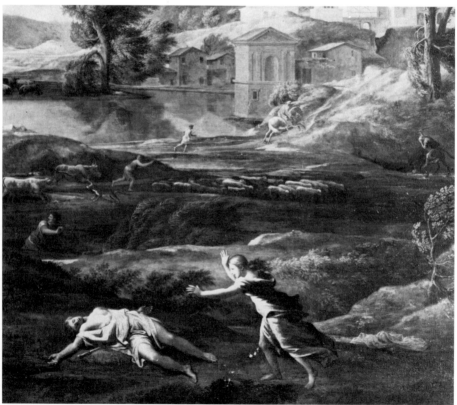

Thisbe finding the body of Pyramus (detail). Nicolas Poussin, 1594–1665

R

Rebecca, see *Isaac.*

Resurrection Christ's Resurrection – his rising from the dead – is mentioned in all four Gospels, and in the Epistles of St Paul. Matthew xxviii, 2–6 describes the events, when early on Easter Sunday morning the two Marys came to the sepulchre: 'And, behold, there was a great earthquake: for the angel of the Lord descended from heaven, and came and rolled back the stone from the door, and sat upon it. His countenance was like lightning, and his raiment white as snow. And for

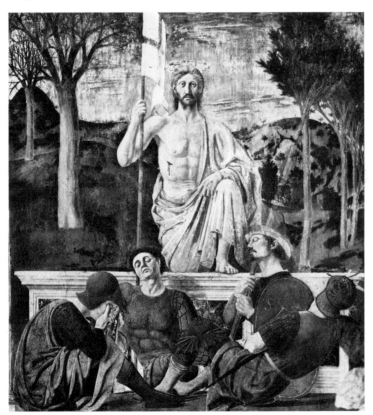

Resurrection. Piero della Francesca, 1410/20–1492

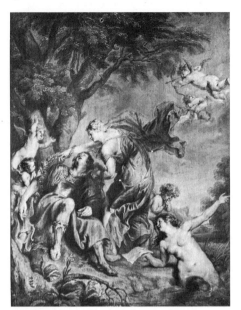

Rinaldo and Armida. Anthony van Dyck,
1599–1641

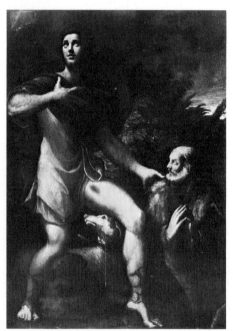

St Roch. Parmigianino, 1503–1540

fear of him the keepers did shake, and became as dead men. And the angel answered and said unto the women, Fear not ye: for I know that ye seek Jesus, which was crucified. He is not here: for he is risen' This Resurrection is the fundamental doctrine of Christianity and is incorporated into the various Creeds. The image often used by artists of Christ rising out of the tomb as a gravity-free body is not in the Biblical text.

Rinaldo One of the heroes of Tasso's romantic epic *Jerusalem Delivered*, which deals with the First Crusade, Rinaldo is a combination of Aeneas and Achilles (*q.v.*). He emerges as a vague ancestor of Tasso's employers, the Este Dukes of Ferrara. The only parts of the poem which come to life are the love affairs between the Christian heroes and the pagan women, Clorinda, Erminia, and Armida. The latter – a late-Renaissance version of Dido – entices Rinaldo by her magic and holds up the capture of Jerusalem. The adventures of the couple provided exotic subjects for painters.

Roch, St The 14th-century French saint of Montpellier was born with a cross-shaped birthmark on his left shoulder. As a young man this influenced him to take up the spiritual life. On a pilgrimage to Rome he arrived in an Italian town stricken by the plague. He tended the victims of this lethal disease and was later stricken by it himself. During his illness only his faithful dog looked after him, bringing him a daily loaf of bread. On returning home, he was unrecognizable because of the plague's ravages, and was imprisoned as an impostor. He died in prison and a miraculous tablet was found in his cell testifying that prayers for Roch's intercession would protect against the plague. Italian merchants stole his remains and brought them to Venice where they lie in San Rocco. His attributes are a dog, and the physical manifestations of the plague. He appears in paintings exposing his groin with its buboes – characteristic lymphatic swellings – or pointing to a purpuric spot on his leg. He seems to have suffered from both the bubonic and septicaemic types of the disease. St Roch's name is invoked against infectious diseases.

S

Sabine Women, Rape of The painters'
source for the story of the Rape of the Sabine
Women was Livy. He tells of the early days of
Rome when there was a shortage of women.
Romulus attempts to kidnap the neighbouring
Sabine Women, leading to a battle between
the two cities. Peace is achieved by the women
themselves proposing a compromise. The
subject provided an excellent opportunity to
portray sexual violence under the guise of
illustrating ancient history.

Sacraments, Seven, see *Seven Sacraments.*

Sainte-Victoire, Montagne This moun-
tain, whose name commemorates some
obscure victory in the 1st century BC, is about

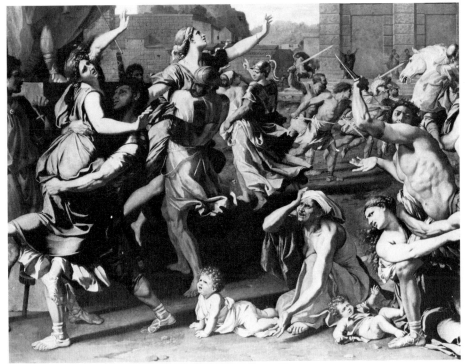

Rape of the Sabine Women (detail). Nicolas Poussin, 1594–1665

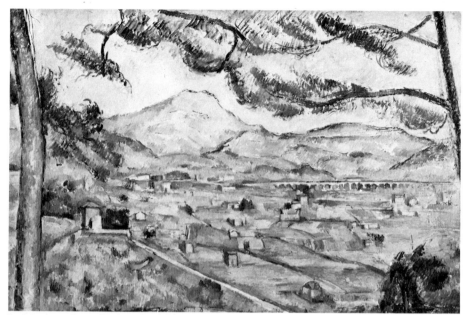

La Montagne Sainte-Victoire. Paul Cézanne, 1839–1906

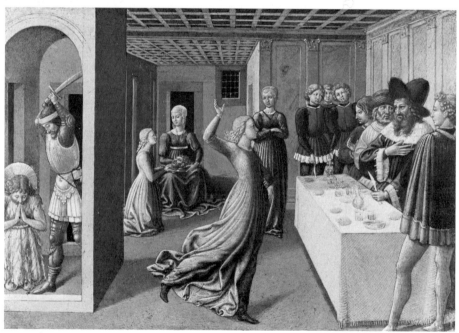

Dance of Salome. Benozzo Gozzoli, 1420–1497

three thousand feet high and is situated about ten miles from Aix-en-Provence in the south of France. It has been immortalized by a painter of the region, Paul Cézanne. By concentrating on nature as something permanent and solid as it really is – and not as interpreted in the light of classical antiquity, or of the transitory appearance of the Impressionists – he was able to impose order on it like a scientific Poussin, and thereby revolutionized modern man's whole approach to painting.

Salome The story of Salome, daughter of Herodias and step-daughter of Herod Antipas, is told in Matthew xiv, 6–8: 'But when Herod's birthday was kept, the daughter of Herodias danced before them, and pleased Herod. Whereupon he promised with an oath to give her whatsoever she would ask. And she, being before instructed by her mother, said, Give me here John Baptist's head in a charger.' An executioner beheaded John the Baptist (*q.v.*) in prison and brought back the head for Salome. Salome was merely the instrument of her mother's hatred of John who had publicized what local custom considered her adulterous relation with Herod. According to legend Herodias had been in love with John the Baptist and Herod with Salome.

Samaritan, Good The parable of the Good Samaritan, told in Luke x, 30–37, was Christ's answer to the question of the lawyer, 'Who is my neighbour?' It is the story of the man left half dead by robbers on the road from Jerusalem to Jericho. A priest and a Levite in turn passed him by. But a Samaritan – i.e. a native of Samaria – took care of him and paid for his lodging at an inn until he recovered.

Samson After many childless years, Manoah (*q.v.*) and his wife, following extra-strict dietary laws, produced Samson, who became the Israelite leader in the struggle against the then dominant Philistines. Brought up strictly, Samson left his hair completely uncut. He had great strength and unusual skills. On one occasion he caught three hundred foxes, tied firebrands to their tails and set them loose in the Philistine fields. Three thousand of his unappreciative compatriots tied him up and

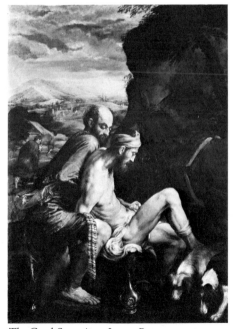

The Good Samaritan. Jacopo Bassano, 1510(?)–1592

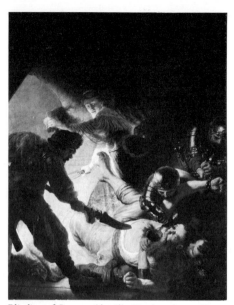

Blinding of Samson (detail). Rembrandt van Ryn, 1606–1669

delivered him to the Philistines. Breaking out of his bonds, he picked up a fresh jawbone of an ass and killed a thousand Philistines. After a night with a Gaza whore he still had enough strength to tear up and carry away the city gates. He then encountered the Philistines' greatest menace, the enticing Delilah. During their affair she worked on him until he finally revealed the secret of his strength. While he slept, she had his hair shaved off. His strength gone, the Philistines arrested him and put out his eyes. During a feast in the Temple of Dagon, his captors brought the blind Samson out of his prison to make sport of him. His hair had grown, and praying to Jehovah for strength, he pulled down the supporting columns of the Temple, destroying himself and more than three thousand Philistines. Originally perhaps a solar myth, the story became an exemplary tale of sexual passion leading to utter destruction.

San Romano, Battle of On 1 June 1432 in a battle at San Romano in the fringe lands between the expanding power of Florence and the contracting power of Siena, the Florentines under the command of Niccolo da Tolentino defeated the Sienese and their Milanese allies, the Visconti. Hostilities had been going on intermittently between Florence and Siena for about two centuries. The quarrels of the two wealthy cities were largely of a feudal nature, and were for control of towns and territories between them. But Florence with its superior industrial technology, particularly in wool textiles, and its banking skills had already established its superiority over Siena by the time of the Battle of San Romano. Within two years of the battle – relatively bloodless as Uccello's three famous panels suggest – the Medici won power in Florence and held it almost without interruption for three centuries. Uccello's paintings were commissioned for the Medici Palace in Florence by Cosimo de' Medici, who developed the family banking and mercantile interests and established its political power.

Sarah, see *Isaac.*

Satan, see *St Michael.*

The Battle of San Romano (detail).
Paolo Uccello, c. 1397–1475

Saturn Devouring his Children Saturn – the Greek god Cronus, or Time – married his sister Rhea, and was the father of Jupiter (*q.v.*) and Juno (*q.v.*). To defeat the prophecy that a son would supplant him, Saturn ate his children as they were born (time devours everything). Jupiter was smuggled away at birth. In his youth he secured employment as cup-bearer to his unknowing father. He administered an emetic potion and Saturn regurgitated his children, alive. Under Jupiter's leadership they fought a ten-year war against Saturn and his Titans whom they defeated and banished. The Romans who took over Saturn as God of Agriculture, considered his reign as the Golden Age.

Satyr Satyrs were part of the retinue of Bacchus (*q.v.*). They were woodland creatures with the nether parts of a goat and the top half of a hairy human except for a set of horns and pointed ears. When they were not accompanying Bacchus on his orgiastic processions, their main activity seems to have been pursuing nymphs.

Saul, see *David and Saul.*

Saturn devouring his Children (detail).
Francisco de Goya, 1746–1828

Massacre de Scio (Massacre at Chios).
Eugène Delacroix, 1798–1863

Scio, Massacre de During the Greek struggle for independence at the beginning of the 19th century, some Greek patriots in 1822 attacked the Turkish garrison of the island of Chios (Scio), off the coast of Asia Minor from Smyrna. After repelling the attackers, the Turkish authorities took their revenge on the natives, slaughtering men, women, and children. The punitive massacre of the natives, who had been against the original attack, aroused the sympathy of many Western Europeans. It inspired the painting of Delacroix which was revolutionary in technique.

Scipio, Triumph of The Scipios were a Roman family who distinguished themselves in public life, particularly in the wars against Carthage. Publius Cornelius Scipio Aemilianus Africanus was the adopted son of Scipio Africanus. He carried on the Scipio tradition and fought the Carthaginians in Spain and North Africa, finally capturing and totally destroying their capital, Carthage, in 146 BC and ending their power for ever. The citizens gave him a military triumph on his return to Rome. A cultured conciliatory man of centrist tendencies, his opposition to an extremist faction led to his assassination.

The Triumph of Scipio (detail). Andrea Mantegna, 1430/31–1506

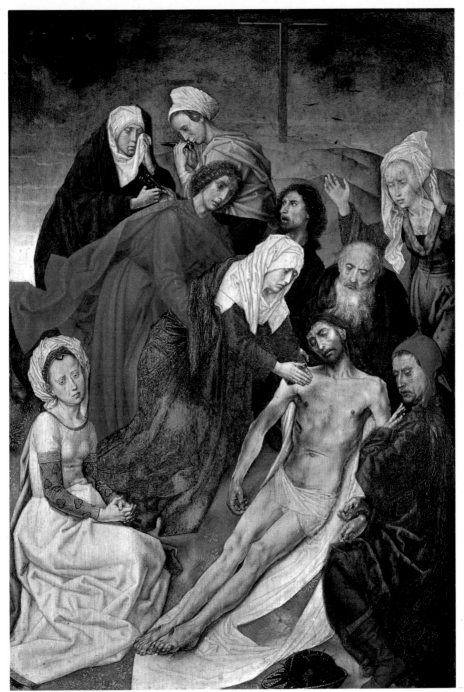

Pietà (Lamentation). Hugo van der Goes, active 1467–1482

St Sebastian. Georges de la Tour, 1593–1652

The seven deadly Sins (detail).
Hieronymus Bosch, c. 1450–1516

Sebastian, St St Ambrose said that Sebastian, an officer in Diocletian's Praetorian Guard, was born in Milan. The *Golden Legend* has him born in Narbonne in the south of France in the 3rd century. On discovering that he was a Christian, the Emperor ordered him to be shot with arrows. Left for dead, the widow of another martyr dressed his wounds and he recovered. He presented himself to the Emperor to illustrate the power of Christ. Diocletian then ordered him to be cudgelled to death and thrown into the main sewer of Rome. This he did not survive. His attribute is an arrow, and he appears in Renaissance painting almost nude, his body riddled with arrows. St Sebastian is patron of pin-makers. See p. 208.

Seven Deadly Sins The subject of the Seven Deadly Sins had great popularity in the Middle Ages. The subject was frequently presented didactically, with the sins grouped round the eye of God, accompanied by a motto such as 'Beware, God watches'. This was often followed by scenes from the Last Judgment, and Hell with graphic details of the punishments meted out to sinners. The Seven Deadly Sins with their Latin names in parentheses are as follows: Pride (*Superbia*), Envy (*Invidia*), Anger (*Ira*), Lust (*Luxuria*), Sloth (*Accidia*), Avarice (*Avaritia*), and Gluttony (*Gula*).

Seven Sacraments Baptism, Confirmation, the Holy Eucharist, Penance, Ordination, Marriage, and Extreme Unction. Their formal basis stems from the decision of the Council of Trent which closed in 1563. This merely confirmed what was done at the Council of Florence in 1439. Indeed, by the mid-12th century, Peter Lombard had enumerated them as we know them today. Luther accepted only the sacraments of Baptism, Holy Eucharist, and Penance. Many Protestants such as the Anglicans dropped the latter but recognized the others as rites. A sacrament is nowhere better described than in the words of the Anglican catechism, 'an outward and visible sign of an inward and spiritual grace'.

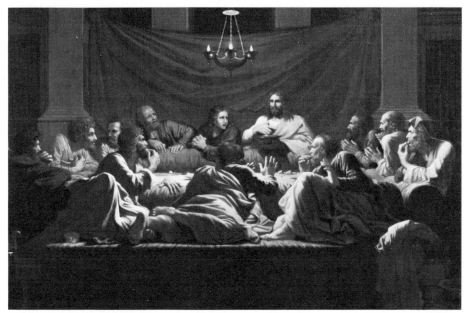

The Seven Sacraments: Eucharist. Nicolas Poussin, 1594–1665

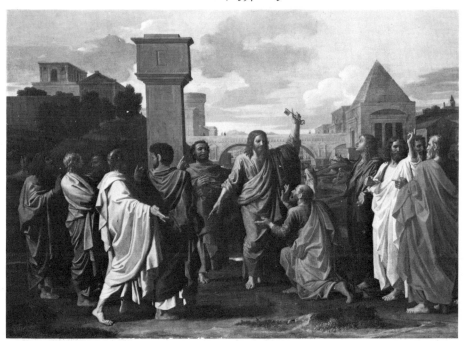

The Seven Sacraments: Ordination. Nicolas Poussin, 1594–1665

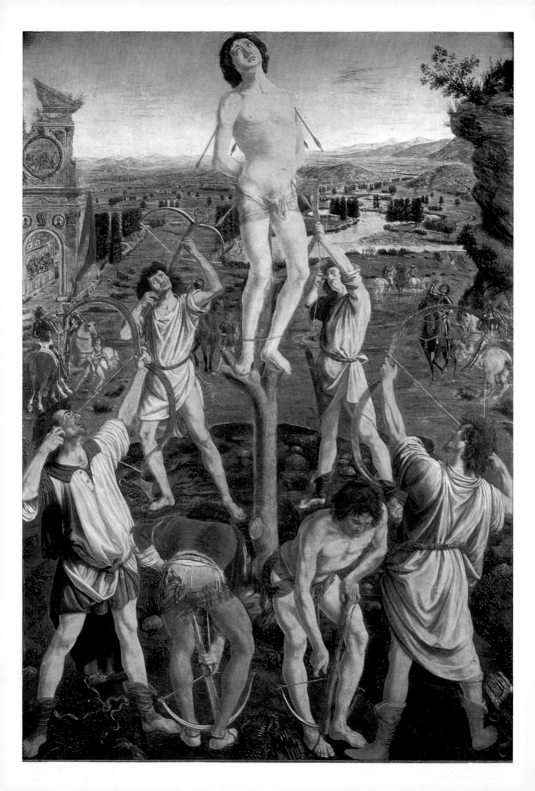

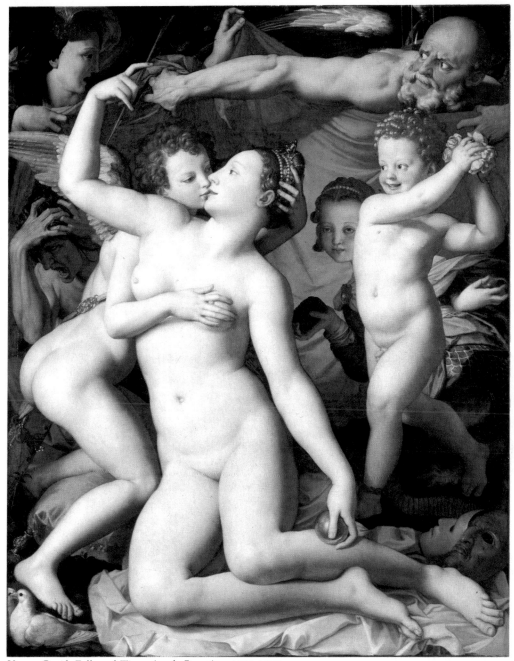

Venus, Cupid, Folly and Time. Angelo Bronzino, 1503–1572

(Left) Martyrdom of St Sebastian. Antonio (c. 1432–1498) and Piero (c. 1441–c. 1496) Pollaiuolo

The Seven Virtues. Pesellino and studio, c. 1422–1457

Seven Virtues Fascinated by the magic number of *seven* the late Middle-Age mind had Seven Virtues to counter the Seven Deadly Sins. With their Latin names in parentheses they are as follows: Prudence (*Prudenza*), Justice (*Justitia*), Faith (*Fides*), Charity (*Charitas*), Hope (*Spes*), Fortitude (*Fortitudo*), and Temperance (*Temperanza*). The entire symbology of the subject is summarized in Pesellino's painting of the subject. Thus Faith holds a chalice and a cross, and has St Peter at her feet. Hope prays and has before her St James the Greater. Charity holds a small child in one hand and a flame or heart in the other; before her is St John the Divine. Temperance holds two vases and at her feet sits Scipio Africanus. Prudence has two faces, and holds a snake and a mirror; Solon sits before her. Fortitude holds a column to indicate Samson's destruction of the Philistine temple; in front of her sits Samson holding the jawbone of an ass. Finally, Justice holds scales and a sword; the Emperor Trajan sits before her.

Sheba, Queen of News of the glory and wisdom of Solomon had penetrated down to the south-east corner of the Arabian Peninsula, to Saba or Sheba in what is now Yemen. The Queen of Sheba with a great train of servants and present-bearers paid an official visit to Solomon – in the words of 1 Kings x, 1, 'to prove him with hard questions'. Such was the attraction of the story of Solomon and the Queen of Sheba that it is somewhat incongruously included in Caxton's translation of *The Golden Legend*, or *Lives of the Saints*. It adds little to the splendidly pageant-like account in the Old Testament. Solomon

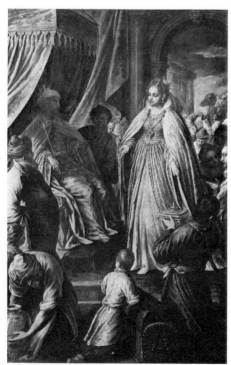

The Queen of Sheba visiting Solomon.
Leandro Bassano, 1557–1622

acquitted himself well 'and gave unto the Queen of Sheba all her desire'. Indeed, the present reigning dynasty in Ethiopia claims direct descent from the child which resulted from the fulfilment of that desire.

Ship of Fools Writers and artists of the early Renaissance in northern Europe were fascinated by the idea of *Folly*, that commonest weakness of the human condition. Two great literary works of the late 15th and early 16th centuries put into wide circulation in satiric fashion the sum of knowledge on that subject. They were *The Ship of Fools* by the Strasbourg scholar-humanist Sebastian Brant, published in 1494, and Erasmus' *The Praise of Folly*, published in 1509. Brant's didactic work is a long poem in which he sets out a satirical analysis of society's stupidities and hypocrisies by using the allegory of a ship of fools, steered by fools, *en route* to the fool's paradise, Narragonia.

Sibyl The Sibyls were originally priestesses of Apollo who had clairvoyant gifts for foretelling the future during periods of ecstasy in which there was much foaming at the mouth and other motor-hysterical manifestations.

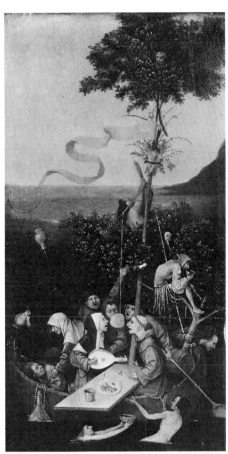

Ship of Fools. Hieronymus Bosch, c. 1450–1516

Cumaean Sibyl. Michelangelo Buonarroti, 1475–1564

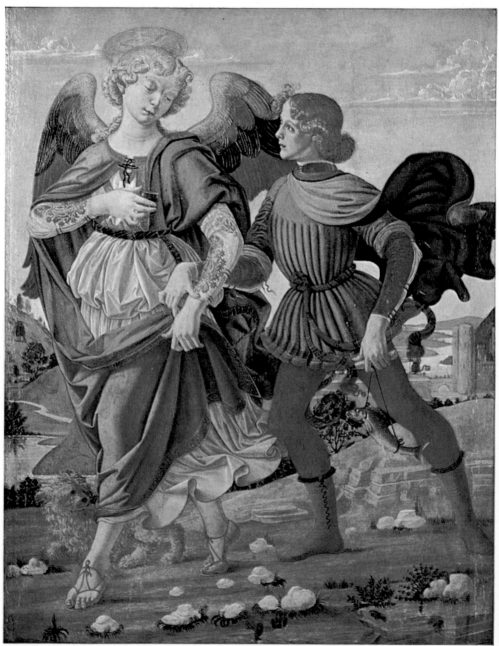

Tobias and the Angel. School of Andrea del Verrocchio, c. 1435–1488

The most famous of an ever-expanding pro-
fession was the Cumaean Sibyl of southern
Italy, encountered by Aeneas in Book vi of
Virgil's work. The sayings of the Sibyls were
recorded. These were consulted in times of
trouble. The Sibyls had a special fascination
for Renaissance thinkers and artists because of
their alleged connection with the well-known
but spurious Sibylline Books. The prophecies
in these forgeries showed an apparent bond
between the classic world of Greece, Jewish
prophetic literature, and Christianity.

Silenus Silenus was the good-natured tutor
of Bacchus and a permanent member of his
entourage. He staggered along held up by
Satyrs (*q.v.*) or sat insecurely on an ass. He was
a man of immense knowledge and when
totally inebriated had the gift of prophecy.
Although his father was Pan (*q.v.*) he bore no
trace of his father's goatish features.

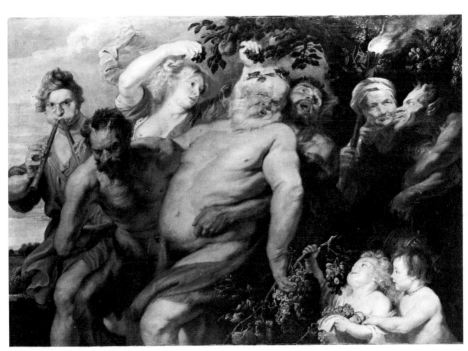

Silenus. Anthony van Dyck, 1599–1641

Judgment of Solomon (detail). Nicolas Poussin,
1594–1665

Solomon, Judgment of The most spectacular of the kings of Israel was Solomon, son of David and Bathsheba (*q.v.*). His prowess as ruler, builder, husband, and host of the Queen of Sheba (*q.v.*) are colourfully described in 1 Kings ii–xi. The wisdom of this poet-king (the supposed author of the *Song of Songs*) 'with an understanding heart ... with seven hundred wives, princesses, and three hundred concubines' was celebrated by his famous *Judgment*. Two harlots disputed the possession of a baby. Solomon ordered the child to be sliced into two pieces, one half for each claimant. He quickly recognized the true mother as the one who was willing to give up her baby to save its life.

Stations of the Cross, see *Calvary*.

Stephen, St The martyrdom in Jerusalem of Stephen, one of the first Deacons of the Christian Church, is described in Acts vi and vii. Accused of blasphemy, this first Christian martyr was given the traditional punishment of being stoned to death. The executioners' clothes were guarded by Paul who had not yet seen the light. At a later date St Stephen's relics were brought to Rome and buried beside those of St Lawrence (*q.v.*). It is said that when the tomb was opened St Lawrence moved over to make room for St Stephen, and offered him his hand. St Stephen's attributes are a stone, and the palm traditionally seen in paintings of martyrs.

Styx, see *Charon.*

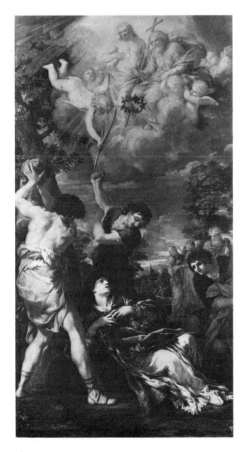

Martyrdom of St Stephen. School of Pietro da Cortona, 1596–1669

Transfiguration. Raphael, 1483–1520

Susanna During the Babylonian captivity, Susanna, the beautiful wife of a prominent member of the Jewish community, caught the fancy of two old men, also men of influence in their community. Susanna rejected their advances and they denounced her as a would-be adulteress. The wise Daniel (*q.v.*) – the story is told in an apocryphal addendum to his writings – proved them liars by exposing an inconsistency in their accusations and they were executed.

Syrinx, see *Pan*.

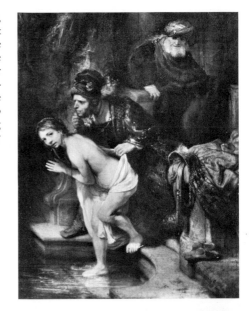

Susanna and the Elders (detail).
Rembrandt van Ryn, 1606–1669

Susanna and the Elders. Tintoretto, 1518–1594

T

Tancred Tancred was one of the heroes of *Jerusalem Delivered*, Tasso's poem about the First Crusade. He had fallen in love with a Saracen girl named Clorinda. Engaged in battle, Tancred fought a whole night with a Saracen soldier, whom he eventually defeated. To his horror, however, the mortally wounded enemy turned out to be his beloved Clorinda. Unbeknown to him she was a warrior in the Saracen army. Dying, she told him that she was the white, unbaptized daughter of Ethiopian Christians. Before her death Tancred baptized her. Another beautiful Saracen lady – Erminia – secretly loved Tancred and, finding him wounded, cut off tresses of her hair to bind up the dressings of his injuries. He converted her to Christianity.

Temptation of St Antony, see *St Antony*.

Temptation of Christ, see *Christ in the Desert*.

Tancred and Erminia. Nicolas Poussin, 1594–1665

Teresa of Jesus, St Teresa was born in 1515 at Avila in Spain, of pious aristocratic parents. Against the wish of her father she secretly entered the Carmelite convent at Avila at the age of twenty. She practised spiritual exercises with such intensity that she began to have visions and carry on conversations with God. Her health suffered. She had the gift of recalling her ecstatic spiritual experiences with great clarity and was able to record them in a series of books, the most famous being the extraordinary *Interior Castle*. During the ecstasies which accompanied her mystical marriage with God an angel transpierced her with a golden spear which scarred her heart. In her own words, 'The pain was so strong and the sweetness thereof was so passing great that no one could wish ever to lose it.' This incident inspired Bernini's famous sculpture in Santa Maria della Vittoria in Rome. Teresa founded the austere order of Discalced (i.e. unshod) Carmelites. Her life and writings were much exploited during the Counter-Reformation.

St Teresa delivering Bernadin de Mendoza from Purgatory. Peter Paul Rubens, 1577–1640

Theseus Theseus had two reputed fathers: Aegeus, King of Athens, and Neptune (*q.v.*),

Theseus killing the Minotaur (detail from a cassone panel). 16th century

Jupiter and Thetis. Jean-Auguste-Dominique Ingres, 1780–1867

Third of May 1808 (detail). Francisco de Goya, 1746–1828

King of the Sea. At an early age he proved his human paternity by lifting a huge rock and finding under it the sword and sandals of his (mortal) father. He then set out on a hero's career, killing monsters and giant oppressors, among them Procrustes who put his captives in a bed, cutting of their feet if too big, and stretching them if too small. His stepmother Medea (*q.v.*) tried to poison him. He expelled her from Athens, whose throne he then shared with his father. His most famous exploit was to end the export of Athenian boys and girls as tribute-sacrifice for the bull-headed Minotaur of Crete. With the help of Ariadne, daughter of the King of Crete, he made his way into the Minotaur's lair, the Labyrinth, trailing a thread, killed the monster and returned by following the thread. He abandoned Ariadne (*cf.* Bacchus) and married her sister Phaedra, living unhappily thereafter.

Thetis Thetis the Nereid was the mistress of Jupiter and Neptune. They arranged her marriage to the mortal Peleus because of the prophecy that her child would outshine its father. Jupiter promised immortality to the child – Achilles (*q.v.*) – if she immersed it in the Styx (*q.v.*). The omission to invite to her wedding Eris, the goddess of Discord, set in train the events leading to the Trojan War. (See *Paris*.)

Third of May, 1808, Massacres of In 1808 the decadent, dim-witted Spanish royal family with the collusion of most of the higher nobility, higher clergy, and bureaucracy sold their country to Napoleon. Spontaneous uprisings against the French occupying troops culminated in street fighting with Murat's troops in Madrid on Sunday, 2 May. Through that night and in the early hours of the morning of Monday, 3 May, Murat's troops secured control of the virtually unarmed citizens. His execution squads then massacred hundreds of them. Goya, an eye-witness of the bloody events, recorded the scene in a revolutionary work which, with David's *Death of Marat* (*q.v.*) introduced into art the principle of direct political protest.

Thomas, St (The Apostle) One of the Apostles about whom little is known. He is referred to as 'doubting Thomas'. His reaction when other disciples told him they had seen the resurrected Christ is told in John xx, 25 ff.: 'Except I shall see in his hands the prints of the nails, and put my finger into the print of the nails, and thrust my hand into his side, I will not believe . . . then came Jesus . . . and said . . . reach hither thy finger, and behold my hands: and reach hither thy hand, and thrust it into my side: and be not faithless, but believing. And Thomas answered and said unto him, My Lord and my God.' According to the apocryphal *Acts of Thomas* he travelled to south India and converted the Keralans, who for centuries called themselves 'St. Thomas Christians'. According to the *Golden Legend*, Christ sent St Thomas to India to help the King of India with some building problems. The Apostle got himself into much trouble through persuading the king's wife to refuse marital rights to her husband. This

Martyrdom of St Thomas. Stefan Lochner, c. 1400–1451

(Below) The Incredulity of St Thomas. Guercino, 1591–1666

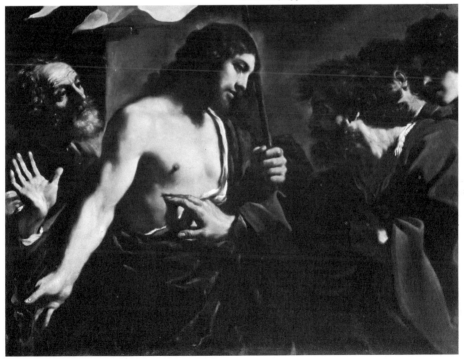

St Thomas Aquinas (detail). Sassetta, 1392–1450

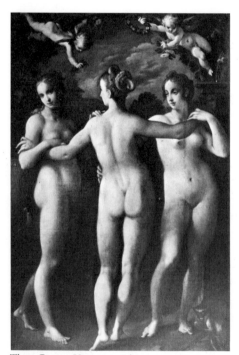

Three Graces. Hans von Achen, 1552–1615

eventually led to St Thomas' martyrdom. The subject of 'doubting Thomas' appealed greatly to painters. His attributes are a carpenter's rule and a spear. He is the patron of Christian India as well as of architects, carpenters and masons.

Thomas Aquinas, St He was born in southern Italy about 1225, the son of aristocratic parents. Precociously brilliant, he started his studies at the University of Naples at the age of eleven. He joined the Dominican Order in his late teens. His family tried to corrupt his religious vocation and imprisoned him: but in a dream two angels gave him a girdle of perpetual virginity. He then went to Paris where he studied under Albertus Magnus. The saintly St Thomas Aquinas rejected all worldly honours and devoted his considerable energies to theological study and teaching which culminated in his *Summa Theologica*, the most complete and influential of the many medieval compendia of theology, philosophy, and canon law. His excessive labours during a life of great austerity produced frequent ecstasies. He died at the age of about fifty.

Three Graces Three sisters who were sired on Eurynome by Jupiter. Their names were Aglaia (Brilliant), Thalia (Flowering), and Euphrosyne (Joy). They were frequently associated – and confused – with the Muses (*q.v.*).

Three Maries at the Sepulchre, see *Entombment.*

Time By the mid-16th century, Mannerist painters had transformed the pictorial conception of the figure of Time from the relentless child-devouring Cronus or Saturn (*q.v.*) to a winged old man carrying an hour-glass, and sometimes a scythe. Still relentless and sometimes allied with a hard-faced figure of Truth, he appears in allegories casting some bitter reflection on the way of the world. Thus in Bronzino's coldly erotic allegory, Time and Truth lift a curtain to reveal that the pleasures of upper-class love are surrounded by discord, envy, jealousy, and deceit. See p. 209.

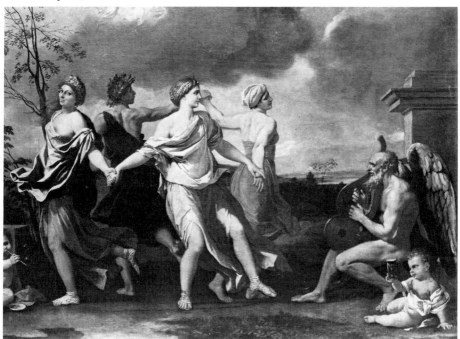

A Dance to the Music of Time (detail). Nicolas Poussin, 1594–1665

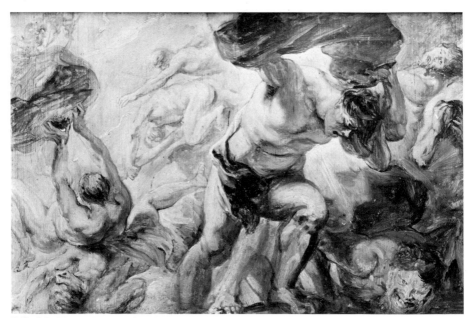

Fall of the Titans. Peter Paul Rubens, 1577–1640

Titans The ancient Greeks considered the Titans as the first divine race. They were the six sons and daughters of Uranus, the Starlit Sky, and his mother the Earth Goddess, Gaea. The other progeny of the union were Cyclops and miscellaneous monsters, including three with one hundred arms and fifty heads. Uranus buried all his children in the centre of the earth. There was a revolt and the youngest of the Titans, Cronus or Saturn (Time) (*q.v.*), aided by his mother, castrated Uranus and took his place. Wary of his children he devoured them as they were born. Jupiter (*q.v.*) escaped this fate and eventually started a war against the Titans, defeated them, and assumed supreme authority. The mythologues consider the story as a symbol for the victory of law and order over raw nature.

Tobias and the Angel The exemplary story of Tobias comes from the apocryphal *Book of Tobit* which appeared in Alexandria in the 3rd century B C. Sent on a long business trip by his father – blinded by bird droppings – Tobias picked up as a travelling companion the Archangel Raphael, travelling incognito. On the way Raphael showed Tobias how to

catch an aggressive fish which they ate, keeping only some of its offal for future use. They reach the house of Tobias' cousin Sarah who had been married seven times but each of whose husbands had died on his wedding night. Tobias exorcised the evil spirits around Sarah by burning the heart of the fish he had caught. He then married Sarah himself. On his return home to his father he cured the old man's blindness by applying fish gall to his eyes. See p. 212.

Transfiguration On a high mountain – thought to be Mount Tabor in Galilee – and in the presence of St Peter (*q.v.*), St John (*q.v.*), and St James (*q.v.*) Christ 'was transfigured before them: and his face did shine as the sun, and his raiment was white as the light' (Matthew xvii). With the three disciples still present, Christ then spoke with Moses and Elias, and a voice emanating from a cloud said, 'This is my beloved Son, in whom I am well pleased: hear ye him.' This divine manifestation of Christ in glory with its emphasis on light, greatly attracted painters. See p. 216.

Transfiguration (detail). Giovanni Bellini, c. 1430–1516

Transfiguration. Duccio, c. 1255/60–1318/19

Holy Trinity adored by the heavenly choir.
Tintoretto, 1518–1594

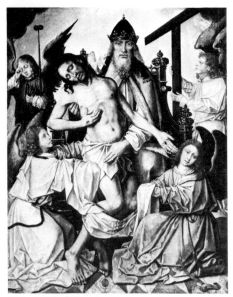

Holy Trinity. Master of Flémalle,
1378/79–1444

Tribute Money, see *Christ and the Tribute Money.*

Trinity The Christian concept of God existing as three persons, God the Father, God the Son, and God the Holy Ghost, is a mystery which surpasses human understanding. Theophilus of Antioch put the term 'Trinity' into use towards the end of the 2nd century. It was elaborated fully in the 6th century in what is known as the Athanasian Creed. Understandably, painters experienced difficulty in satisfactory pictorial representation of such a difficult concept. Possibly the Church as principal patron of works dealing with that basic subject determined its treatment. We thus find the Trinity portrayed as the three following figures: God the Father, a weightless and patriarchal figure holding below him a cross on which Christ is nailed, and above or below these two figures hovers a dove, symbol of the Holy Ghost. Sometimes the Three Persons are shown crowned and sitting side by side on thrones.

U

Ulysses Ulysses (*Odysseus* in Greek) the King of Ithaca was one of the most famous of the Greek heroes. His involvement in the Trojan War is told in the *Iliad*. A man of peace, he had feigned madness to escape his obligation to help Menelaus recover his abducted wife Helen (*q.v.*). Using as draught animals an ox and an ass, he ploughed his fields sowing salt in the furrows. Palamedes exposed his fraud by placing Ulysses' young son Telemachus in the path of the plough. Ulysses showed he was not mad by turning the plough aside. During the war Ulysses avenged himself on Palamedes by concocting false charges which led to his execution by the Greeks as a traitor. The

Scenes from the Odyssey (detail). Pintoricchio, active 1481, d. 1513

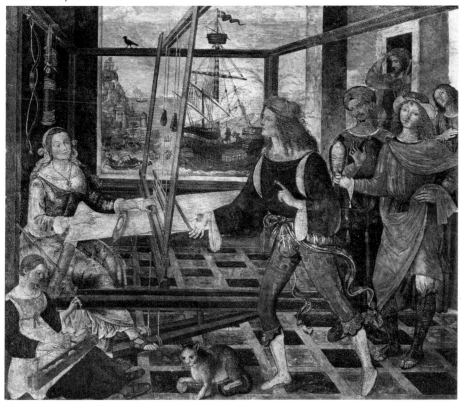

Wooden Horse (see *Laocoön*) was Ulysses'
idea: it enabled the Greeks to enter, capture,
and destroy Troy.

The *Odyssey* relates Ulysses' adventures dur-
ing his ten-year return to Ithaca and his wife
Penelope. His first adventure is his escape from
the island of the Lotus Eaters whose principal
food induces complete forgetfulness. He then
falls into the hands of the Cyclops, Poly-
phemus (*q.v.*), whom he blinds. Neptune, the
father of Polyphemus, punishes Ulysses by
pursuing him with storms for the rest of his
journey. After escaping from the Laestry-
gonian cannibals, Ulysses gets temporarily
entangled with Circe (*q.v.*). He avoids the fatal
seduction of the singing Sirens by filling the
ears of his crew with wax and having himself
lashed to the mast of his ship. Passing with
small losses between the man-eating Scylla
and the deadly whirlpool of Charybdis he
reaches the island of Thrinacia where his
starving men eat one of the cattle sacred to
Helios, the sun god. As a punishment Jupiter
destroys all but Ulysses. The sea throws him
up on Calypso's island. She keeps him a
prisoner of love for eight years but he finally
breaks away. The raft he had made is wrecked
at sea and he is washed up on the island of
Scheria (Corfu) where he is discovered by
Nausicaa (*q.v.*). Her hospitable people help
him to reach Ithaca where he finds his faithful
wife fending off suitors by promising to make
her choice once she has finished weaving a
garment for her father-in-law. Each night she
undid the previous day's work. Pushed to a
final decision Penelope promises at a banquet
to marry the suitor who can bend Ulysses'
famous bow. Ulysses, disguised as a beggar,
brings the story to an end by taking the bow
and using it to shoot all the suitors.

Ursula, St According to medieval legend this
princess of Cornwall agreed to marry the
English king's son if he became a Christian and
waited three years until she returned from a
pilgrimage to Rome with her eleven thousand
virgins. On the return journey they were met
by the Huns and all slaughtered. The subject
was very popular with painters – especially
Venetians – as it provided an opportunity to
paint ships. St Ursula's attribute is an arrow.

Embarkation of St Ursula (detail). Claude Lorraine, 1600–1682

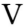

V

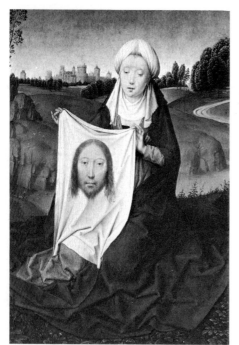

St Veronica. Hans Memlinc, c. 1430/35–1494

Veil, see *St Veronica.*

Veronica, St The story of St Veronica has no Biblical authority. It got wide circulation in the early Middle Ages through the apocryphal *Gospels of Nicodemus* which tell of Veronica offering her handkerchief to the sweating Christ, carrying his cross up to Calvary. When he returned the handkerchief it bore the permanent imprint of his face. Since the 8th century St Peter's in Rome has had a cloth called 'Veronica's Veil'. Her attribute is a cloth bearing the image of Christ's face. She is patroness of linen-drapers and washerwomen.

Venus Venus or Aphrodite was the goddess of love, fertility, and beauty. Her father was Jupiter (*q.v.*). She is said to have been born of sea foam, and her cult was probably introduced into Greece from Asia Minor where Astarte

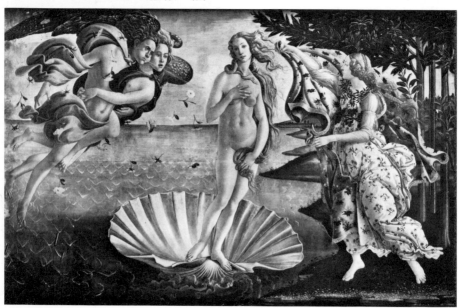

Birth of Venus. Sandro Botticelli, c. 1445–1510

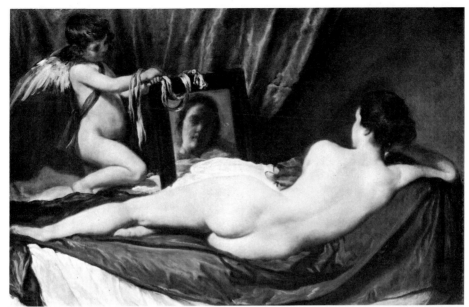

*Toilet of Venus (the Rokeby Venus).
Velazquez, 1599–1660*

has similar characteristics. It is also suggested that the foam from which she was born was created when the genitals of the castrated Uranus the Titan (*q.v.*) were thrown into the sea. Venus was married to her half-brother, the ugly Vulcan, but this did not stop her from having affairs with her father, her other half-brothers Mars (*q.v.*) and Mercury (*q.v.*), and miscellaneous mortals, including Anchises who became the father of Aeneas (*q.v.*) and ancestor of Rome. In order to gain the golden apple thrown into the wedding feast of Thetis (*q.v.*) she influenced the judgment of Paris (*q.v.*) by promising him Helen (*q.v.*). The most famous affair of Venus was with Adonis, who had been brought up by Persephone or Proserpina (*q.v.*), Queen of Hades. The dispute between the two goddesses for possession of the beautiful young man was settled by Calliope. Adonis was to spend four months with Venus, four months with Proserpina, and to have the remaining four months to himself. The jealous Mars sent a savage boar to kill Adonis during a hunt. From his blood sprang the anemone. The story, told at length by Ovid, is a perfect example of metamorphosis, of the death and rebirth of flowering nature.

*Venus and Adonis (detail). Paolo Veronese,
c. 1528–1588*

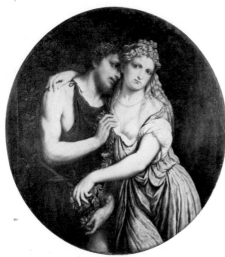

Vertumnus and Pomona. Paris Bordone, 1500–1571

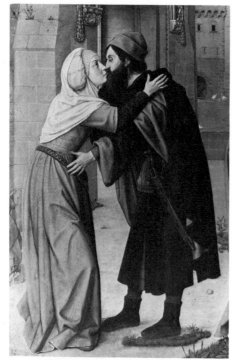

Joachim and Anne meeting at the Golden Gate (detail). Studio of the Master of Moulins, active 1483–c. 1500

Vertumnus and Pomona Once more it is to Ovid's *Metamorphoses* that we owe the story of the Roman goddess of tree fruit (hence *pomology*, the science of fruit production). Such was Pomona's devotion to her orchards that she had no time for lovers. Vertumnus, Roman protector of gardens and orchards, finally won her by appearing as an old woman and telling her what a magnificent husband Vertumnus would make. Pomona's attribute in art is a pruning knife.

Virgin Mary For the person who after Jesus Christ appears most frequently in Renaissance and post-Renaissance painting, it is surprising how little reference to the Virgin Mary can be found in the New Testament. Indeed, the main literary sources of information concerning her birth, life, and death are apocryphal books such as the *Protevangelium of St James* and the stories collected in the *Golden Legend*. The cult of the Virgin Mary started in the 5th century after the Council of Ephesus proclaimed her Theotokos (Mother of God). The principal events connected with the Virgin Mary which have provided subject matter for painters are the following:

Parentage of the Virgin Mary The story of her birth is told in the *Protevangelium of St James*, repeated with embellishments in the *Golden Legend*. Her parents were the aged Joachim and Anne, childless for many years. Not permitted to sacrifice in the Temple because of his sterility, Joachim fasts and prays for forty days in the wilderness. To both him and Anne individually an angel of the Lord proclaims that they will have a child. Joachim returns from the mountains and his solemn meeting with Anne by the Golden Gate at Jerusalem is a favourite theme with artists who wish to stress the supernatural element in the child's birth. St Anne conceives – immaculately, according to the dogma of the Immaculate Conception (*q.v.*) and becomes the mother of the Virgin Mary.

Nativity of the Virgin Mary Paintings of this scene show St Anne in bed in a sumptuous room receiving friends and visitors who have come to congratulate her and see the infant Mary. Emphasis is often given to the material surroundings.

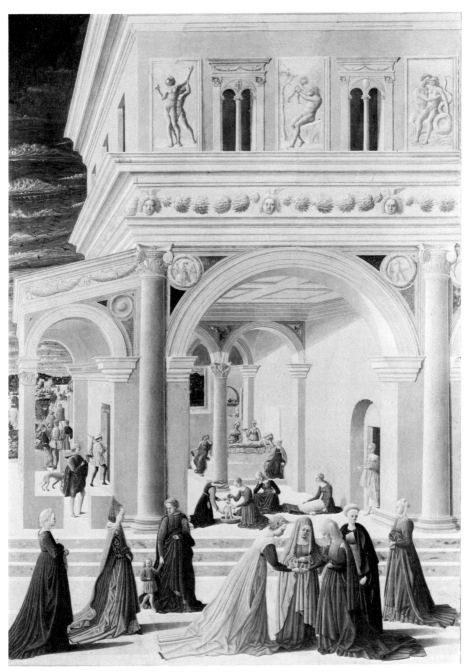

Nativity of the Virgin. Fra Carnavale, active 1456, d. 1484

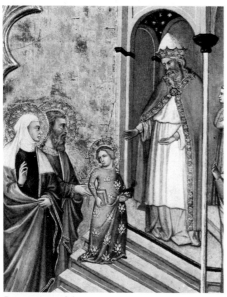

Presentation of the Virgin (detail).
Andrea di Bartolo, 1389–1428

Presentation of the Virgin Mary
According to apocryphal literature, St Anne
promised that if she had a child she would
dedicate it to the Lord. Accordingly, at the
age of three the Virgin Mary was brought to
the Temple to serve there. It is said that she
remained in the Temple until she was fourteen.

**Betrothal and Marriage of the Virgin
Mary** The Temple priests arranged for all the
fourteen-year-old girls to marry: but the
Virgin Mary at first refused as she considered
herself dedicated to the Lord. According to
the *Golden Legend* an oracle told the priests to
assemble eligible men from the House of David
and the one whose staff flowered would be the
husband of the Virgin Mary. Among the men
was the diffident old carpenter, Joseph of
Nazareth. He brought his staff only when
forced to. It flowered and he married the
Virgin Mary. In the background of this scene
one usually sees the disappointed suitors
breaking their staffs.

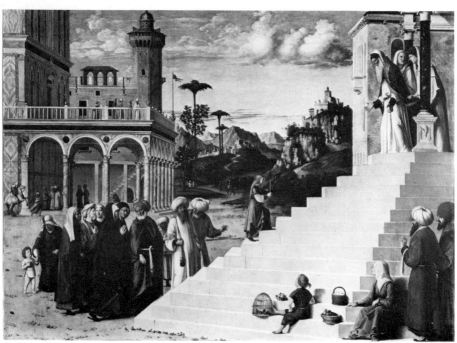

Presentation of the Virgin. Cima di Conegliano, 1459/60–1517/18

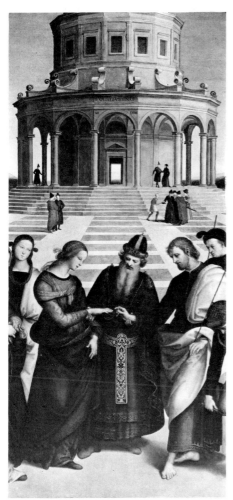

Marriage of the Virgin (detail). Raphael,
1483–1520

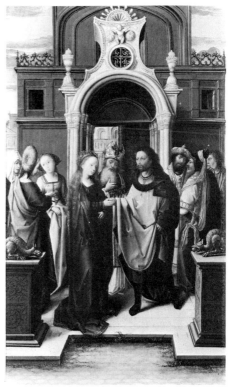

Marriage of the Virgin. Bernaert van Orley,
c. 1488–1541

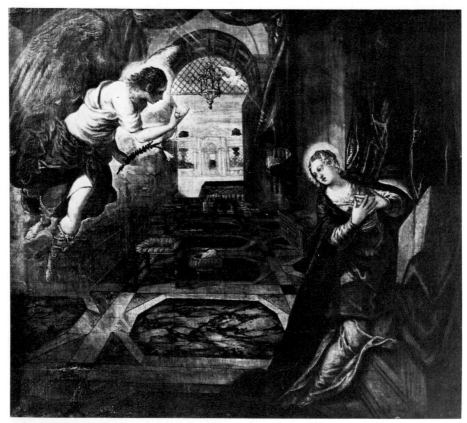

Annunciation. Tintoretto, 1518–1594

Visitation (detail). Albrecht Altdorfer,
c. 1480–1538

**Announcement by Gabriel of the Birth
of Christ** See *Annunciation*.

Visitation According to Luke i, 39–57,
shortly after the Annunciation (*q.v.*) the preg-
nant Virgin Mary paid a visit to Hebron to her
pregnant cousin Elizabeth who was carrying
John, the future Baptist and precursor of
Christ. Sensing the presence of the Divine
Child, Elizabeth's baby 'leaped in her womb:
and Elizabeth was filled with the Holy Ghost.'
Mary stayed about three months with
Elizabeth and then returned to Nazareth.

The Nativity of Christ See *Adoration of
the Shepherds*.

Purification of the Virgin See *Christ,
Presentation in the Temple*.

Mourning of Christ See *Pietà*.

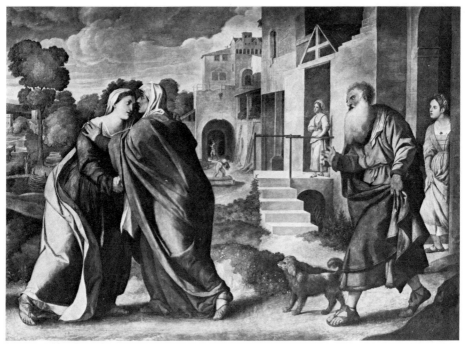

Visitation (detail). Palma Vecchio, 1480–1528

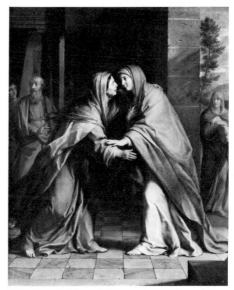

Visitation. Philippe de Champaigne, 1602–1674

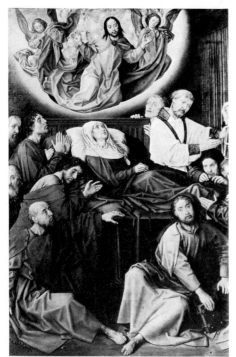

Dormition (or Death) of the Virgin Mary The last Biblical reference to the Virgin Mary is in Acts 1, 14 where she is mentioned as being in the company of the Apostles and followers waiting for Pentecost and the coming of the Holy Spirit. The story of her Dormition (death) and Assumption – often taken together – is based solely on legends, the best known being those included in de Voragine's *Golden Legend or Lives of the Saints*. One widely accepted legend has her dying in Jerusalem with all the Apostles present. Other legends have her dying in Ephesus, a significant choice of site in view of the famous cult there of Diana (*q.v.*) the virgin goddess. In painting, the Dormition and the Assumption are divided into a series of events starting with an angel offering her a palm – symbol of triumph over sin and death – and ending with her soaring up into space.

Death of the Virgin (detail). Hugo van der Goes, active 1467–1482

(Below) Death of the Virgin Mary. Hans Holbein the Elder, c. 1465–1524

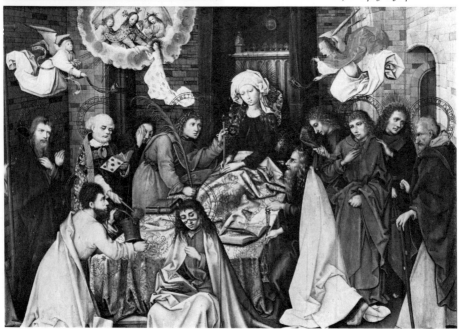

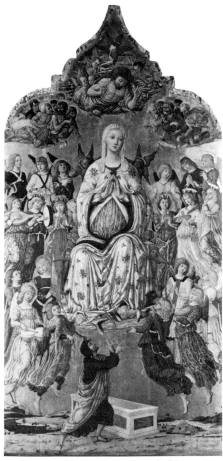

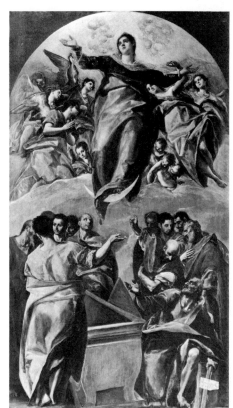

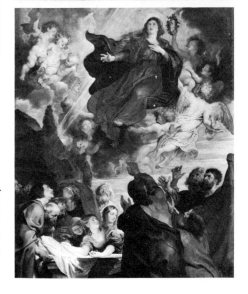

Assumption of the Virgin. Matteo di Giovanni, active 1452–1495

(Above right) Assumption of the Virgin. El Greco, 1541–1614

(Below right) Assumption of the Virgin (detail). Peter Paul Rubens, 1577–1640

Assumption The Roman Catholic belief (now a dogma) that the Virgin Mary was taken up bodily into Heaven is necessarily vague in its details. She is usually shown being carried skywards by angels, while the Apostles stand in amazement round her empty tomb.

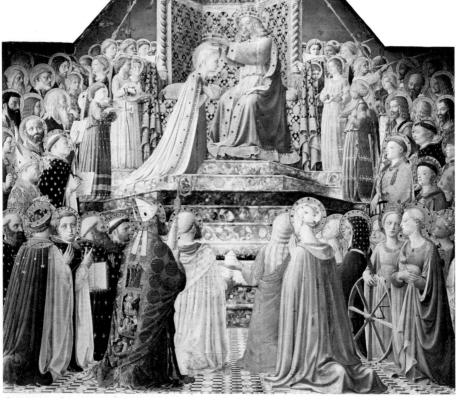

Coronation of the Virgin (detail). Fra Angelico, 1386/87–1455

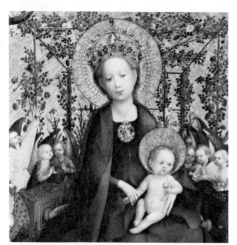

Virgin Mary as Queen of Heaven (Madonna of the Rose Garden). Stefan Lochner, c. 1400–1451

Coronation of the Virgin Mary. Virgin Mary, Queen of Heaven In the symbology of the Virgin Mary as Queen of Heaven, she is frequently shown as suspended in space, standing on a crescent moon, a symbol borrowed from the Apocalypse but of extremely ancient origin. She is also shown in a rose garden, or distributing rose wreaths (a symbol in early catacomb art of martyrdom). The rose was considered the flower of perfection and according to St Ambrose acquired its thorns after Adam and Eve sinned. In devotional literature the Virgin Mary was referred to as 'the Rose without Thorns'. The rose was also the flower of Venus, Eros, and Dionysius. In spite of its pagan connections, it was customary at one time to put a rose above the confessional, hence the expression *sub rosa* for secrecy.

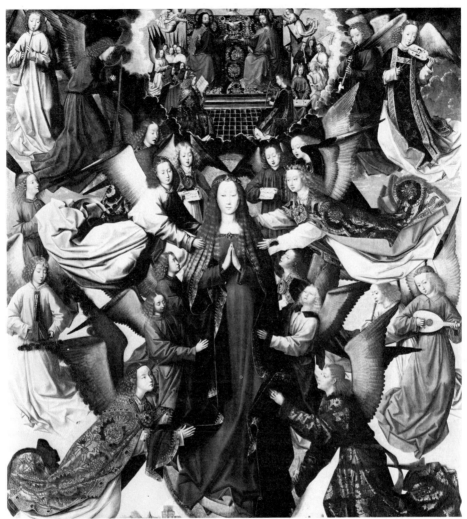

The application of temporal, institutional rites like Coronation to divine personalities such as the Virgin Mary, shows the significant role of the painter as instrument of propaganda for the power system of the medieval and Renaissance Church. The Virgin Mary's elevation by Coronation to Queen of Heaven made her the intermediary with, and channel to, Almighty God. This enhanced the power and authority of the Church, for only through the Church could the intercession of the Virgin Mary be obtained.

Virgin Mary, Queen of Heaven (detail). Master of the St Lucy Legend, active 1480–1489

Virtues, Seven, see *Seven Virtues.*

Visitation, see *Virgin Mary.*

Vulcan, see *Venus* and *Mars.*

Wooden Horse, see *Laocoön.*

Zenobius, St This Florentine saint who died at the beginning of the 5th century was a friend of St Ambrose. He was a bishop of Florence and one of its patrons. He is remembered chiefly for his miracles, especially restoring the dead to life. It is said that on his way to the grave his body accidentally touched a dead tree which immediately revived. His attribute is frequently a dead child, or a child under the wheels of a waggon.

Zeus, see *Jupiter.*

St Zenobius restoring a dead man to life (detail). Sandro Botticelli, c. 1445–1510

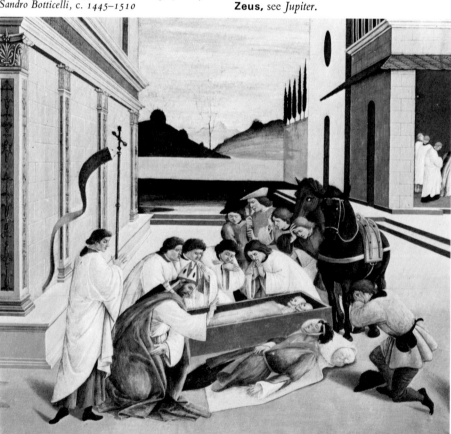

List of illustrations

List of illustrations

Measurements in centimetres. Height precedes width. The numbers refer to pages.

30 PIERO DELLA FRANCESCA: *St Apollonia*. Oil on panel, 39 × 28. Samuel H. Kress Collection, National Gallery of Art, Washington D.C.

31 ALBRECHT DÜRER: *The Four Apostles* (detail). Oil on panel, 214·5 × 76. Alte Pinakothek, Munich. Photo: Bayerische Staatsgemäldesammlungen.

32 VELAZQUEZ: *The Spinners*. Oil on canvas, 220 × 289. Prado, Madrid. Photo: Mas.

32 NICOLAS POUSSIN: '*Et in Arcadia Ego*' (detail). Oil on canvas, 85 × 121. Louvre, Paris. Photo: Bulloz.

33 REMBRANDT VAN RYN: *The Ascension*. Oil on canvas, 93 × 68. Alte Pinakothek, Munich. Photo: Bayerische Staatsgemäldesammlungen.

34 GUIDO RENI: *Atalanta and Melanion (Hippomenes)*. Oil on panel, 208 × 299. Capodimonte Museum, Naples. Photo: Mansell-Alinari.

34 PETER PAUL RUBENS: *Atlas*. Oil on canvas, 27 × 42. Prado, Madrid. Photo: Mas.

35 SANDRO BOTTICELLI: *St Augustine in his Cell*. Oil on panel, 41 × 427. Uffizi, Florence. Photo: Mansell-Alinari.

35 FRA FILIPPO LIPPI: *St Augustine and the child* (detail). Hermitage, Leningrad.

36 MARTEN VAN VALCKERBORCH: *The Tower of Babel*. Oil on wood, 75·5 × 105. Gemäldegalerie, Dresden.

37 JAN VAN EYCK: *Giovanni Arnolfini and his wife*. Oil on panel, 81·8 × 59·7. National Gallery, London.

38 PETER PAUL RUBENS: *Bacchanal*. Oil on canvas, 200 × 215. National Museum, Stockholm.

39 TITIAN: *Bacchus and Ariadne*. Oil on canvas, 69 × 75. National Gallery, London.

40 NICOLAS POUSSIN: *Aurora and Cephalus*. Oil on canvas, 96·5 × 130·5. National Gallery, London.

40 CARAVAGGIO: *Young Bacchus*. Oil on canvas, 98 × 85. Uffizi, Florence.

41 SANDRO BOTTICELLI: *St Augustine in his Study*. Fresco. Ognissanti, Florence. Photo: Scala.

42 NICOLAS POUSSIN: *The Baptism of Christ* (from the Seven Sacraments). Oil on canvas, 117 × 178. Collection of the Duke of Sutherland, on loan to the National Gallery of Scotland, Edinburgh. Photo: Annan.

42 JAN VAN EYCK: *St Barbara* (detail). 32·2 × 18·6. Musée des Beaux-Arts, Antwerp. Photo: A.C.L.

43 PETER PAUL RUBENS: *Bathsheba*. Oil on wood, 175 × 126. Gemäldegalerie, Dresden.

43 MASTER OF S. BARTHOLOMEW: *St Bartholomew*. Oil on panel, 129 × 161. Alte Pinakothek, Munich.

44 GIOVANNI BELLINI: *The Baptism of Christ*. Oil on panel, 410 × 265. S. Corona, Vicenza.

45 REMBRANDT VAN RYN: *Bathsheba*. Oil on canvas, 141·2 × 141·2. Louvre, Paris.

46 DANTE GABRIEL ROSSETTI: '*Beata Beatrix*'. Oil on canvas, 86 × 66. Tate Gallery, London.

46 HIERONYMUS BOSCH: *St Bavon*. Oil on wood, 167 × 60. Kunsthistorisches Museum, Vienna.

46 ANON: *St Benedict blessing Desiderius* (detail). Illuminated manuscript. Vat. Inst. 1202 f. 2 r. Biblioteca Apostolica Vaticana, Rome.

47 FRA FILIPPO LIPPI: *The Vision of St Bernard* (detail). Oil on panel, 205 × 192·5. Chiesa di Badia, Florence.

48 VELAZQUEZ: *Surrender of Breda* (detail). Oil on panel, 307 × 367. Prado, Madrid. Photo: Scala.

49 SANO DI PIETRO: *St Bernardino preaching in the Square of St Francis* (detail).

49 FRANCISCO DE ZURBARÁN: *Papal Election through intervention of St Bonaventura* (detail). Oil on canvas, 239 × 222. Gemäldegalerie, Dresden. Photo: Deutsche Fotothek, Dresden.

50 FRANÇOIS BOUCHER: *Jupiter and Callisto*. Oil on canvas, 142 × 114. North Carolina Museum of Art, Raleigh, North Carolina.

50 TITIAN: *Diana and Callisto*. Oil on canvas, 188 × 211. Collection of the Duke of Sutherland, on loan to the National Gallery of Scotland, Edinburgh.

51 TITIAN: *Christ carrying the Cross*. Oil on canvas, 89·5 × 77. The Hermitage, Leningrad.

51 UGOLINO DI NERIO: *Deposition*. Predella panel from an altarpiece, 34·5 × 52·5. National Gallery, London.

52 PAOLO VERONESE: *The Marriage at Cana* (detail). Oil on canvas, 666 × 990. Louvre, Paris. Photo: Mansell-Alinari.

52 FRANCISCO DE ZURBARÁN: *St Casilda* (detail). Oil on panel, 184 × 90. Prado, Madrid. Photo: Mas.

53 Copy after LEONARDO DA VINCI: *Leda* (detail). Oil on panel, 114 × 86. Gallotti Spiridon Collection, Rome.

54 HANS MEMLINC: *The Betrothal of St Catherine*. Tempera and oil on panel, 69 × 73. Metropolitan Museum of Art, bequest of Benjamin Altman, 1913.

54 LUCAS CRANACH THE ELDER: *Martyrdom of St Catherine*. Oil on panel, 126 × 139·5. Gemäldegalerie, Dresden.

55 FRANCESCO VANNI: *St Catherine of Siena* (detail). Fresco, Chiesa di S. Domenico, Siena. Photo: Mansell-Alinari.

55 CARLO DOLCI: *St Cecilia playing the Organ*. Oil on canvas, 96·5 × 81. Gemäldegalerie, Dresden. Photo: Deutsche Fotothek, Dresden.

56 JOACHIM PATINIR: *The Crossing of the River Styx* (detail). Oil on canvas, 64 × 193. Prado, Madrid. Photo: Mas.

56 TADDEO GADDI: *The Presentation in the Temple*. One of a series of quadrilobes, c. 44 × 46. Accademia, Florence. Photo: Mansell-Alinari.

57 HIERONYMUS BOSCH (copy): *Christ among the Doctors*. Oil on panel, 74 × 58. John G. Johnson Art Collection, Philadelphia.

57 DUCCIO: *Temptation of Christ* (detail). Oil on wood, 43·2 × 46. The Frick Collection, New York.

58 EL GRECO: *Christ healing the Blind Man* (detail). Oil on wood, 65·5 × 84. Gemäldegalerie, Dresden.

58 CONRAD WITZ: *The miraculous draught of fishes* (detail). Oil on panel, 132 × 154. Musée d'Art et d'Histoire, Geneva.

59 MASACCIO: *The Tribute Money* (detail). Fresco. Brancacci Chapel, Sta Maria del Carmine, Florence. Photo: Alinari.

59 TITIAN: *The Tribute Money*. Oil on wood, 75 × 56. Gemäldegalerie, Dresden.

60 GIOVANNI BATTISTA TIEPOLO (after Veronese): *Christ in the House of Simon the Pharisee* (detail). Oil on canvas, 132 × 159. National Gallery of Ireland, Dublin.

60 PAOLO VERONESE: *The Feast in the House of Levi.* Oil on canvas. Accademia, Venice. Photo: Mansell-Alinari.

61 GIOTTO: *Christ entering Jerusalem* (detail). Fresco. Cappella degli Scrovegni all'Arena, Padua. Photo: Mansell-Alinari.

62 BERNARDO CAVALLINO: *Christ cleansing the Temple.* Oil on canvas, 101 × 128. National Gallery, London.

62 TINTORETTO: *Christ washing his Disciples' Feet* (detail). Oil on canvas, 200·6 × 408·3. National Gallery, London.

63 DUCCIO: *Christ before Pilate* (detail). Fresco. Cathedral Museum, Siena.

63 REMBRANDT VAN RYN: *The Denial of Peter.* Oil on canvas, 154 × 169. Rijksmuseum, Amsterdam.

63 HIERONYMUS BOSCH: *The Betrayal of Christ.* Oil on wood, 51 × 81·5. Fine Art Gallery, San Diego, California.

64 HANS MEMLINC: *The Presentation in the Temple.* Oil on panel, 95 × 73. Prado, Madrid.

65 HIERONYMUS BOSCH: *Christ carrying the Cross.* Oil on panel, 57 × 32. Kunsthistorisches Museum, Vienna.

66 TINTORETTO: *Flagellation* (detail). Oil on canvas, 118·3 × 136. Kunsthistorisches Museum, Vienna.

67 MATHIS GRÜNEWALD: *The Small Crucifixion.* Oil on panel, 61·6 × 46. Samuel H. Kress Collection, National Gallery of Art, Washington D.C.

67 GIOVANNI BELLINI: *Christ descending into Limbo.* Vellum glued to wood, 51·2 × 36·8. City Art Gallery, Bristol.

67 BENVENUTO DI GIOVANNI: *Passion of our Lord.* Five panels framed, 282·9 × 60·3. Samuel H. Kress Collection, National Gallery of Art, Washington D.C.

68 HIERONYMUS BOSCH: *The Crowning with Thorns.* Oil on panel, 73 × 59. National Gallery, London.

69 GIOVANNI BELLINI: *Crucifixion.* Oil on panel, 54 × 30. Museo Correr, Venice.

70 QUENTIN MASSYS: *St Christopher* (detail). Oil on panel, 67 × 49. Samuel H. Kress Collection, Allentown Art Museum, Allentown, Pennsylvania.

70 HANS MEMLINC: *St Christopher.* Memlinc Museum, Bruges. Photo: A.C.L.

71 DOSSO DOSSI: *Circe and her Lovers in a Landscape* (detail). Oil on canvas, 101 × 135. Samuel H. Kress Collection, National Gallery of Art, Washington D.C.

71 LUCA SIGNORELLI: *The Circumcision* (detail). Oil on wood, 258·5 × 180. National Gallery, London.

71 MASTER OF HEILIGENKREUZ: *The Death of St Clare* (detail). Oil on panel, 66·4 × 54·5. Samuel H. Kress Collection, National Gallery of Art, Washington D.C.

72 FRANCESCO PARMIGIANINO: *Cupid cutting his Bow.* Oil on wood, 135 × 65·3. Kunsthistorisches Museum, Vienna. Photo: Meyer.

73 GIOVANNI BATTISTA TIEPOLO: *The Banquet of Cleopatra* (detail). Oil on canvas, 249 × 346. National Gallery of Victoria, Melbourne.

74 PIETER BRUEGHEL THE ELDER: *Land of Cockaigne.* Oil on wood, 52 × 78. Alte Pinakothek, Munich. Photo: Bildarchiv Foto Marburg.

74 LUCA SIGNORELLI: *Coriolanus persuaded by his family to spare Rome* (detail). Fresco transferred to canvas, 125·5 × 125·5. National Gallery, London.

75 FRA GIOVANNI ANGELICO: *The attempted Martyrdom of SS. Cosmas and Damian with their brothers* (detail). Oil on panel, 36 × 46. National Gallery of Ireland, Dublin.

75 GENTILE BELLINI: *Procession in Piazza S. Marco* (detail). Oil on canvas, 743 × 362. Accademia, Venice.

76 SEBASTIANO RICCI: *The Finding of the True Cross.* Oil on canvas, 84 × 35. Samuel H. Kress Collection, National Gallery of Art, Washington D.C.

77 After PALMA VECCHIO: *Venus and Cupid.* Oil on canvas, 116 × 205. Art Museum of the Socialist Republic of Romania, Bucharest.

77 ANTOINE WATTEAU: *Embarkation from the Island of Cythera* (detail). Oil on canvas, 129 × 194. Louvre, Paris. Photo: Archives Photographiques.

78 JAN GOSSAERT called MABUSE: *Danaë.* Oil on panel, 113 × 95. Alte Pinakothek, Munich.

78 TITIAN: *Danaë.* Hermitage, Leningrad.

79 REMBRANDT VAN RYN: *Belshazzar's Feast.* Oil on canvas, 163·7 × 203·7. National Gallery, London.

79 REMBRANDT VAN RYN: *The Vision of Daniel.* Oil on canvas, 96 × 116. Gemäldegalerie, Berlin-Dahlem.

80 EUGENE DELACROIX: *Dante and Virgil in Hell* (detail). Oil on canvas, 188 × 246. Louvre, Paris. Photo: Giraudon.

80 PAOLO VERONESE: *The Family of Darius III before Alexander* (detail). Oil on canvas, 234 × 473. National Gallery, London.

81 CARAVAGGIO: *David with the Head of Goliath.* Oil on canvas, 125 × 91. Borghese Gallery, Rome.

81 REMBRANDT VAN RYN: *David playing the Harp for Saul.* Oil on wood, 62 × 50. Städelsches Kunstinstitut, Frankfurt. Photo: Bildarchiv Foto Marburg.

82 PIETER BRUEGHEL THE ELDER: *Triumph of Death* (detail). Oil on panel, 117 × 162. Prado, Madrid.

82 HENRI BELLECHOSE: *Martyrdom of St Denis.* Oil on panel transferred to canvas, 161 × 210. Louvre, Paris. Photo: Giraudon.

83 HANS BALDUNG GRIEN: *Death and the Maiden.* Tempera on panel, 30 × 14·5. Offentliche Kunstsammlung, Basel.

84 ROGIER VAN DER WEYDEN: *Deposition.* Oil on panel, 220 × 262. Prado, Madrid. Photo: Mas.

84 PETER PAUL RUBENS: *Diana returning home from the Hunt* (detail). Oil on canvas, 136·5 × 182. Gemäldegalerie, Dresden. Photo: Deutsche Fotothek, Dresden.

85 LIBERALE DA VERONA: *Dido's Suicide* (detail). Oil on panel, 42·5 × 123. National Gallery, London.

85 JACOB JORDAENS: *Diogenes with his Lantern in the Market Place.* Oil on canvas, 233 × 349. Gemäldegalerie, Dresden.

86 BONIFAZIO VERONESE: *The Parable of the Rich Man's Feast.* Accademia, Venice. Photo: Anderson.

86 LIPPO DI VANNI: *St Dominic* (detail), Oil on panel, 66 × 51. Samuel H. Kress Collection, University of Miami, Joe and Emily Lowe Art Gallery, Coral Gables, Florida.

87 HUGO VAN DER GOES: *SS. Anthony and Matthew and Donor*. Left wing of Portinari Altarpiece, 253 × 141. Uffizi, Florence. Photo: Alinari.

87 HUGO VAN DER GOES: *SS. Mary Magdalene, Margaret and Donor*. Right wing of Portinari Altarpiece, 253 × 141. Uffizi, Florence. Photo: Alinari.

88 SANDRO BOTTICELLI: *Adoration of the Magi*. Oil on panel, 111 × 134. Uffizi, Florence. Photo: Mansell-Anderson.

89 FRANCESCO DI GIORGIO: *St Dorothea and the Infant Christ*. Oil on panel, 33 × 20·5. National Gallery, London.

89 PIETER BRUEGHEL THE ELDER: *Dulle Griet* (Mad Meg) (detail). Oil on panel, 115 × 161. Musée Mayer van den Berg, Antwerp.

90 HIERONYMUS BOSCH: *Ecce Homo*. Oil on panel, 75 × 61. Städelsches Kunstinstitut, Frankfurt.

90 NICOLAS POUSSIN: *Echo and Narcissus* (detail). Oil on canvas, 74 × 100. Louvre, Paris. Photo: Giraudon.

91 HIERONYMUS BOSCH: *Expulsion from Eden* (detail from left wing of *Haywain* triptych). Oil on panel, 135 × 45. Prado, Madrid.

91 GIOVANNI BATTISTA PIAZZETTA: *Elijah taken up in a Chariot of Fire*. Oil on canvas, 174·6 × 264·8. Samuel H. Kress Collection, National Gallery of Art, Washington D.C.

92 BARTOLOMÉ MURILLO: *St Elizabeth of Hungary* (detail). Oil on canvas, 325 × 245. Prado, Madrid.

92 CARAVAGGIO: *The Supper at Emmaus*. Oil on canvas, 139 × 195. National Gallery, London.

93 PAOLO VERONESE: *Entombment*. Musée d'Art et d'Histoire, Geneva.

93 FRA ANGELICO (attrib.): *Entombment* (detail). Oil on panel, 89 × 55. Samuel H. Kress Collection, National Gallery of Art, Washington D.C.

94 DIERIC BOUTS: *Martyrdom of St Erasmus*. Oil on panel, 82 × 80. St Pierre, Louvain. Photo: A.C.L.

94 JACOPO DEL SELLAIO: *Esther and Ahasuerus* (detail). Oil on panel, 45 × 42·7. National Gallery, Budapest.

95 REMBRANDT VAN RYN: *Haman begging Esther for forgiveness*. Oil on canvas, 236 × 186. Art Museum of the Socialist Republic of Romania, Bucharest.

96 LEONARDO DA VINCI: *Last Supper*. Fresco. Sta Maria delle Grazie, Milan. Photo: Alinari.

96 PAOLO VERONESE: *Rape of Europa* (detail). Ducal Palace, Venice. Photo: Mansell-Anderson.

97 MICHELANGELO: *Entombment*. Oil on panel, 161 × 149. National Gallery, London.

98 ANTONIO PISANELLO: *Vision of St Eustace*. Oil on panel, 54·5 × 65·5. National Gallery, London.

99 SODOMA: *The three Fates*. Oil on canvas, 200 × 212. Galleria Nazionale, Rome.

99 GIOVANNI BELLINI: *Feast of the Gods* (detail). Oil on canvas, 170 × 188. Widener Collection, National Gallery of Art, Washington D.C.

100 DIERIC BOUTS: *Last Supper* (from the Mystic Meals Altarpiece). Oil on panel, 285 × 227·5. St Pierre, Louvain. Photo: A.C.L.

101 TITIAN: *Rape of Europa*. Oil on canvas, 185 × 205. Isabella Stewart Gardner Museum, Boston.

102 ANTOINE WATTEAU: *Fête Champêtre* (detail). Oil on canvas, 60 × 75. Gemäldegalerie, Dresden.

102 GIORGIONE: *Concert Champêtre* (detail). Oil on canvas, 110 × 138. Louvre, Paris.

103 GERARD DAVID: *Rest on the Flight into Egypt* (detail). Oil on panel, 45 × 44·5. Mellon Collection, National Gallery of Art, Washington D.C.

103 COSIMO TURA: *Flight into Egypt*. Tempera on wood, diameter 38. Jules S. Bache Collection, Metropolitan Museum of Art, New York.

103 SEBASTIEN BOURDON: *Massacre of the Innocents* (detail). Hermitage, Leningrad. Photo: S.C.R.

104 JAN BRUEGHEL I: *Collecting the Animals for the Ark*. Apsley House, Wellington Museum, London.

105 BONAVENTURA BERLINGHIERI: *St Francis preaching to the birds*. Fresco, 151 × 116. S. Francesco, Pescia.

106 GUIDO RENI: *The Building of the Ark*. Oil on canvas, 193·5 × 154·5. Hermitage, Leningrad.

106 REMBRANDT VAN RYN: *Flora*. Oil on canvas, 96·4 × 91·7. The Metropolitan Museum of Art, New York.

107 NICOLAS POUSSIN: *Triumph of Flora* (detail). Oil on canvas, 65 × 94·9. Louvre, Paris. Photo: Giraudon.

107 ALBRECHT ALTDORFER: *Recovering the Body of St Florian* (detail from Florian Altar). Deutsches National-museum, Nuremberg.

108 RAPHAEL: *La Fornarina*. Oil on canvas, 85 × 60. Galleria Nazionale, Rome. Photo: O. Savio.

109 SASSETTA: *St Francis renounces his earthly father* (detail). Oil on panel, *c.* 87·5 × 52·5. National Gallery, London.

109 GIOVANNI BELLINI: *St Francis in ecstasy* (detail). Oil on panel, 124·4 × 141·9. Frick Collection, New York.

110 JAN VAN EYCK: *St Francis receiving the Stigmata* (detail). Oil on panel, 12·7 × 14·6. John G. Johnson Art Collection, Philadelphia.

110 PETER PAUL RUBENS: *Miracles of St Francis Xavier* (detail). Oil on panel, 105·5 × 74. Kunsthistorisches Museum, Vienna.

111 GERARD DAVID: *Archangel Gabriel*. Tempera and oil on wood, 76 × 61. The Metropolitan Museum of Art, New York, bequest of Mary Stillman Harkness.

111 NICOLAS POUSSIN: *Acis and Galatea*. Oil on canvas, 97 × 135. National Gallery of Ireland, Dublin.

112 RAOUX: *Pygmalion and Galatea*. Oil on canvas, 134 × 100. Louvre, Paris. Photo: Giraudon.

112 TINTORETTO: *Christ at the Sea of Galilee* (detail). Oil on canvas, 117 × 168·5. National Gallery of Art, Washington D.C.

112 REMBRANDT VAN RYN: *Ganymede being carried off by the Eagle*. Oil on panel, 171·5 × 130. Gemäldegalerie, Dresden. Photo: Deutsche Fotothek Dresden.

113 PETER PAUL RUBENS: *Garden of Love*. Oil on canvas, 78 × 68. Prado, Madrid. Photo: Mas.

113 TINTORETTO: *St George and the Dragon* (detail). Oil on canvas, 157·5 × 100·3. National Gallery, London.

114 NICOLAS POUSSIN: *Death of Germanicus* (detail). Oil on canvas, 148 × 196·5. William Dunwoody Fund, Minneapolis Institute of Arts.

114 MASTER OF ST GILES: *St Giles and the Hind* (detail). 61·5 × 46·5. National Gallery, London.

115 ANTOINE WATTEAU: *Gilles* (detail). Oil on canvas, 184·5 × 149·5. Louvre, Paris. Photo: Bulloz.

115 NICOLAS POUSSIN: *Adoration of the Golden Calf* (detail). Oil on canvas, 154 × 214. National Gallery, London.

116 MASTER OF FLÉMALLE: *Mass of St Gregory* (detail). Oil on panel, 85 × 73. Musées Royaux des Beaux-Arts, Brussels. Photo: A.C.L.

116 CLAUDE LORRAINE: *Hagar and the Angel* (detail). Oil on canvas mounted on wood, 52 × 44. National Gallery, London.

117 Follower of FRA ANGELICO: *Rape of Helen by Paris* (detail). Oil on wood, irregular octagon, 51 × 61. National Gallery, London.

117 JACQUES-LOUIS DAVID: *Hector*. Musée Fabre, Montpellier.

118 PAOLO VERONESE: *St Helena's Vision of the Cross*. Oil on canvas, 196 × 114. National Gallery, London.

118 PIETER BRUEGHEL THE ELDER: *The Fall of the Rebel Angels*. Oil on panel, 117 × 162. Musées Royaux des Beaux-Arts, Brussels.

119 BERNARDINO PINTORICCHIO: *Hercules and Omphale*. One of 22 panels from the ceiling of the Palazzo del Magnifico, Siena, painted for Pandolfo Petrucci, despot of Siena. Fresco transferred to canvas. The Metropolitan Museum of Art, New York, Rogers Fund, 1914.

119 HANS BALDUNG GRIEN: *Hercules and Antaeus*. Oil on panel, 153·6 × 66·5. Gemäldegalerie, Cassel. Photo: Bildarchiv Foto Marburg.

120 PETER PAUL RUBENS: *Nessus and Dejanira*. Photo: S.C.R.

120 FRANCESCO ALBANI: *Salmacis and Hermaphroditus*. Copper, Louvre, Paris. Photo: Service de Documentation Photographique.

121 MASOLINO: *The Banquet of Herod* (detail). Fresco in the Baptistery, Castiglione d'Olona. Photo: Mansell-Anderson.

121 PETER PAUL RUBENS: *Hero and Leander* (detail). Oil on canvas, 128 × 217. Gemäldegalerie, Dresden.

122 ANON: *Holy Family with St John in a landscape*. Oil on panel, 100 × 71. National Gallery of Ireland, Dublin.

122 NICOLAS POUSSIN: *The Holy Family*. Oil on canvas, 79 × 106. National Gallery of Ireland, Dublin.

123 JACQUES-LOUIS DAVID: *Oath of the Horatii*. Oil on canvas, 330 × 427. Louvre, Paris. Photo: Giraudon.

123 15TH-CENTURY FLEMISH SCHOOL: *Conversion of St Hubert*. 123·8 × 83. National Gallery, London.

124 PIETER BRUEGHEL THE ELDER: *Fall of Icarus* (detail). Oil on canvas, 73·5 × 112 Musées Royaux des Beaux-Arts, Brussels. Photo: A.C.L.

124 PETER PAUL RUBENS: *Miracle of St Ignatius Loyola* (detail). From an altarpiece from the Jesuit Church in Antwerp. Oil on panel, 526·2 × 388·7. Kunsthistorisches Museum, Vienna.

124 EL GRECO: *Adoration of the Name of Jesus* (detail). Oil on panel, 57·8 × 34·8. National Gallery, London.

125 EL GRECO: *St Ildefonso* (detail). Oil on canvas, 112 × 65. Mellon Collection, National Gallery of Art, Washington D.C.

125 GIOVANNI BATTISTA TIEPOLO: *The Immaculate Conception*. Oil on canvas, 279 × 152. Prado, Madrid. Photo: Mas.

126 EL GRECO: *Crucifixion* (detail). Oil on canvas, 161 × 97·5. John G. Johnson Collection, Philadelphia.

126 ANTONIO CORREGGIO: *Io embraced by Jupiter* (detail). Oil on canvas, 163·5 × 74. Kunsthistorisches Museum, Vienna.

127 School of ANTONELLO DA MESSINA: *Abraham visited by three Angels*. Oil on panel, 46·1 × 66·7. Samuel H. Kress Collection, Denver.

127 ANDREA DEL SARTO: *Sacrifice of Isaac*. Oil on panel, 213 × 159. Gemäldegalerie, Dresden. Photo: Deutsche Fotothek Dresden.

127 GIOVANNI BATTISTA PIAZZETTA: *Rebecca at the Well* (detail). Oil on canvas, 102 × 137. Brera, Milan. Photo: Mansell-Alinari.

128 BARTOLOMÉ MURILLO: *Isaac blessing Jacob*. Hermitage, Leningrad. Photo: S.C.R.

128 ALBRECHT ALTDORFER: *Battle of the Issus* (detail). Oil on panel, 117 × 159. Alte Pinakothek, Munich. Photo: Bildarchiv Foto Marburg.

129 ANTOINE WATTEAU: *Mezzetin*. Oil on canvas, 54·5 × 43·5. The Metropolitan Museum of Art, New York, Frank A. Munsey Fund.

129 ANTOINE WATTEAU: *Italian Comedians* (detail). Oil on canvas, 64 × 76. National Gallery of Art, Washington D.C.

130 JOSÉ DE RIBERA: *Dream of Jacob*. Oil on canvas, 179 × 233. Prado, Madrid. Photo: Mas.

131 PALMA VECCHIO: *The Meeting of Jacob and Rachel* (detail). Oil on canvas, 146 × 250. Gemäldegalerie, Dresden.

131 EUGÈNE DELACROIX: *Jacob wrestling with the Angel*. Chapel of the Holy Angels, St Sulpice, Paris. Photo: Giraudon.

132 SIMONE MARTINI and assistants: *St James the Greater*. Oil on panel, 31 × 23. Samuel H. Kress Collection, National Gallery of Art, Washington D.C.

132 MASTER OF ST FRANCIS: *St James the Less* (detail). Oil on panel, 50 × 24. Samuel H. Kress Collection, National Gallery of Art, Washington D.C.

132 GIOVANNI BATTISTA TIEPOLO: *St James the Greater of Compostela* (detail). Oil on canvas, 317 × 162. National Gallery of Art, Budapest.

133 HENDRICK TERBRUGGHEN: *Jacob reproaching Laban*. Oil on canvas, 97·5 × 114·3. National Gallery, London.

134 Follower of PESELLINO: *Cassone panel: scenes from the story of the Argonauts* (detail). Tempera on wood, 50 × 142·5. The Metropolitan Museum of Art, New York, Gift of J. Pierpont Morgan, 1909.

135 SANDRO BOTTICELLI: *Last Communion of St Jerome* (detail). Tempera on wood, 34 × 25·5. The Metropolitan Museum of Art, New York.

135 FRANCISCO DE ZURBARÁN: *St Jerome with St Paula and St Eustochium* (detail). Oil on canvas, 245·1 × 173. Samuel H. Kress Collection, National Gallery of Art, Washington D.C.

136 LUCA GIORDANO: *Martyrdom of St Januarius*. Oil on canvas, 106·7 × 80·6. National Gallery, London.

137 GIOVANNI BATTISTA CIMA: *St Jerome in a Landscape*. Oil on panel, 32 × 25·5. National Gallery, London.

138 WILLIAM BLAKE: *Satan smiting Job with sore boils*. Tempera on mahogany, 32 × 43. Tate Gallery, London.

139 JUAN DE FLANDES: *Decapitation of John the Baptist* (detail). Oil on panel, 88 × 47. Musée d'Art et d'Histoire, Geneva.

139 HIERONYMUS BOSCH: *St John at Patmos* (detail). Oil on panel, 62 × 41. Gemäldegalerie, Berlin-Dahlem.

140 MASACCIO: *Head of St John* (detail). Detail from the *Rendering of the Tribute Money*. Fresco in the Brancacci Chapel, S. Maria del Carmine, Florence.

141 GIOVANNI BATTISTA ROSSO: *Moses defending the Daughters of Jethro*. Oil on canvas, 160 × 117. Uffizi, Florence.

142 REMBRANDT VAN RYN: *Joseph relating his Dreams*. Oil on canvas, 51 × 39. Rijksmuseum, Amsterdam.

142 REMBRANDT VAN RYN: *Judas returning the thirty pieces of silver* (detail). Oil on panel, 79·5 × 102. Collection of the Marquess and Marchioness of Normansby. Photo: Photo Studios Ltd.

143 MATTEO DI GIOVANNI: *Judith with the head of Holofernes*. Oil on panel, 56 × 46. Kress Study Collection, Indiana University, Bloomington, Indiana.

143 PETER PAUL RUBENS: *Juno and Argus*. Oil on canvas, 255 × 348. Wallraf-Richartz Museum, Cologne. Photo: Bildarchiv Foto Marburg.

144 PAOLO VERONESE: *Judith with the head of Holofernes*. Oil on panel, 111 × 100·5. Kunsthistorisches Museum, Vienna. Photo: Photo Meyer.

145 NICOLAS POUSSIN: *The Nurture of Jupiter* (detail). Oil on canvas, 96 × 119·7. Dulwich College Picture Gallery, London.

146 HUBERT and JAN VAN EYCK: *Adoration of the Lamb* (detail of central panel of the Ghent Altarpiece). Oil on panel, 136 × 242. St Bavon, Ghent. Photo: A.C.L.

147 EL GRECO: *Laocoön*. Oil on canvas, 137·5 × 172·5. Samuel H. Kress Collection, National Gallery of Art, Washington D.C.

147 HUGO VAN DER GOES: *Lamentation* (detail). Oil on panel, 33·8 × 23. Kunsthistorisches Museum, Vienna.

148 PIERO DI COSIMO: *Battle between the Lapiths and Centaurs* (detail). Oil on panel, 71 × 260. National Gallery, London.

148 HUBERT VAN EYCK: *Last Judgment*. Tempera and oil on canvas, transferred from wood, 56·5 × 19·7. The Metropolitan Museum of Art, New York.

149 FRA ANGELICO: *St Lawrence distributing alms* (detail). Fresco, St Nicholas Chapel, Vatican, Rome. Photo: Mansell-Anderson.

149 FRANCISCO DE ZURBARÁN: *St Lawrence*. Oil on canvas, 282 × 226. Hermitage, Leningrad.

149 NICOLAS FROMENT: *Raising of Lazarus* (detail). Oil on panel, 175 × 134. Uffizi, Florence. Photo: Mansell-Alinari.

150 ANTONIO CORREGGIO: *Leda with the Swan* (detail). Oil on canvas, 152 × 191. Gemäldegalerie, Berlin-Dahlem. Photo: Bildarchiv Foto Marburg.

150 PETER PAUL RUBENS: *Rape of the Daughters of Leucippas* (detail). Oil on canvas, 222 × 209. Alte Pinakothek. Photo: Bayerische Staatsgemälde-sammlungen, Munich.

150 EUGÈNE DELACROIX: *Liberty Leading the People* (detail). Oil on canvas, 260 × 325. Louvre, Paris. Photo: Bulloz.

151 ANDREA ORCAGNA: *The Crucifixion* (detail). Wood, main part, 108 × 84. National Gallery, London.

151 ALBRECHT ALTDORFER: *Lot and his daughters*. Oil on panel, 107 × 189. Kunsthistorisches Museum, Vienna.

152 LORENZO LOTTO: *A Lady as Lucretia*. Oil on canvas, 95·9 × 110·5. National Gallery, London.

153 FRANCESCO DEL COSSA: *St Lucy*. Oil on panel, 79 × 56. Samuel H. Kress Collection, National Gallery of Art, Washington D.C.

153 ROGIER VAN DER WEYDEN: *St Luke painting the Virgin* (detail). Oil on panel, 135·3 × 108·8. Courtesy of the Museum of Fine Arts, Boston.

154 JEHAN FOUQUET: *Madonna and Child*. Oil on panel, 91 × 81. Musée Royal des Beaux-Arts, Antwerp. Photo: A.C.L.

154 HANS MEMLINC: *Madonna and Child with Angels* (detail). Oil on panel, 59 × 48. Andrew Mellon Collection, National Gallery of Art, Washington D.C.

154 RAPHAEL: *The Small Cowper Madonna*. Oil on panel, 59·5 × 44. Widener Collection, National Gallery of Art, Washington D.C.

155 BACCHIACCA: *The Gathering of Manna* (detail). Oil on panel, 112 × 95. Samuel H. Kress Collection, National Gallery of Art, Washington D.C.

155 REMBRANDT VAN RYN: *The offering of Manoah* (detail). Oil on canvas, 242 × 283. Gemäldegalerie, Dresden. Photo: Deutsche Fotothek Dresden.

156 FRANCISCO DE ZURBARÁN: *St Margaret* (detail). Oil on canvas, 144 × 112. National Gallery, London.

156 TINTORETTO: *Martyrdom of St Mark* (detail). Oil on canvas, 108·5 × 125. Musées Royaux des Beaux-Arts, Brussels. Photo: A.C.L.

157 JACQUES-LOUIS DAVID: *The death of Marat*. Oil on canvas, 165 × 128. Musées Royaux des Beaux-Arts, Brussels. Photo: Scala.

158 PIERO DI COSIMO: *Venus and Mars*. Oil on panel, 72 × 182. Gemäldegalerie, Berlin-Dahlem.

158 PETER PAUL RUBENS: *Apollo and Marsyas*. Oil on panel, 26·5 × 38. Musées Royaux des Beaux-Arts, Brussels. Photo: A.C.L.

159 QUENTIN MASSYS: *St Mary of Egypt*. Oil on panel, 31·1 × 21·1. John G. Johnson Collection, Philadelphia.

160 PETER PAUL RUBENS: *Christ in the House of Martha and Mary*. Oil on panel, 64 × 61. National Gallery of Ireland, Dublin.

161 EL GRECO: *St Martin and the Beggar*. Oil on canvas, 104 × 60. National Gallery of Art, Washington D.C.

162 TITIAN: *Mary Magdalene*. Oil on canvas, 187 × 120. Hermitage, Leningrad.

162 MARINUS VAN ROYMERSVAELE: *The Calling of St Matthew* (detail). Oil on panel, 83 × 109. National Gallery of Ireland, Dublin.

163 HANS BALDUNG GRIEN: *St George and St Maurice* (detail from wing of an altarpiece). Oil on panel, 121 × 28. Gemäldegalerie, Berlin-Dahlem.

163 EUGÉNE DELACROIX: *Medea*. Oil on canvas, 122 × 85. Louvre, Paris. Photo: Archives Photographiques.

163 CARAVAGGIO: *Medusa*. Oil on canvas, diameter 55·5. Uffizi, Florence.

164 MATHIS GRÜNEWALD: *The Meeting of St Erasmus and St Maurice*. Wood, 226 × 176. Alte Pinakothek, Munich. Photo: Joachim Blauel.

165 ANTONIO CORREGGIO: *Mercury instructing Cupid before Venus*. Oil on canvas, 155 × 91·5. National Gallery, London.

166 THÉODORE GERICAULT: *The Raft of the Medusa*. Oil on canvas, 491 × 717·5. Louvre, Paris. Photo: Giraudon.

166 HANS BALDUNG GRIEN: *Mercury* (detail). Oil on panel, 194 × 64. National Museum, Stockholm.

167 DOMENICO GHIRLANDAIO: *St Michael* (detail). Oil on panel, 70·7 × 41·1. Samuel H. Kress Collection, Portland, Oregon. Photo: Portland Art Museum.

167 NICOLAS POUSSIN: *Midas and Bacchus* (detail). Oil on canvas, 98 × 134·5. Alte Pinakothek, Munich.

168 BARTOLOMÉ BERMEJO: *St Michael*. 350 × 158·7. Wernher Collection, Luton Hoo.

169 TINTORETTO: *Origin of the Milky Way* (detail). Oil on canvas, 148 × 165. National Gallery, London.

169 TINTORETTO: *Venus hunted by Minerva* (detail). Prado, Madrid. Photo: Mansell-Anderson.

170 TINTORETTO: *The Finding of Moses*. Oil on canvas, 77·5 × 34. The Metropolitan Museum of Art, New York.

170 DOMENICO FETI: *Moses and the burning bush*. Oil on canvas, 168 × 113. Kunsthistorisches Museum, Vienna.

171 FELIX CHRETIEN: *The Dinteville Brothers before Francis I as Moses and Aaron before Pharaoh*. Tempera and oil on panel, 176·5 × 192·5. The Metropolitan Museum of Art, Catherine D. Wentworth Fund, 1950.

172 COSIMO ROSSELLI: *Crossing of the Red Sea* (detail). Sistine Chapel, Vatican. Photo: Mansell-Alinari.

172 REMBRANDT VAN RYN: *Moses with the Ten Commandments*. Oil on canvas, 167 × 135. Gemäldegalerie, Berlin-Dahlem.

173 EUSTACHE LE SUEUR: *The Muses Clio, Euterpe and Thalia* (detail). Oil on panel, 130 × 130. Louvre, Paris. Photo: Giraudon.

174 A Follower of GIOVANNI ANTONIO BOLTRAFFIO: *Narcissus*. Oil on panel, 23 × 26·5. National Gallery, London.

174 NICOLAS POUSSIN: *Narcissus*. Oil on canvas, 72 × 96·5. Gemäldegalerie, Dresden. Photo: Deutsche Fotothek Dresden.

175 SALVATOR ROSA: *Odysseus and Nausicaa*. Hermitage, Leningrad.

175 MABUSE (JAN GOSSAERT): *Neptune and Amphitrite*. Staatliche Museen zu Berlin.

176 PAOLO VERONESE: *Consecration of St Nicholas*. Oil on canvas, 287 × 175. National Gallery, London.

176 PIETRO CANDIDO: *The Charity of St Nicholas*. Oil on panel, 65 × 97. Kress Collection, Museum of Art, Columbia, South Carolina.

177 LO SCARSELLINO: *Noli me tangere*. Photo: Gabinetto Fotografico Nazionale, Rome.

177 ANTONIO CORREGGIO: *Noli me tangere*. Oil on canvas, 130 × 103. Prado, Madrid.

178 PIERRE-AUGUSTE RENOIR: *Odalisque*. Oil on canvas, 68·6 × 123·3. National Gallery of Art, Washington D.C., Chester Dale Collection.

179 GUSTAVE MOREAU: *Oedipus and the Sphinx*. Oil on canvas, 203 × 103. Metropolitan Museum of Art, New York.

179 NICOLAS POUSSIN: *Blind Orion searching for the Rising Sun* (detail). Oil on canvas, 117 × 183. Metropolitan Museum of Art, New York, Fletcher Fund, 1924.

180 GIOVANNI BELLINI: *Orpheus* (detail). Transferred from wood to canvas, 39·5 × 81. Widener Collection 1942, National Gallery of Art, Washington D.C.

180 DIERIC BOUTS: *Judgment of the Emperor Othon* (detail). Oil on panel, 324 × 182. Musées Royaux des Beaux-Arts, Brussels. Photo: A.C.L.

181 EUGÈNE DELACROIX: *Ovid among the Scythians* (detail). Oil on canvas, 88 × 130. National Gallery, London.

182 JACOB JORDAENS: *Pan and Syrinx*. Oil on canvas, 173 × 136. Musées Royaux des Beaux-Arts, Brussels. Photo: A.C.L.

182 LUCA SIGNORELLI: *Pan*. Oil on canvas, 194 × 257. Destroyed. Formerly Kaiser Friedrich Museum, Berlin.

183 ANON: *Paradise Garden (Hortus Conclusus)*. Oil on panel, 26·3 × 33·4. Städelsches Kunstinstitut, Frankfurt.

183 BENOZZO GOZZOLI: *Paradise* (detail). Fresco. Palazzo Medici-Riccardi, Florence. Photo: Mansell-Brogi.

184 PETER PAUL RUBENS: *Judgment of Paris* (detail). Oil on oak panel, 145 × 194. National Gallery, London.

184 NIKLAUS MANUEL DEUTSCH: *Judgment of Paris* (detail). Tempera on panel, 223 × 60. Offentliche Kunstsammlung, Basel.

185 ANDREA MANTEGNA: *Parnassus*. Oil on canvas, 160 × 192. Louvre, Paris.

186 NICCOLO DELL'ABBATE: *Conversion of St Paul*. Oil on canvas, 177·5 × 128·5. Kunsthistorisches Museum, Vienna.

186 BARTOLOME ZEITBLOM: *Descent of the Holy Ghost*. Oil on canvas, 121 × 66. National Gallery of Ireland, Dublin.

187 PETER PAUL RUBENS: *Perseus and Andromeda*. Oil on wood transferred to canvas, 99·5 × 139. Hermitage, Leningrad.

188 CARAVAGGIO: *Martyrdom of St Peter*. Oil on canvas, 230 × 175. Church of S. Maria del Popolo, Rome. Photo: Mansell-Alinari.

188 PIERRE-NARCISSE GUERIN: *Phaedra and Hippolytus*. Oil on canvas, 257 × 355. Louvre, Paris. Photo: Bulloz.

189 HANS ROTTENHAMMER: *Fall of Phaeton*. Copper, 39 × 54·1. Koninklijk Kabinet van Schilderijen, The Hague.

190 REMBRANDT VAN RYN: *Philemon and Baucis* (detail). Oil on panel, 54·5 × 68·5. Widener Collection, National Gallery of Art, Washington D.C.

190 NICOLAS POUSSIN: *Gathering of the Ashes of Phocion* (detail). Oil on canvas, 121 × 176. Collection of The Right Hon. the Earl of Derby, M.C. Photo: National Gallery, London.

191 ERCOLE ROBERTI: *Pietà*. Tempera on panel, 33·7 × 30·6. Walker Art Gallery, Liverpool.

191 J. M. W. TURNER: *Ulysses deriding Polyphemus* (detail). Oil on canvas, 132·5 × 203·5. National Gallery, London.

192 DIRCK BAEGERT: *Pilate washing his hands* (detail). Oil on wood, 132 × 78·5. Musées Royaux des Beaux-Arts, Brussels. Photo: A.C.L.

192 SANDRO BOTTICELLI: *Primavera*. Oil on panel, 203 × 314. Uffizi, Florence.

193 PIERO DI COSIMO: *A Mythological Subject: Death of Procris*. Oil on panel, 65 × 183. National Gallery. London.

194 DOMENICO FETTI: *Return of the Prodigal Son*. Oil on panel, 60 × 45. Gemäldegalerie, Dresden.

194 PIERO DI COSIMO: *Allegory of Prometheus*. Oil on panel, 68 × 120. Alte Pinakothek, Munich. Photo: Mansell-Alinari.

195 NICCOLO DELL'ABBATE: *Rape of Proserpina* (detail). Louvre, Paris. Photo: Giraudon.

196 NICOLAS POUSSIN: *Pyramus and Thisbe* (detail). Oil on canvas, 192·5 × 273·5. Städelsches Kunstinstitut, Frankfurt. Photo: Bildarchiv Foto Marburg.

197 PIERO DELLA FRANCESCA: *Resurrection*. Fresco. Borgo S. Sepolcro, Palazzo Communale. Photo: Anderson.

198 ANTHONY VAN DYCK: *Rinaldo and Armida*. Oil on wood, 56·5 × 41·5. Musées Royaux des Beaux-Arts, Brussels. Photo: A.C.L.

198 PARMIGIANINO: *St Roch*. Panel, 329 × 228. S. Petronio, Bologna.

199 NICOLAS POUSSIN: *Rape of the Sabine Women* (detail). Oil on canvas, 154·6 × 210. Metropolitan Museum of Art, New York.

200 PAUL CÉZANNE: *La Montagne Sainte-Victoire au Grand Pin*. Oil on canvas, 59·5 × 67. Phillips Collection, Washington D.C.

200 BENOZZO GOZZOLI: *Dance of Salome*. Oil on panel, 23·8 × 34·3. Samuel H. Kress Collection, National Gallery of Art, Washington D.C.

201 JACOPO BASSANO: *The Good Samaritan*. Oil on canvas, 102 × 80. National Gallery, London.

202 REMBRANDT VAN RYN: *Blinding of Samson* (detail). Oil on canvas, 45 × 62. Städelsches Kunstinstitut, Frankfurt.

203 PAOLO UCCELLO: *The Battle of San Romano* (detail). Oil on panel, 183 × 319·5. National Gallery, London.

203 FRANCISCO DE GOYA: *Saturn devouring his Children* (detail). Oil on canvas, 143 × 83. Prado, Madrid.

204 EUGÈNE DELACROIX: *Massacre de Scio* (detail). Oil on canvas, 417 × 354. Louvre, Paris. Photo: Giraudon.

204 ANDREA MANTEGNA: *Introduction of the Cult of Cybele at Rome (the Triumph of Scipio)* (detail). Oil on canvas, 73·5 × 268. National Gallery, London.

205 HUGO VAN DER GOES: *Lamentation*. Kunsthistorisches Museum, Vienna.

206 GEORGES DE LA TOUR: *St Sebastian*. Oil on canvas, 160 × 129. Gemäldegalerie, Berlin-Dahlem.

206 HIERONYMUS BOSCH: *The seven deadly sins* (detail). Oil on panel, 120 × 150. Private Collection.

207 NICOLAS POUSSIN: *The Seven Sacraments: Eucharist*. Oil on canvas, 117 × 178. Collection of the Duke of Sutherland. On loan to the National Gallery of Scotland, Edinburgh. Photo: Annan.

207 NICOLAS POUSSIN: *The Seven Sacraments: Ordination*. Oil on canvas, 117 × 178. Duke of Sutherland Collection. On loan to the National Gallery of Scotland, Edinburgh. Photo: Annan.

208 ANTONIO and PIERO POLLAIUOLO: *Martyrdom of St Sebastian*. Oil on panel, 291·5 × 202·5. National Gallery, London.

209 ANGELO BRONZINO: *Venus, Cupid, Folly and Time*. Oil on panel, National Gallery, London.

210 PESELLINO AND STUDIO: *The Seven Virtues*. Oil on panel, 44·5 × 149. Samuel H. Kress Collection, Birmingham Museum of Art, Birmingham, Alabama.

210 LEANDRO BASSANO: *The Queen of Sheba visiting Solomon*. Oil on canvas, 168 × 112. National Gallery of Ireland, Dublin.

211 HIERONYMUS BOSCH: *Ship of Fools*. Oil on panel, 56 × 32. Louvre, Paris.

211 MICHELANGELO: *Cumaean Sibyl*. Fresco. Sistine Chapel, Vatican, Rome. Photo: Mansell-Anderson.

212 School of ANDREA DEL VERROCCHIO: *Tobias and the Angel*. Oil on panel, 84 × 66. National Gallery, London.

213 ANTHONY VAN DYCK: *Triumph of Silenus*. Oil on canvas, 137 × 196. National Gallery, London.

214 NICOLAS POUSSIN: *Judgment of Solomon* (detail). Oil on canvas, 101 × 150. Louvre, Paris. Photo: Bulloz.

215 School of PIETRO DA CORTONA: *Martyrdom of St Stephen*. Hermitage, Leningrad.

216 RAPHAEL: *Transfiguration*. Oil on panel, 405 × 278. Vatican Galleries. Photo: Scala.

217 REMBRANDT VAN RYN: *Susanna and the Elders* (detail). Oil on panel, 76·5 × 92·8. Gemäldegalerie, Berlin-Dahlem.

217 TINTORETTO: *Susanna and the Elders*. Oil on canvas, 146 × 193·6. Kunsthistorisches Museum, Vienna.

218 NICOLAS POUSSIN: *Tancred and Erminia*. Oil on canvas, 98·5 × 146·5. Hermitage, Leningrad.

219 PETER PAUL RUBENS: *St Teresa delivering Bernadin de Mendoza from Purgatory*. Oil on panel, 194 × 139. Musée des Beaux-Arts, Antwerp. Photo: A.C.L.

219 ANON: *Theseus killing the Minotaur* (detail from a cassone panel). Louvre, Paris. Photo: Giraudon.

220 JEAN-AUGUSTE-DOMINIQUE INGRES: *Jupiter and Thetis*. Oil on canvas, 326·5 × 253. Musée, Aix-en-Provence. Photo: Giraudon.

220 FRANCISCO DE GOYA: *Third of May 1808* (detail). Oil on canvas, 266 × 345. Prado, Madrid. Photo: Mas.

221 STEFAN LOCHNER: *Martyrdom of St Thomas*. Oil on panel, 40 × 40. Städelsches Kunstinstitut, Frankfurt. Photo: Bildarchiv Foto Marburg.

221 GUERCINO: *The Incredulity of St Thomas*. Oil on canvas, 115 × 140. National Gallery, London.

222 SASSETTA: *St Thomas Aquinas* (detail). Oil on panel, 23·6 × 39. National Gallery, Budapest.

222 HANS VON ACHEN: *Three Graces*. Oil on canvas, 209·7 × 138·6. Art Museum of the Socialist Republic of Romania, Bucharest.

223 NICOLAS POUSSIN: *A Dance to the Music of Time* (detail). Oil on canvas, 83 × 105. Wallace Collection, London. Reproduced by permission of the Trustees of the Wallace Collection.

224 PETER PAUL RUBENS: *Fall of the Titans*. Oil on panel, 26·5 × 42·5. Musées Royaux des Beaux-Arts, Brussels. Photo: A.C.L.

225 GIOVANNI BELLINI: *Transfiguration of Mount Tabor* (detail). Museo Civico, Venice. Photo: Alinari.

225 DUCCIO: *Transfiguration*. Oil on panel, 44 × 66. National Gallery, London.

226 TINTORETTO: *Holy Trinity adored by the heavenly Choir*. Oil on canvas, 116·5 × 108·5. Kress Collection, Columbia Museum of Art, Columbia, South Carolina.

226 MASTER OF FLÉMALLE: *Holy Trinity*. Oil on panel, 93·5 × 77·5. Musées Royaux des Beaux-Arts, Brussels. Photo: A.C.L.

228 PINTORICCHIO: *Scenes from the Odyssey* (detail). Fresco transferred to canvas, 125·5 × 152. National Gallery, London.

229 CLAUDE LORRAINE: *Embarkation of St Ursula* (detail). Oil on canvas, 113 × 149. National Gallery, London.

230 HANS MEMLINC: *St Veronica*. Oil on panel, 31·1 × 24·2. Samuel H. Kress Collection, National Gallery of Art, Washington D.C.

230 SANDRO BOTTICELLI: *Birth of Venus*. Oil on canvas, 175 × 278. Uffizi, Florence.

231 VELAZQUEZ: *Toilet of Venus (the Rokeby Venus)*. Oil on canvas, c. 122·5 × 177. National Gallery, London.

231 PAOLO VERONESE: *Venus and Adonis* (detail). Oil on canvas, 145 × 173. Nationalmuseum, Stockholm.

232 PARIS BORDONE: *Vertumnus and Pomona*. Oil on canvas, 130 × 124. Louvre, Paris. Photo: Service de Documentation Photographique.

232 Studio of the MASTER OF MOULINS: *Joachim and Anne meeting at the Golden Gate* (detail). Oil on panel, 72 × 59. National Gallery, London.

233 FRA CARNAVALE: *Nativity of the Virgin*. Tempera and oil on panel, 142·5 × 94. Metropolitan Museum of Art, New York.

234 ANDREA DI BARTOLO: *Presentation of the Virgin* (detail). Oil on panel, 44 × 32. Samuel H. Kress Collection, National Gallery of Art, Washington D.C.

234 CIMA DI CONEGLIANO: *Presentation of the Virgin*. Oil on panel, 105 × 145. Gemäldegalerie, Dresden. Photo: Deutsche Fotothek Dresden.

235 RAPHAEL: *Marriage of the Virgin* (detail). Oil on canvas, 170 × 118. Pinacoteca di Brera, Milan. Photo: Mansell-Anderson.

235 BERNAERT VAN ORLEY: *Marriage of the Virgin*. Oil on panel, 53·7 × 32·3. Samuel H. Kress Collection, National Gallery of Art, Washington D.C.

236 TINTORETTO: *Annunciation*. Oil on canvas, 100 × 124. Art Museum of the Socialist Republic of Romania, Bucharest.

236 ALBRECHT ALTDORFER: *Visitation* (detail). Oil on panel, 101·5 × 77·5. Courtesy of the Cleveland Museum of Art, Cleveland, Ohio.

237 PALMA VECCHIO: *Visitation* (detail). Oil on canvas, 168 × 354. Kunsthistorisches Museum, Vienna.

237 PHILIPPE DE CHAMPAIGNE: *Visitation*. Oil on canvas, 94 × 75·5. Musée d'Art et d'Histoire, Geneva.

238 HUGO VAN DER GOES: *Death of the Virgin* (detail). Oil on wood, 149 × 122. Musée Communale des Beaux-Arts, Bruges. Photo: A.C.L.

238 HANS HOLBEIN THE ELDER: *Death of the Virgin Mary*. Oil on panel, 147 × 227. National Gallery of Art, Budapest.

239 MATTEO DI GIOVANNI: *Assumption of the Virgin*. (Central panel from an altarpiece.) Oil on panel, 331 × 173. National Gallery, London.

239 EL GRECO: *Assumption of the Virgin*. Oil on canvas, 401·3 × 228·6. Courtesy of the Art Institute of Chicago.

239 PETER PAUL RUBENS: *Assumption of the Virgin* (detail). Kunstmuseum, Düsseldorf. Photo: Carlfred Halbach.

240 FRA ANGELICO: *Coronation of the Virgin* (detail). Oil on panel, 164 × 206. Louvre, Paris. Photo: Giraudon.

240 STEFAN LOCHNER: *Madonna of the Rose Garden* (detail). Oil on panel, 50·5 × 40. Wallraf-Richartz Museum, Cologne. Photo: Rheinisches Bildarchiv.

241 MASTER OF THE ST LUCY LEGEND: *Virgin Mary, Queen of Heaven*. Oil on panel, 215·9 × 185·4. Samuel H. Kress Collection, National Gallery of Art, Washington D.C.

242 SANDRO BOTTICELLI: *Three Miracles of St Zenobius* (detail). Tempera on wood, 67 × 150·5. Metropolitan Museum of Art, Kennedy Fund, 1911.